PAINTING
EXPRESSIVE
WATERCOLOUR

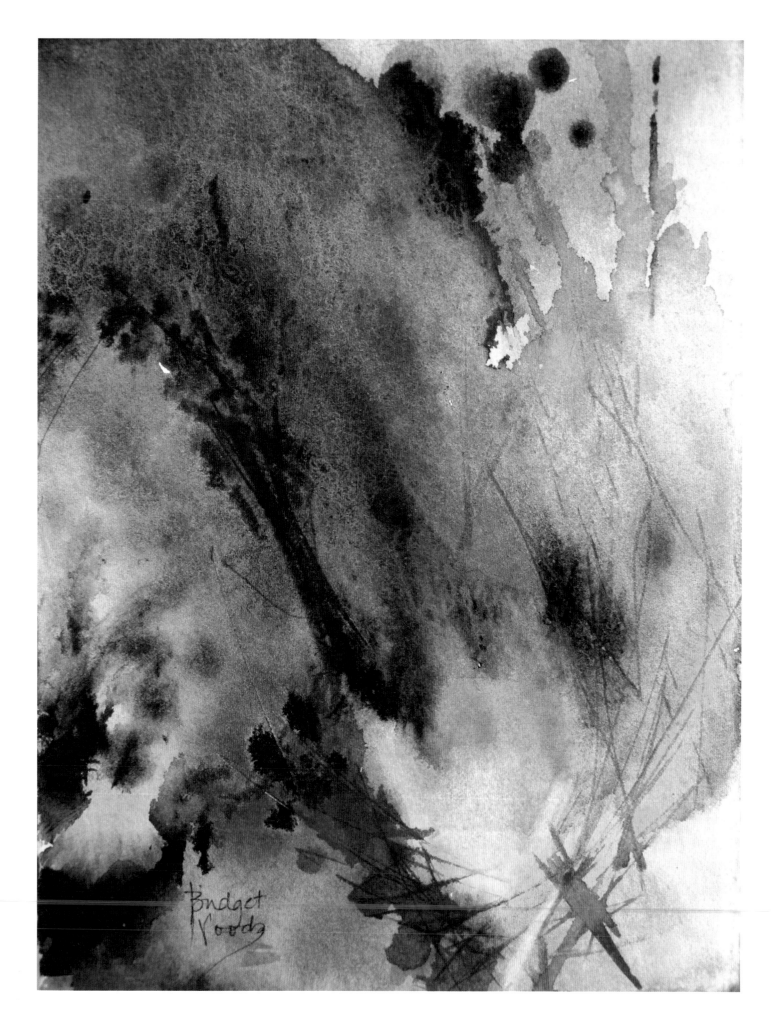

PAINTING EXPRESSIVE WATERCOLOUR

BRIDGET WOODS

THE CROWOOD PRESS

First published in 2014 by
The Crowood Press Ltd
Ramsbury, Marlborough
Wiltshire SN8 2HR

www.crowood.com

British Library Cataloguing-in-Publication Data
A catalogue record for this book is available from the British Library.

ISBN 978 1 84797 750 2

Frontispiece: *Ardent*. Summing up my passion for watercolour.

You must be shapeless, formless, like water. When you pour water in a cup, it becomes the cup. When you pour water in a bottle, it becomes the bottle. When you pour water in a teapot, it becomes the teapot. Water can drip and it can crash. Become like water my friend.
Bruce Lee

Typeset by Sharon Dainton, Isis Design, Stroud.
Printed and bound in India by Replika Press Pvt Ltd.

CONTENTS

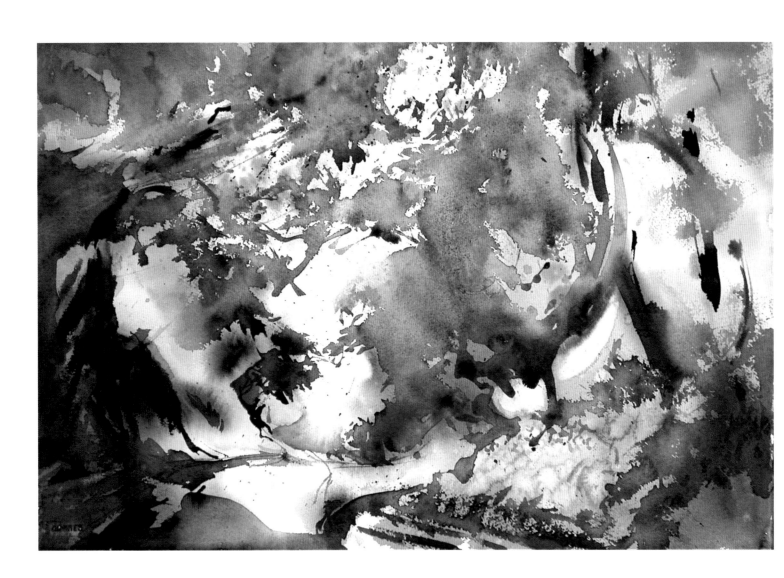

PREFACE

I am not a teacher, only a fellow-traveller of whom you asked the way.
I pointed ahead – ahead of myself as well as you.
George Bernard Shaw

As a painter, I am continually learning:

- In the studio, the importance of the simple, basic joy of observation and 'play', questioning, imagining and wandering with attention, no matter how bizarre the trail. These contemplative factors enable me to be, at times, fluidly inventive, at others, wildly expressive.

- In the field, to engage all of my senses. Sometimes, I can sense a connection to an energy that is flowing seamlessly through me. Whatever the subject, by paying attention I open myself to this sensation, especially when painting wet watercolour. All I have to do is have the painting skills ready to let this energy flow through me and onto the paper. As flowing water picks up flotsam in nature, the clear energy passing through me picks up colour and is 'tinted' by the person that I am and a painting happens. Though I am in an altered state of awareness I have become reality. This is less to say that I have no will in the event, more that I am the event.

- Whether this sensation is a buzz, joy, excitement or thrill, it is so positive that I am driven to refind it. It happens sometimes by quietly focusing on the visual world, learning and copying with precision. At other times by occupying other senses with, for example, music, flowers, dance, voices, heat, birdsong or rain while painting. This distraction of the conscious mind often allows a subconscious response to the situation to slither through via the play skills, and create a painting that can never be repeated. Either way, whether I am flailing with seven loaded brushes or pecking and stroking with a 0.3mm lead pencil, time is stilled.

As a teacher I am still discovering the power of watercolour to express the past, present, future ideas and dreams of my world through trial, error and an open mind. Aware of the perseverance that is involved, I want to share my discoveries thus far, offering shortcuts and encouragement to other learners while holding a space for their own moment of discovery, development and personal expression.

This to me is the key for watercolour painting at any level of experience: the beginner's mind which is aware of what is and open to what might be. I feel keenly that it is this 'playing attention' that engenders questions like, 'Could I...?' and 'What about...?' and opens a world of possibilities, invention and individuality.

With this approach, as a teacher, I learn more and the process of watercolour painting becomes an infinite, living thing, stretching way beyond the realms of finite accomplishment towards its unique potential for personal expression.

Watercolour may be considered by many to be a humble medium, yet it is my teacher and honest companion. Gentle, stern and frivolous, it is a mirror to my behaviour and can reveal my subconscious when I am sufficiently humble to look. For me it is the best visual descriptor of the human condition: mind, body and spirit. It unrelentingly tells me to be open, here, now. But secretly I hope, one day in the future, to be a worthy friend.

LEFT: *Autumn Wind*. A bold step from soft to sharp marks to express the bittersweet change of season.

INTRODUCTION

WHY DO WE PAINT?

Throughout history there have been many aspirational, practical, life-enhancing incentives for painting. How many of the following factors affect us now in our own society, whether as painting or non-painting individuals?

Survival – 'capturing' an animal on a cave wall
Spiritual – expressing the 'worth-ship' of powers greater than man
Immortality – creating an artefact to outlive its maker or subject
Direction – making signage and map symbols
Embellishment – decorating our bodies and homes
Symbolic – displaying identity with signs bold, discreet or coded
Communication – conveying a visual likeness, news or response
Expression – literally 'getting out' a non-verbal feeling or idea
Sensuality – 'doing'; a multi-sensory proof of being alive
Study – learning by observing and recording a subject
Preservation – holding a visual moment in time
Meditation – focusing attention to occupy or calm the mind
Giving – creating an image to offer to another person or deity
Selling – exchanging an image for money for food and living needs

Today, when photography and film are available for visual communication, it might be said that the artist is released from the job of painting a likeness. Yet interest in super-real imagery in painting is still alive.

Painting offers an alternative and personal means of reportage. Every painter makes selective choices when delivering their viewpoint or testimonial. By accentuating or taking away some of the available information, all forms of painting lie somewhere along the scale of 'expressive abstraction'. (Even a photographer does this by reducing three dimensions to two, 're-presenting' forms as visual, not tactile facts and involving personal selection, such as framing and cropping.)

So what individual motives drive us artists, amateur and professional alike, to want to create an image or to paint? Here are some of mine:

- For the excitement of making something new, whether I am copying an external subject or an internal idea in my head.
- By observing, giving my attention to my surroundings, putting out 'feelers' to establish a connection and, allowing my senses to soak luxuriously into the elements, attuning to them. This motive for looking adds another dimension to scanning for survival reasons alone.
- To take time to develop visual skills which are continually enriched, even by dreams and on my 'inner screen'. This enhances my experience of life and personal identity.
- To realign my own human time frames: physical, mental and 'spiritual'. Painting takes me, as a separate

LEFT: *Geysir Pool – 2*. An example of 're-presentation'. A metre of reality painted as accurately as possible yet still inviting many questions about scale, texture and depth.

Liz's Mushrooms. Small but perfectly formed, these mushrooms encapsulate another existence.

right across a wide range of visual interpretation. This may be to study clinically, to learn about the purely visual character of the subject as it appears to my eye through a factual representation of colour and tone; more subjectively, to communicate my response to the subject; in more abstract terms, to express myself, the entity that I am, in any given situation. This can feel like an act of surrendering the ego and requires faith that I

being, from 'in here' towards 'out there' and obliges me to acknowledge the awesome fact that, out there in the landscape, are elements with much longer or shorter lives than mine. This attention to my place and lifespan helps me to slip into gear with it. Within an unknown universe, feeling more at one with the world I see can give me a sensation of peace, trust and openness, flowing with positive energy. The place between this sense of integration and the realization that the human holds a lonely role in the animal power chain on the planet is, at once, appalling, exhilarating and thrilling. I can feel this, whatever the subject.

- For the joy of playing with and learning to understand water: as an artist, I am always eager to try new approaches and ease the process of a medium that can fuse the connection between environment, consciousness and sub-consciousness. This fusion, which hints at true spiritual alchemy, happens rarely, yet the long-term effect is a sense of well-being. In order to create and draw together more of those magical moments I am happy to 'train' to be fit and ready for them.
- Ultimately, to express this connected sense of place

Stoke Clump Cloud. An everyday occurrence, yet this cloud stopped me in my tracks.

will 'return'. I also accept that these paintings may not be understood or resonate with any other individual. All these verbose routes are possible and yet... I can feel this connection while painting a single cloud.

Painting develops my visual memory: the pleasure of visualizing is magical and can lift and move me no matter where I am. To be able to imagine, for example, an autumn day of soft mist, crunchy leaves and dank smells is a deep, basic joy of living. With observational and painting skills in hand, to be able to paint that idea, place and time is even better.

With a painting you can tell a story, a lie, a fantasy, invent, design new objects, animals and worlds. Visual information not only stimulates the eye but by association, triggers much more to invoke and express remembered atmospheres and the other senses of touch, sound and smell. When shown a bright yellow, oval shape the brain may subliminally remember the smell, touch, taste and warmth of ripening sunshine that makes a lemon.

To be able to express the sensations that you feel requires only two things: most importantly, your wish to express them, and painting processes that are effective for you.

CAN ANYONE DO IT?

Yes. Painting is an activity, a skill that can be learnt by anyone. It is considered by many to be a gift. I believe that it is a choice and a human right, as is driving a car. Learning to drive is complex and takes time and practice, involving not only different activities for each foot and hand but several modes of looking and thinking. Yet around the world, in most countries, regardless of age, gender, religion or nationality people are driving cars (and most of the time, avoiding each other).

Why? Because they choose to. Driving is neither a talent, nor is it hereditary, and with concentration and practice can be done extremely well. Painting is less complex and far less dangerous.

Learning this skill begins with the question, 'What do I see?' There are only five main visual factors to consider and identify. I call them the 'Big Five':

- **Colour**
- **Tone**
- **Shape**
- **Texture**
- **Size**

These are the building blocks of painting. Magic is not necessary to paint; only the ability to identify these basic visual elements. If you can see and identify these five factors out there or in your head then, with practice, you can paint what you want.

But this is the magic. Because every person is unique, their painting will be different not only from a photo but also from every other person's. You don't have to be 'dramatic' to be worthy, or already skilful in other expressive areas. Nor do you have to be 'good' in the subjective opinion of other people, to enjoy what is a basic human right, an expression of personal identity.

Everyone works in a different way. Some artists immerse, marinate and slow cook a theme and then say much with a few marks; others hop from idea to idea to refresh their creativity or frequently change their vantage point for an overview, while others revisit the same subject over a period of years. Every working practice is right, according to the artist.

The best way to express yourself in paint is your way, and your chosen way need not be influenced by a formula, fashion or habit. The magic will float in on the skill.

WHY CHOOSE WATERCOLOUR FOR SELF-EXPRESSION?

We humans have an affinity with water and a natural response to and respect for it. Not only do we gestate in it but water makes up about 50–70 per cent of human body weight. I believe that the attraction of seaside, lake and river holidays for people of all ages and the lure of raging seas and waterfalls is not coincidental. It is said that negative ions released by moving water give us a sense of well-being.

Watercolour is:

- *Inexpensive* – six colours, brushes, paper and water are all you need.
- *Harmless* – water is a non-toxic vehicle that does not damage health or clothing, and paints are monitored for safety.
- *Unpretentious* – watercolour can go anywhere and discreetly report any event, response or thought.
- *Honest* – transparency allows every mark made to remain visible so that diaphanous subjects, subtle ideas, even chronology can be expressed on one surface.
- *Fun to play with* – water is flexible and will run, splash, drip, dribble, soak, spray and evaporate.
- *Good-looking* – diluted with water, its transparency has a glow and luminosity that opaque media do not have.
- *Sensitive to weather and season* – water on paper, like a litmus, responds appropriately to heat, cold, wind,

Riverbank – spring.

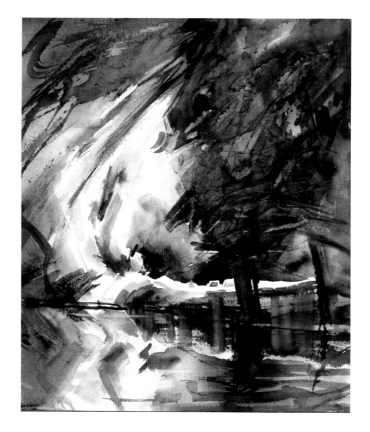

Riverbank – blazing evening light.

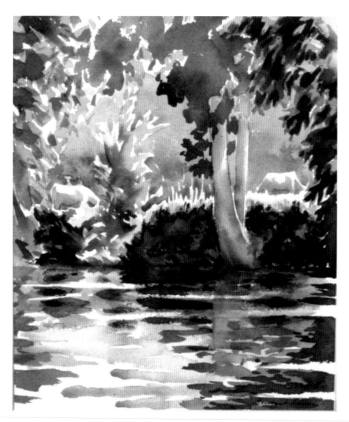

Painted over a fifteen-year period,
these three paintings express a different
response to the same location.

Riverbank – midsummer, midday overhead sun.

humidity, mist, rain and snow.

- *Sensitive to artist's mood* – its versatility can make a wide diversity of marks and always reflects your personal language and mood.
- *Practical* – light and portable, forget gizmos and gadgets.
- *Speedy* – while a camera can visually record action or changing weather conditions, water can quickly spread colour while also evoking the artist's subjective feelings.

- *'Alchemical'* – watercolour makes an original creation with the combined reaction of earth, water, air and fire: pigment, water evaporation and heat. The alchemy is complete if the painting sells for gold!

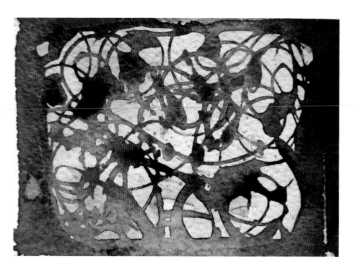

Fluidity. With water it was easy to drip in dark paint for this stained glass fretwork.

Fish in Orange Colander (detail). A translucent fin.

Mapson's Farm Under Snow. Obliged to use melted snow for painting, cold, slow-drying conditions combined to give this tiny painting a soft, frosty look.

Eucalyptus – Summer Breeze (detail). Contrasted by a dark, dense background, swaying leaves are wetly painted to transmit the glow of sunlight.

Scorching Sunflowers. The harsh heat of midday sun in southern France caused quick-drying, sharp-edged paint marks.

Crystal Sealight. The thought of a North Cornish cliff-top, exhilarating wind, emerging sun and the smell of the sea encouraged me to be daring with marks.

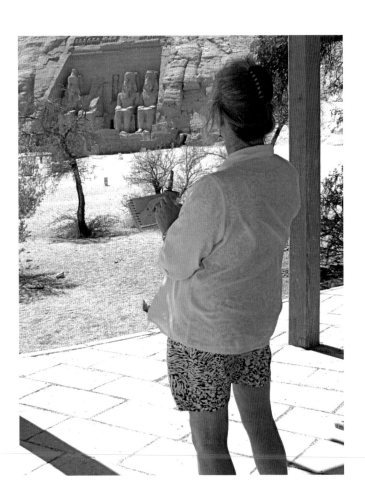

Painting at Abu Simbel, using a field box and water-filled brushes.

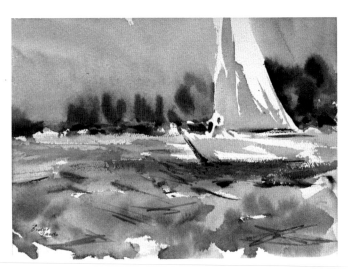

Boat Passing – Sailor Waving. Painted from a small boat while tacking, I managed to make a series of six five-minute paintings in a half-hour sail.

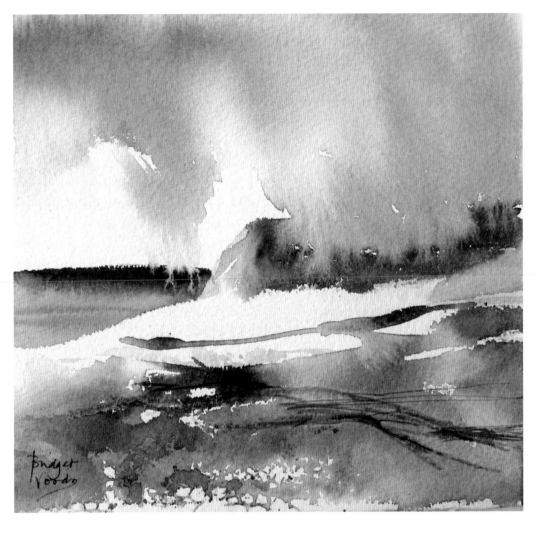

Stoupe Brow Beck – approaching rain. I obviously had to stop painting but, in tune with the elements, this little watercolour painted itself both through, and despite, me.

The challenges are also the joys

Many people believe that watercolour is difficult because 'mistakes' cannot be covered up and that water is uncontrollable. But consider these two challenges for a moment because they also bring the greatest joys of watercolour.

The 'no cover-up' factor enables transparent glazing and the potential to express veils of memory, idea, suggestion and chronological time: an expression of serial events viewed simultaneously but always showing the palimpsest of the past.

In practical terms, semi-transparent paint allows a tentative, safe build-up of colour while an underlying construction is still visible beneath.

The free-flowing nature of water can easily be used to quickly cover large areas of paper with colours varying in hue and from light to dark.

The apparent unpredictability of flowing water brings the exquisitely sensory pleasures of play. Working with the mobility of wet colour, whether strong and rich or transparently opalescent, encourages the artist to live 'in the moment'.

It is a condition of being human to want some control of our situation – not just external events but also our inner reaction to them. Interacting with water, nature, weather and life outside the self develops ways of adapting to and working with the whole environment. In combination with the landscape, watercolour offers the chance to ease up for a continuing journey to self-discovery and understanding of the human being in the world.

In this respect, watercolour has been and continues to be my brilliant teacher.

Time

Watercolour is positively addictive for describing weather conditions, whether you live in a temperate climate of four changing seasons, where there is always an exciting development, surprise or shock for the senses, calling to be painted, or one of

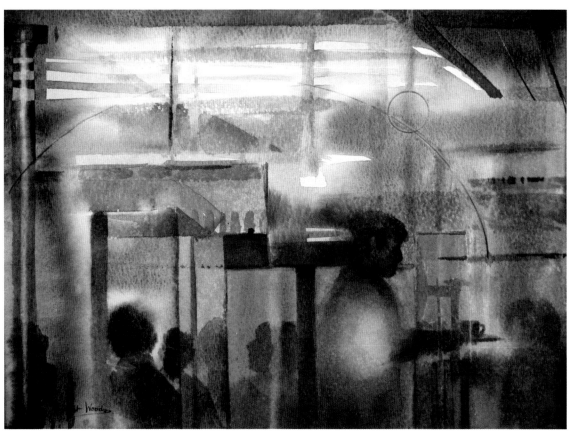

Ferry Café Sunset. The funnelling together of diverse people, temporarily locked in a floating vessel, no land in sight. Fixed yet moving, it is an edgy world, a no-man's-land of arbitrary time and place, which at twilight subjects its inmates to the paradox of overlapping light, natural and neon, mingling in windows and mirrors.

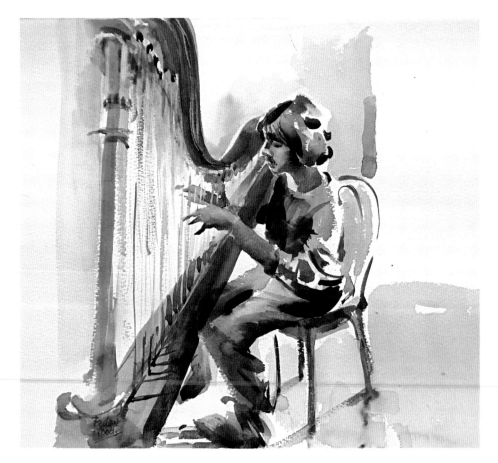

Move to the Rhythm. Though proportionately inaccurate (focused on the moving hands, the enormity of the harp took me by surprise), this was a galvanizing experience combining free movement while painting and a treat for my ears and soul.

extremes. But the transparent quality of watercolour is also capable of describing the abstract dimension of time, allowing the eye and brain to visualize a past, present and imagined future and, by painting layers, superimpose them in any appropriate order. So, this special medium can accentuate these interfacing notions of weather, climate and chronology; concepts which are made visible at times by their pattern and regularity, then at other times intersecting, crossing, blocking each other's life rhythms, whether this be breathing, water, birds, wind, heartbeats, clouds, people clustering on a beach, roads through woods, walking or rock formations.

Painting people ('life') with watercolour gives me a similar thrill because, like the model, the medium is also alive, 'breathing', moving and changing and, whether the pose is short or long, it has the capacity to 'dance to the rhythm' of the subject.

MATERIALS

The least for the most

This list will be brief because I believe in carrying the least amount – both in size and weight – that can achieve the most. Carrying less, the more likely you will be to take painting equipment with you on any trip or walk and also have less to pack up, wherever you are.

PAINTS

For portability and economy, a palette needs no more than these six colours. If you are not sure of a colour by its name, there is an international colour index numbering system, e.g. PV19, which identifies and links colours regardless of manufacturers' names. (The reason for this choice and ordering of colours will be made clear in Chapter 1.)

- Ultramarine (PB29), Cobalt Blue Deep (PB73) or Cobalt (PB28).
- Winsor Blue (Green Shade) (PB15), Phthalo Blue (PB15) or Intense Blue (PB15).
- Winsor Lemon (PY175).
- Transparent Yellow (PY150), New Gamboge (PY153) or Winsor Yellow (PY154)
- Scarlet Lake (PR188) or Winsor Red (PR254).
- Permanent Rose (PV19).

BRUSHES

Round at the neck and with a pointed tip. Soft, natural hair brushes are better than nylon for water-holding and avoiding scrubbing, abrading the paper or smearing previous washes. Good Chinese brushes are ideal.

- 1 × small (length of hairs approximately 12mm).
- 2 × medium (length of hairs approximately 25mm).
- 3 × large (length of hairs approximately 40mm).
 A soft make-up brush is ideal and inexpensive.
- 2 × sable riggers, sizes of your choosing (I have sizes 0, 2 and 3).
- Nylon Ivory Short Flat No. 6 (www.rosemaryandco.com) for lifting paint off when dry (nobody is perfect – I call it 'unpainting').
- Emery board (wide) for textured and italic marks.
- For keeping the brushes together: a rubber band or split bamboo brush holder (never leave brushes in the water or upright as water in the neck can expand and break a bamboo handle or rot the bristle). To avoid losing brushes on site, consider adding red fluorescent tabs or nail varnish.
- Foam toenail separator – for supporting several prepared and loaded brushes. These are cheap and, if pink, easy to spot in the long grass.

PAINTBOX

I recommend a lightweight box that contains deep mixing palettes and compartments for your own choice of half pan, full pan or tube colours, which neatly closes. The 'Liz Deakin' paintbox is ideal.

WATER POT

Low, broad for stability, leakproof and with a handle. A cut off water bottle or food containers can be customized.

SKETCHBOOK

A5 size cartridge paper.

PENCILS/CHARCOAL

- Mechanical pencil (no need for sharpening) or combination biro/pencil, with 2B leads if possible, for tonal work.
- Water-soluble graphite pencil.
- Thick (1cm diameter) charcoal and fixative.

WATERCOLOUR PAPER

Types

- Cotton rag: generally, when water soaks into the paper, it stays wet longer and dries more consistently than wood pulp paper.
- Wood pulp: the paint sits more on the surface, generally dries faster and less evenly than rag.

Colour

White (ideally) – to best express the wide-ranging tonal contrast of emitted light, from dim to dazzling. Consider that paper cannot emit, only reflect light and that a textured surface (even virgin) is visible by its little grey shadows.

Weight

Use different weights as appropriate to your needs. I usually use a middle weight (140lb) paper in full sheets (often pre-cut or folded smaller), light enough when dry for me to carry several sheets out on location yet heavy enough to take a good soak for slow, consistent drying in a temperate climate and, when wet, for me to physically sense, in my arms, its changing wetness. I do not stretch paper but only temporarily clip it. If a painting has cockled, then prior to framing, simply wet it on the back, let it expand, then put it between two sheets of clean newsprint, put them between two boards and press it under a weight till the painting is dry and exquisitely flat.

Sizing and surface

Sizing is an important factor in watercolour painting. This preparation stops the water/paint solution from soaking straight in like blotting paper. It is either put into the wet cotton or wood-pulp mixture ('tub sized') or applied to the surface after the paper is made ('surface sized').

There are three named paper surface types:

- Hot Pressed (HP) = smooth (for fine detail marks without ragged edges, e.g. botanical, miniature painting).
- NOT = not hot pressed, also known as cold pressed (for general use).
- Rough = rough (as it sounds).

For landscape, I prefer Rough to either HP (smooth surface) or NOT (medium texture) for the following reasons:

- The paint/water solution sits longer in the deeper tooth ('valleys') of rough paper and therefore dries more consistently, especially in hot/windy weather, than on a smoother surface.
- These deeper valleys naturally hold more solution, causing the paint to dry more slowly, giving a more luminous and less flat, matte appearance when dry.
- Because Rough paper offers a wider range of textural mark-making, from soft-edged to sharp and textured, it has the potential for making an image of greater three-dimensional profundity, sense of recession or subjective choice of focus. I prefer a paper with a surface texture pattern that appears to be more random than mechanical.

Nevertheless, for different reasons, Bockingford and more highly- or surface-sized wood-pulp papers may show paint colour differentiation more vibrantly because the solution soaks in less and sits on the paper surface, allowing separation of colours, edge-acutance and the white of the paper to show through. Generally, I find this quicker-drying paper, even a smoother quality cartridge, good for vibrant holiday sketches, mini trial sketches, giving a lively 'surface' image, and also – heaven forfend – for washing out the paint.

Although I recommend rag papers for several reasons, they may sporadically have sizing problems so please do not assume that you are at fault when small dots appear on the surface but tell the importer/manufacturer.

I am still searching for a perfect watercolour paper but at the moment of writing, am using Rough surface 140lb/300gsm Arches, Saunders Waterford, Bockingford and Khadi papers and sketchbooks.

PLASTIC ERASER
Lifts graphite, charcoal and pastel cleanly. Can be washed, cut to fine point and does not attract water-resistant oil.

PASTELS
For quick preliminary colour ideas.

PAINTING BAG
I have customized a light picnic rucksack. Flat-bottomed, it stands up to make a 'table' for my brushes. The front can open like a hinged door to act as a windshield if necessary (when I am painting lying on a cliff, for instance). It has elastic fixtures for utensils and an insulated, waterproof compartment for food and drink. (I bless the friends who gave it to me.)

PAPER
Such a key element in successful watercolour painting (after understanding water) that I recommend trying to find the paper(s) that you like and sticking with it (them) for all painting, including important playtime. Nevertheless, keep an eye open for new papers and listen to other artists. Further information on paper types is given opposite.

NEWSPRINT PAPER/NEWSPAPER
To lay under my painting and absorb any excess moisture, particularly at the edges, avoiding unplanned oozles.

CLIPS
Two to four bulldog (not slide-on) clips.

BOARD
Corrugated plastic board or foam board is firm but light and can easily be cut to size.

PAPER PORTFOLIO
Lightweight, sturdy and waterproof, with a shoulder strap. Size to suit. For general use and travelling, I use half-sheet size, i.e. 19 × 25in (48 × 64cm).

EASEL
The ideal easel for standing to paint is metal, sturdy yet light, with a long 'mast' bar which tips and grips between horizontal and vertical postitions, in a non-distracting colour, with case. My current preferred easel is the 'Sheffield' by Reeves. A hinged table easel that easily tips and grips between horizontal and vertical can be used for standing or sitting in the studio.

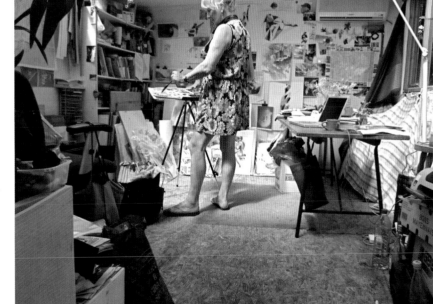

Painting in my studio. This photo shows: the evolving accretion of stimuli and memorabilia that express me and influence my painting; painting bag with canvas brush holder across the top and toe separator in use; Chinese and Japanese brushes; corrugated plastic board, newspaper; unfixed painting; easel with waterpot hooked over the front.

An 'orchestra' in your pocket

This is my minimum painting pack:

- Winsor and Newton field box, customized with six colours (as above) plus brush, larger-headed than supplied, with handle shortened to fit in box.
- Five water-filled plastic brushes for speedy paint sketching – although fibres are nylon, they are non-tangling and self-cleaning (e.g. Aquash by Pentel).
- Small Rough watercolour sketchbook or Khadi Zigzags, brilliant for turning a walk, day out, weekend into a short story you will never forget.
- Plastic bag to carry field kit and, in damp conditions, for sitting on.
- I also work from my digital camera in pubs and even restaurants with this lightweight and unobtrusive kit.
- Just a thought: sight, touch, taste, smell, hearing. We process all that sensory information in a head that is the same size as a field painting kit (watercolour, of course). The major difference is weight (average head: 1,400g; box, brushes, paper, water: 225g). So it is worth carrying them both at all times.

GUIDELINES FOR USING THIS BOOK

The Big Five:
Colour, tone, shape, texture, size

These are the basic ingredients of our visual world, which combine with our other senses to keep us alive and affect our quality of daily living. On painting courses, when they are brought together under dry 'umbrella' concepts such as composition and perspective, for example, it can be easy to wait for the 'rules' and sacrifice the deep intuitive sensation that tells us how we individually feel – glimpsing, looking around, sniffing, listening out for the atmosphere. While most paintings combine the Big Five, Chapters 2 to 5 will focus broadly upon each visual factor and the dominant links it may have with other human senses and feelings. Understanding the importance of these instinctive associations can help the artist identify personal response, then add to, transform or depart from photographic likeness with confidence. Related projects will be suggested as starting points from which the artist can develop their own style with ease.

Watercolour is the vehicle of expression in this book, and though later chapters can be used separately, they are all under-

Painting olive trees before breakfast. A few spare minutes, field box and zigzag of paper.

pinned by the essential skills in Chapter 1, Getting in the Mood. It may be useful for the reader-painter to shake off habits and approach this with a beginner's mind. I believe that the secret of watercolour handling lies not in a mindset of mastery, but in a basic understanding of equality and friendship with the medium.

Expression or communication?

In painting terms, these are not necessarily the same.

Expression: literally, to press out, make a representation of, state.

Expressive painting can describe a likeness, a response, a feeling or an idea and may be shared, understood and communicated or not. Expression can be any statement, from a wandering doodle to raw paintmarks, which are used to offload a powerful feeling or to engage in a purely personal 'dialogue' when other means are not sufficiently subtle or effective.

However, unintentionally, images do frequently communicate to others, either through the by-product of shared human or cultural conditions, or sometimes simply by triggering a totally different memory. Nevertheless, expression does not need an external viewer.

Communication: to share, enjoy in common.

For a painting to communicate, an external body is usually a stimulus for its creation and the measure of its success. If this is the case, be prepared for the notions of dual judgment, of good and bad, which are often defined not just by an individual's subjective response but according to the criteria and influences of society, fashion of the day or cultural habits.

What would you like your painting to achieve? How much does it matter to you that what you express communicates to others, and to whom?

Tone or value

I will use the word 'tone', rather than 'value', to mean lightness or darkness to avoid any ambiguity with value's other meaning of 'worth'.

Brushstrokes

I use the word 'brushstrokes' to describe a mark resulting from the dry or wet condition of first the brush and then the paper. So, I will call a mark made with a wet brush on wet paper a 'wet in wet' brushstroke; likewise, 'dry in wet', 'wet on dry', 'dry on dry'. After the first description of these marks I will use the abbreviations WW, DW, WD and DD for simplification.

The physics of watercolour painting

I aim to be an experiential art tutor in a real 3D teaching situation and as far as possible, within time constraints, encourage empirical discovery to create a learning situation for everyone. What I know of water, light and colour is largely based on observation with students over many years. But, in the 2D realms of a book, while wanting to share my adventure (so far) in the same way, rather than dialogue with you, I am obliged to offer some suggestions and findings. I am not a theoretical physicist and can only accept that, for example, a yellow pigment particle apparently absorbs all other light from the white light spectrum except yellow, which it reflects for my eye and brain to identify with the word 'yellow'.

In truth, I have no idea what it is like to be a yellow-coloured particle and accept this as a reasonable explanation. Though I may have an anthropomorphic tendency when describing the fragility of paper or the bullying or yielding activities of water, if this yellow pigment were in pollen or petals, I am under no illusion, however attractive I may find the flower in question, that it has any reciprocal intentions towards me! Rather instead, a desire to attract birds and bees who apparently perceive a different range of colour to humans.

The neuroscience of eye and brain

I am sceptical about simplified explanations of the functions of the human brain, the study of which continues to reveal more complexity, subtlety and plasticity. In my own experience as an artist/teacher, I am empirically convinced that there are undiscovered depths of sensory awareness, particularly in the area of synaesthesia, or linked senses waiting to be explored. So, lacking knowledge and in order to leave the gate flexibly open when teaching, I often refer to the 'grey mass' as 'Clever brain' to serve as a blanket description for an organ with surprising abilities that I can only, with amazement, witness in others and experience first-hand.

Speed, link, mark

Given the tiniest hint of visual information, the brain can, through memory, likeness, comparison and other remembered sensory experiences, identify, interpret and respond at lightning speed. Is this important for the artist? For me, the speed of the link between received information, response, message and mark is vital (a word which encompasses both life and necessity) and requires a medium that is an extension of that spark.

*Genius is when an idea and the execution of that idea
are simultaneous.*
Albert Einstein

The expression of being

Comparing media, current technology offers ways of expressing an idea at speed by, and for, the 'brain on the sofa' but leaves some corporeal, tactile aspects of living unaddressed and unexpressed. Some painting and 3D media may involve a greater physicality but compared to watercolour, are often heavier, impractical to carry and require a studio that is away from a subject like landscape.

Watercolour is a light, portable medium, ready to express a wide range of the sensibilities of being, from ideological to visceral, with vitality. Because its application involves the whole being, its marks can convey that sense of humanity to the viewer. While new technology can film, send, enlarge, print or design an event or artefact with button, key or touchpad, there is relatively less engagement for both practitioner and responder. Watercolour, used in the way to which I aspire (sometimes momentarily achieve), invites a combination of mental and

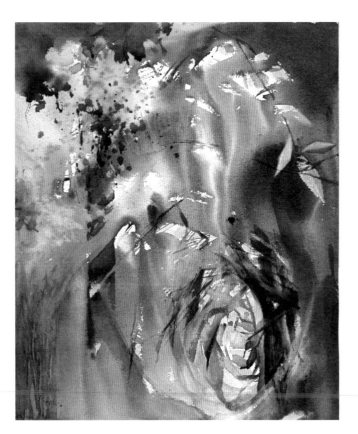

Woodland Spirit. A touchpad cannot mimic the sensation of making these marks.

physical engagement and can really flow and express – more than just reportage – a direct response, the layered subtlety of message, conversation and even time.

Painting speed may vary but 'fast' really does come with skill, which is born of open-ended play, reflection and again, more play.

The importance of 'playing attention'

Play with water. See what happens when....

Many people paint only once a week, then, losing the momentum of that session's gained skill, gradually develop a safe draw-and-fill-in process, which excludes the major enjoyment of watercolour. Intuition is born of skill, which is itself born of experience. There is only one way to understand watercolour and that is to regularly 'jump in' and splash about. Just a few minutes' regular play increases skill and is risk free. If you hear the word 'why?' from outside or in, reply 'why not?' If you play, you cannot be wrong and you will learn from the marks you make.

If possible, stand to paint. Strangling the brush by the neck, anxiously bending over the paper, timidly dipping the tip of the brush in damp paint and pecking at the paper can quickly become a habit. You and the brush will get neck ache, the muddy results will only affirm your fears and the water will get bored!

*We may content ourselves with a joy ride in a paint
box. And, for this, Audacity is the only ticket.*
Winston Churchill

Subject base

There is nothing like drawing or painting on the spot for savouring the effects of natural ambient light on the eye and the accompanying smells, sounds and weather conditions of an all-round physical experience. I choose my subjects for differing reasons but believe that any subject has the power to make a connection when it receives attention. I am not fixed to one type of visual source because the interaction, sensation or idea is what counts. This can be strongly felt and painted in the moment or make no impact until recalled by memory or be revealed later by increased understanding. Sometimes a photograph or sketch can lay down facts that lie dormant for years until they revive a complete experience that is easier or clearer to identify at a distance. Each of these different 'realities' can tap into the feeling for me.

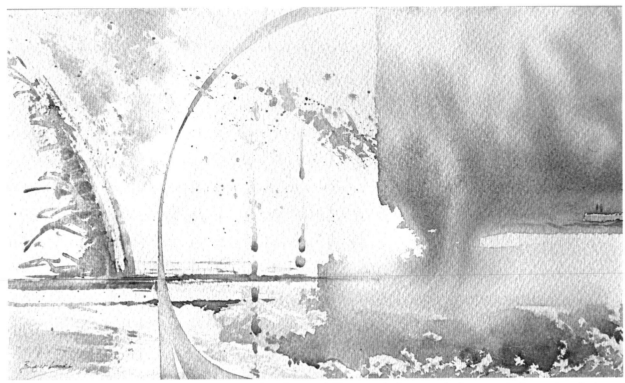

Water. I was only, but with great attention and no fear, puddling, pondering, wandering, wondering and exploring different ways in which water manifests itself. I am fond of this painting because this state of open-minded discovery has an un-selfconscious freedom and confidence, which feels very joyful.

Your relationship with you, the artist

Develop an even-handed approach to your appraisal of all things visual. Not cold, but neutral and open to response without prejudice, so that when you look at your own painting, you can more objectively ask, know and feel what you have achieved. Developing an awareness of not just how you respond to any image but why, will help your skills of visual self-expression. Say it out loud or write it down if necessary until you are in the habit of responding to the aspects of your painting which have worked, as well as those which have not. There is no external yardstick. This is your decision.

BEST LEARNING
Stand back from your painting frequently. Take time to observe and, without lying, celebrate your progress with praise, develop an understanding of the links between your internal and visual sensations, and encourage yourself to persevere.

Not looking at, tearing up or throwing away a painting is like destroying your most important tool for development: the 'evidence'. It can quickly become a cyclical habit, leaving no opportunity for open-minded learning. It can also waste the backside of the paper which could have been a masterpiece, if only the painted side had been studied! False modesty is negative and can, by affirmation, cloud your own and everyone's assessment of your painting and is a truly terrible waste of good creative energy. When you make marks that you know feel right, savour their lusciousness, incisiveness and significance.

SIXTY-SECOND TURNAROUND
If ever I feel despondent, I have a stretch and give myself sixty seconds to turn my mood towards a neutral, even-handed view. I look at my watch and usually within ten seconds I am 'there' – because I want to be.

BE A POSITIVE TEACHER
A good teacher encourages, is open to, draws out, shares, works with and learns from their student. Both people arrive somewhere new as a result of this discourse, in the time that it takes. If you are painting for yourself and on your own then please be this positive teacher. The rewards will be to experience joy in the process of painting and to see your individual style emerging with confidence. Remember, nothing needs to be shown publicly unless you decide to share it.

Watercolour as a friend

If you follow the book I guarantee that you will feel more confident about your own skills and painting 'voice'. Always try each new idea or exercise several times on different subjects because watercolour is your patent, plain-speaking friend and will always manifest to you 'where' you are. It announces when you are unsure, slick, timid, impatient or daring. Because it is transparent and all marks will show, the learning process is a serial one, so, like a dialogue with an intimate friend, watercolour has the potential to work like a recording mirror, if you will let it. And when you have to paint your way into dark places, even to a completely black sheet, it will go with you without resting and still be available afterwards to mull over your decisions along the way.

But like a good friend, watercolour is always longing to play again, try out other routes with you and will reward you tenfold if you observe how it naturally wants to behave. The best watercolour shortcut I ever made was simply accepting this fact.

No man can know where he is going unless he knows
exactly where he has been and exactly how he arrived
at his present place.
Maya Angelou

THE HUMAN, THE SURROUNDINGS AND EXPRESSION
We unconsciously accept the associations we have between the senses of sight, touch, taste, smell, hearing and physiological response, including emotion, as a part of our survival mechanism because they stem from an archaic but sophisticated awareness, evolved over millennia, of our small selves within a large world. These links also enable us to wonder about the universe. This book aims to keep that combined awareness alive in the following ways:

- Developing a sense of self 'worthship' in the individual to express himself as both different from, and part of, a whole with mankind and nature.
- Acknowledging, developing, maybe rediscovering, these sensory links through the weather- and mood-sensitive medium of watercolour.
- Offering my watercolour discoveries (so far), not as a formula but as jumping-off points for finding/growing your own style and to speed your progress by possibly avoiding years of hit-and-miss.
- Encouraging a contemporary development or re-birth of watercolour (paradoxically considered to be a 'lesser' or 'difficult' medium).
- Pointing to our changing natural world, rather than objective 'traditional' landscape.
- Showing that, together with new, brilliant, non-toxic, light fast pigments (not available in the past), it is this special combination of artist, medium and subject, which is both 'of the moment' and universally timeless.

In short, by championing a personal response by the individual to the subject through the medium.

The next chapter offers the artist, regardless of experience, the 'tools' of transparent watercolour painting in such a way that will hopefully invite the most important outcome: a personal response that develops a unique style of expression.

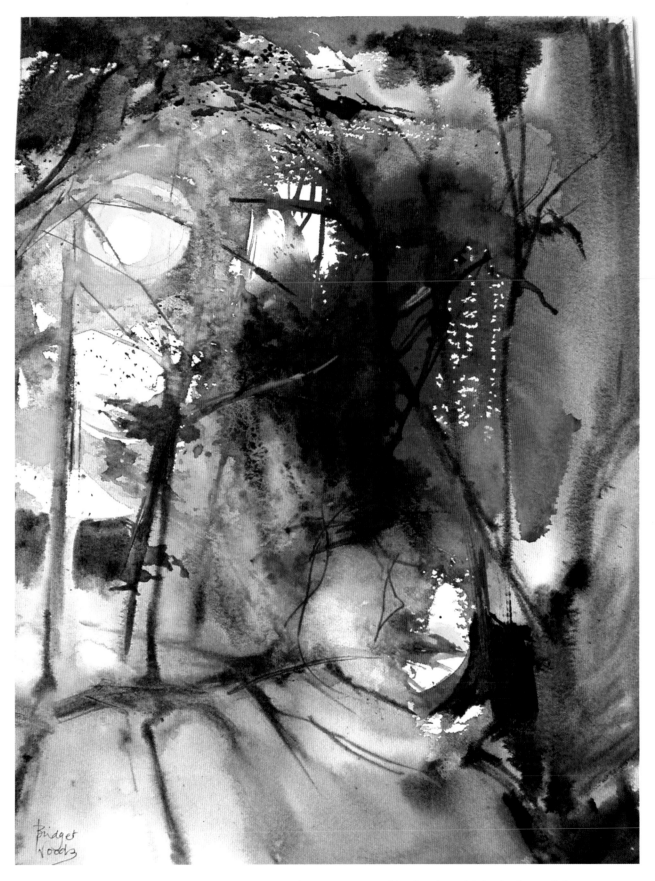

Morning Blaze. Turning a shady corner, I looked up to wave to a friend and was hit by the force of the sun.

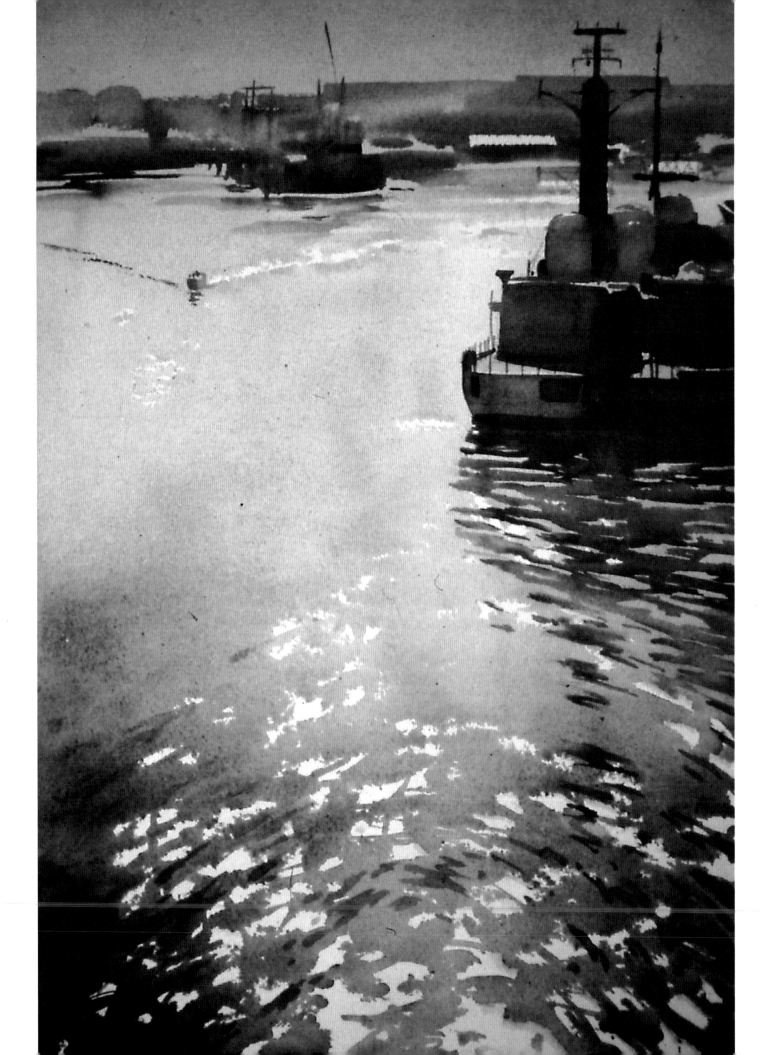

GETTING IN THE MOOD

Limbering up, open-ended exploration, regular exercises for building confidence and finding new paths of expression

IT'S NORMAL TO BE DIFFERENT

We are all one-off individuals, living in a co-operative society. Trying to conform yet simultaneously be unique can sometimes bring about a sense of unease or dis-ease. Painting allows us to step safely into ourselves.

Most of us have several personae and, chameleon-like, we move between them, appearing in one situation like the rest of our group for mutual approval or bonding, or blending into the crowd perhaps for anonymity or peace from the demands of other roles but also wanting to feel unique and special in other situations. Depending on the roles we play, this desire or need can vary from moment to moment and affect our behaviour. For example, a parent may be describing a sense of personal fragility to a friend then, in a momentary flash, 'become' a warrior captain when their small child runs towards the road.

This much is a fact of daily life. But when we are painting, we can fit in as much or as little with 'normal' as we choose to and release the stress which can be caused by housing the various personae we need to cope with all those paradoxical demands. Furthermore, we can do this in complete safety.

However, it is one thing to want to paint but quite another to create something which is unlike anything that has ever gone before. Although this only takes courage and a non-judgmental approach, avoidance can be tempting.

LEFT: *Leaving Portsmouth at Dawn.* Slipping out of a grey, dank harbour gradually pierced by sun and seen from the best vantage point.

I hear and have often given reasons for not painting but now recognize that they are usually born of fear not fact. Here is a selection.

I can't paint

The best 'lesson' I ever had was from a retired art college principal, also a Royal Portrait Academician. He declined my request to teach me oil painting but suggested that, if I provided a model, I could paint alongside him. I arrived to find identical kits – two easels, palettes, paints, brushes – generously prepared in his studio. After an hour's painting, I tentatively asked if I was doing the 'right' thing. Peering at me over half-moon spectacles, he said, with a deep, exasperated sigh, 'Look, painting is just about picking something up with something and sticking it onto something else and hoping that it doesn't fall off.'

I felt that I had learnt something quite profound. He was engaged in the present and, after a lifetime's teaching, many years an art college principal, was not going to give me a formula or play judge. It was for me to make my painting, learn from both process and results and find my path; to give my positive energy to experiment and discovery rather than to notions of 'right' and 'wrong'. I smiled to remember his words when later I was searching in a national gallery for a well-known landscape and was told that it was temporarily in Conservation because, according to the attendant, 'the sun is painted so thickly that it occasionally drops off and has to be re-fixed'.

Of course, for the practical aspects of painting, there are the technical shortcuts of other artists' lifelong learning to be garnered and tested. Choosing experienced artists who inspire you to see why and how they make the marks that they do is already

a creative selection on your part. However, the route to your own expression is via an open mind, engagement and reflection.

And it starts with 'sticking something onto something else'.

I have no time to paint

In three minutes you can paint a layer of paint, drip rich colour into a watery mark, look at a magazine upside down (not to read but for interesting, exciting shapes) or scribble a charcoal sketch for painting reference.

I have nothing to say

Reality: everyone has something to say, *is* someone. Art also meant 'are'.

Thou art.

> *Do not worry about your originality. You could not get rid of it even if you wanted to.*
> Robert Henri

I can't find a beautiful subject

Painting can be a part or expression of your life – not the grand opus but the everyday. It's not just what you say, but how you say it that reinforces a sense of identity and proof of being alive. Light falling across concrete, passing through glass, shining on enamel, casting shadows on the floor can be exhilarating when an eye for tone has been developed. Whatever our mood, we are surrounded by a world of visual interest, waiting to become beautiful to us, simply through our giving a little time and attention.

I have no imagination

Apparently we all dream, whether we remember our dreams or not. If so, we have the ability to conjure up an image on our 'inner screen'. When awake, taking note of visual facts for reasons other than survival, or drawing and painting what the eye actually sees externally, quickly develops the ability to consciously visualize or remember an image away from reality. Then, with closed eyes, imagining an image can often allow feelings to permeate and personalize that image even better without the clutter of visual reality.

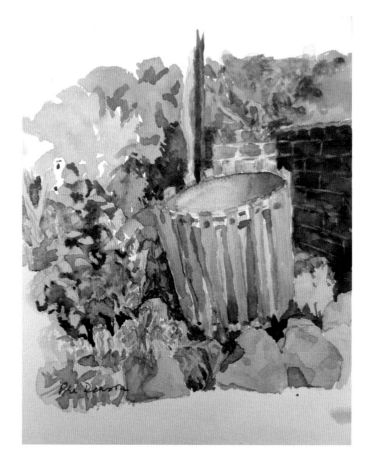

Rubbish Bin by Bea Deason. I was teaching a painting group in the Bishop's Gardens in Chichester: a varied location with flowers in full summer bloom set against old city walls, a clear view of the Cathedral and many obvious subjects to paint. But at the final line-up, this painting of a rubbish bin was the unanimous favourite.

> *Experience has shown, and a true philosophy will always show, that a vast, perhaps the larger portion of the truth arises from the seemingly irrelevant.*
> Edgar Allen Poe

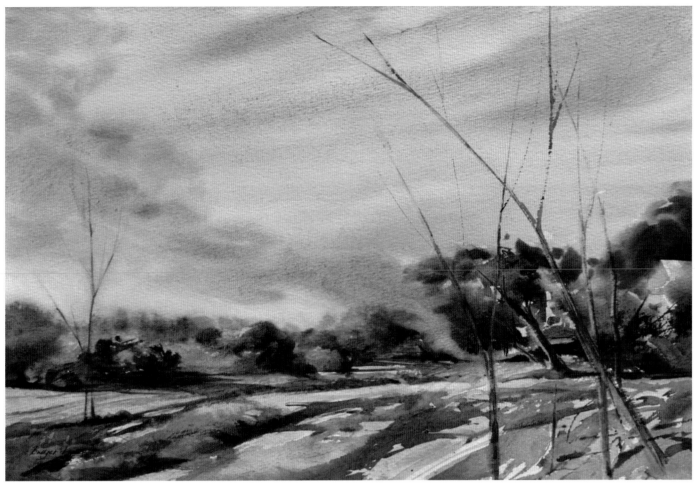

Autumn Smoke. I only caught a glimpse of this gentle, warm, 'drifting' sight through the trees while driving along one evening and painted it the following day from memory. Although it doesn't resemble the reality, which was barred by verticals, it sums up the mood and the moment for me in a succinct way that words cannot.

THE BIG FIVE

As painters, the fundamental question is, 'What do we see?' The visual world may appear complicated but is a combination of only five major visual factors for the painter to consider: colour, tone, shape, texture, and scale.

Visual information comes flooding into the eye, passing through the lens to the retina at the back of the eye. Behind the retina are many receptors in two shape categories. Cone-shaped receptors 'read' the colour quality and rod-shaped receptors the tonal variation between dark and light. It is the brain, which on receiving this colour and light information from the stimulated cones and rods, interprets it: 'If my eyes see this colour and tone begin here and end there, then I know that there is an edge, something which is this shape, this texture and

this size.' On receiving this information the brain searches the memory for comparisons to identify the 'something' and usually does so in nanoseconds.

The representational artist gently rewinds this process to identify what the eyes first saw, to be able to paint the perceived colours and tones in the right places for the shape, texture and size to look like the 'something'.

This may sound quite straightforward, but for survival purposes, the colour and tonal facts of seeing, though crucial, are of less importance to the brain than their interpretation by the brain. (Once the 'then' information has been noted and logged the brain is busy noting and logging the new 'now'.)

Also, remembering the child running towards the road mentioned above, to effectively link 'see' to 'know' to 'action', this process must be fast. It is the brain, not the eye, which instructs

the action of the arm and hand and after complex interpretation of the Big Five, it understandably wants to paint what it 'knows', not necessarily what the eye originally saw. People are often unaware that problems they encounter with perspective or identifying colour and tone are mostly due, not to ineptitude, but rather to this swift and brilliant mechanism of survival which incites a rush by the brain to paint what it 'knows'.

There may be only five major factors but according to situation, temperament, mood and message, the brain prioritizes these factors and the permutations are infinite. For example, when white-water rafting or cleaning, form and texture may be the most important visual elements for success, so the five may be reordered to tone, texture, scale, shape and colour. Or when, say, cooking, colour awareness may be emphasized. Prioritization and varied accentuation of these five elements allow each artist to express their own sensation through a unique creation in the moment.

The processes in this book are designed to introduce you to the Big Five so that when you want to prioritize consciously or select from these elements you can do so from a point of confident choice rather than avoiding challenges or succumbing to old habits, easy solutions or gadgetry.

ALL YOU NEED

- Materials.
- Space. Apart from the great outdoors, it is ideal to have a place (no matter how small) that is always available only to you and preferably, where you can leave materials out and ready to use. If necessary, clearly tell others you live with that this is your sanctuary, not a public gallery. There are times when a negative response, no comment or even a positive one can stop the creative flow, which is especially crucial to watercolour.
- Brushstrokes. A familiarity with the basic mark-making language.
- Colour mixing. The ability to mix any colour and tone.
- A beginner's mind.

*It is the open mind, the attitude that includes both
doubt and possibility, the ability to see things always
as fresh and new. It is needed in all aspects of life ...
the world is its own magic.*
Shunryu Suzuki, *Zen Mind, Beginner's Mind*

PHYSICALLY RELAXED AND READY TO EXPRESS YOURSELF

If you can, stand to paint, either at an easel or table easel (placed at a low height to see the horizontal image and allow a comfortable arm swing). This will help an idea to easily travel from brain to paper and is good physical practice. Where fluid expression and direct response are what you want, use your whole body and the length of the brush handle when painting. Walking back and forth, you can, like a superbly articulated crane, use legs, spine, shoulders, elbows, wrists and knuckles, all working as one so that energy is not blocked but diffused throughout the body. This allows a physical ease and smooth flow of ideas from eye and brain to hand to paper and at any angle, speed or direction. Avoid bending over with hunched shoulders, clutching the brush round the neck in a vice-like grip, resting the arm or wrist and dabbing timidly with the tip of the brush. Apart from seriously limiting your range of marks, this posture can tighten the neck and back muscles and affect blood-flow and oxygen to the brain causing muscle strain and headache. Also, working too closely, it is easy to dab and muddy the paint, be over-critical of tiny faults and become blocked, have an angled, thus distorted view of your painting and be less able to see the 'big picture'. I find a bit of stretching and twisting and shaking of limbs before painting helps to unblock any tension and increase confidence. Make this a habit before and during painting.

EXERCISE – MAKING YOUR MARK: BRUSHSTROKES

Watercolour painting is both simple and magical. Watercolour itself can now be, and stay, brilliant, since within the last century, pigments have become lightfast. But in the past, depending on ambient conditions, vibrant images may have either faded like a memory in sunlight, washed away like a dream in moisture, changed like coloured leaves, flowers and lichen or, by contrast, lasted for millennia, like bright, rich Egyptian and cave paintings. The act of making marks is more than just a preliminary to 'learning watercolour painting', it is watercolour painting. Especially when used for landscape painting, the components of earth, fire, air and water are not only the means of the message but actually are the message. Pigment is blend-

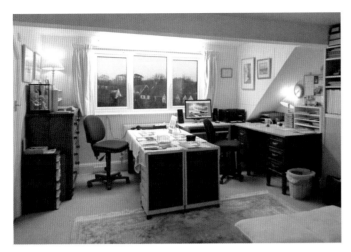

John and Sakura's space, where John Hill paints and shares administration space with fellow artist, Sakura Misumi.

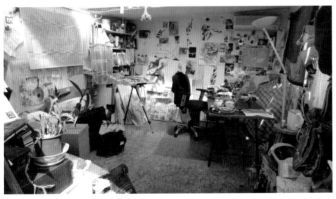

My space (4 × 5m). You might imagine:

- That I could have tidied up for the photo. I wanted it to be seen as it is.
- That this is confusion. Locating things can sometimes trigger new projects.
- That I carry many materials out painting but if necessary, I can carry my painting bag (see customized picnic bag) on my little finger with easel bag on shoulder.
- That I have no painting table. My painting bag doubles as a table for paints.
- That the walls are distracting. True, but they are covered with an accretion of visual and confidence-inspiring images, letters and quotes, which evolves with me. I occasionally take 'white sheet' days by pinning cloth or placing Corex over them.

ed with, and taken by, the vehicle of water to a surface and fixed there by air and evaporating heat.

The only extra element that can bring this enduring combination into life is you. To understand and fully use these simple but 'alchemical' ingredients to their full potential requires the simple act of watching water.

Nicky at Jonquil. A pencil and wash sketch showing that mental space can be found anywhere if you are a travelling artist.

Basic brushstrokes: mark edges

There are four basic ways of making textured marks and their difference depends upon the dryness or wetness of the brush and of the paper. To get the most out of this session, prepare to play, discover and enjoy the process with an open mind and no planned outcome. I make no apology for including what may seem to be obvious points and questions. I passionately believe that it is this simplicity that can transform an everyday water-colour painter into an expressive artist.

*In the beginner's mind there are many possibilities,
but in the expert's, there are few.*
Shunryu Suzuki

Paradoxically, a mental state of emptiness can allow the greatest space for experience.

If you are a beginner – you will never be in this situation again, so, for the most rewarding results, aim to use plenty of good paper, which can be filed for reference.

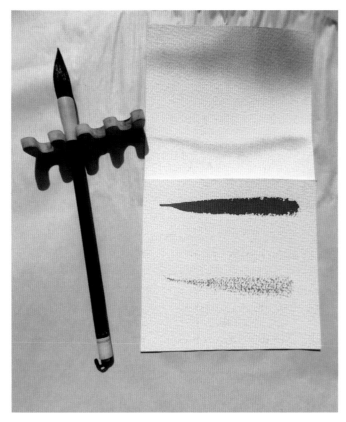

Four basic brushstrokes. From the top: WW, DW, WD and DD brushstrokes painted on Arches 140lb (300gsm) rough paper, placed on newsprint. Each of these sample brushstrokes has been made using the same strength of blue solution to illustrate their differences in tone and behaviour.

If you are an experienced artist – you will understand that this practice is as important for a watercolour painter as the playing of scales for a concert pianist and limbering-up for a professional dancer or Olympic champion.

This basic practice loosens up the physiological co-ordination and flow between eye, brain and body to give a comfortable painting posture and can psychologically maintain or revive courage. By reminding the painter of the range of possibilities that watercolour offers, it enhances mental spontaneity and the avoidance of a formulaic style. However basic, this play which does not force, is crucial for fresh and continued learning.

As this is an experiment (you are about to make a unique, new statement), using one colour throughout means that you will clearly see the difference between these marks in terms of their texture, tone, shape and size. For the same reasons, the chosen colour needs to be one which can be painted in all tones, from pale to dark and which will also behave in a normal way. There will be more description of paint behaviour later but for now, Winsor Blue (Green Shade), Phthalo or

GOOD WATERCOLOUR PRACTICE

Cutting paper

A full sheet of cotton rag paper usually has a watermark (visible when the light source is behind the paper) and/or a raised impression of the trademark, easily seen when the light lies obliquely across the paper surface. When the embossed (raised) words read forwards you are facing the 'right', best painting surface of the paper. I recommend that you immediately write your initials and paper type (if more than one are used) on each corner of the reverse side, e.g. BW SWR140 (Saunders Waterford Rough 140lb). This means that if you cut the paper in the future to smaller sizes, there is an indication of the right side, which is not easy to discern by eye. A guillotine is useful in the studio, but 'on the hoof' I fold the paper back and forth then tear it or use a useful small cutting gadget.

Mixing paint

Dip the brush into the water and wet the palette a little. Then stroke excess water off the brush and either dip it into tube colour or stroke the solid pan of paint several times. Take the paint to the palette and thoroughly mix it into the water by stroking in the direction of the hairs, neck to tip (if hairs get tangled, a brush will lose its point), turning it between strokes to evenly mix the paint and loading it from tip to ferrule so that blank paper or lumps of solid paint do not surprise you later when painting.

When diluting, it is important to scrape excess solution off the brush in the palette before using the brush to briskly scoop water into the mixture. (Some artists use an eye-dropper to add water.) In economic terms, this practice:

• keeps the water cleaner for longer; means carrying less water (important if walking long distances);
• helps to keep control of the balance of both the consistency and the colour of the mixture (especially important when creating subtle colours), thus saving paint and time; and
• wastes less paint – why put it down the drain?

Also, when adding paint, scrape off excess solution first to avoid over-wetting the paint source.

Intense Blue, is recommended.

While painting, remember that, like an experiment, this process is about finding out what paint and you do together. Because the marks you make will be unique in the whole of time, they are incomparable and cannot be right or wrong, so forget duality in this play session and savour your marks while you are making them.

EXERCISE – BRUSHSTROKE: WET IN WET (WW)

Of all the brushstrokes, the one which is the most unpredictable and therefore fun, is making marks with a wet brush on a wet surface (WW). Many watercolourists avoid it and, timid of its less controllable nature, only use marks that do not run. However, not only is WW special to watercolour but it can act as the quiet backdrop, a 'humming' contrast to sharper, more focused 'voices'. WW skills hold the key to underpainting and expressing atmosphere and 'ideas' when you choose. For these reasons, this section will start with this important mark and its lengthy but necessary description.

What will you learn?

- How to 'paint' the paper (with water) without damaging the surface or washing away the sizing. Also, to evenly and thoroughly wet the surface of the paper giving you more drying consistency and time to paint WW than is achieved by plunging straight in. (The reason for not dunking the paper in the sink or under the tap is that, on location, in any weather, this method offers more control. Also, depending on the paper quality, too much or trapped water can leach away sizing and cause blotting paper effects and jumpy, inconsistent drying).
- How to make marks in varying conditions of brush- and paper-wetness and observe their behaviour.

Materials

- Large and medium brushes
- Winsor Blue (Green Shade) or similar
- Cotton rag paper, not less that 140lb/300gsm

Method

If possible, to allow the paper to stay wet for longer, make sure that the ambient temperature is not too high.

Using the medium-sized brush, mix a large puddle of paint which is quite dark but not syrupy, yet watery enough to be able to just see the paper through a trial paint mark on your sketch/notebook paper. To achieve the right consistency, add more water or paint.

Then continue mixing more paint and water until you have a large source of mixture which will be used for all four brushstrokes. Now stroke off excess paint solution and without washing the brush, put it to one side.

Paper preparation

Holding one corner, shake the watercolour paper to get a sense of its weight, texture and sound for comparison later. Get clean water if necessary and check that your board is horizontal; there will be a lot of water on the paper and it is important that it does not pour straight off or that the paper dries sooner at the top end than at the bottom end. Lay several sheets of flat newsprint on your board (to soak up any excess moisture under and at the edges of your paper) and a sheet of cotton-rag paper on top, without fixing it down. (When the paper is absorbing water it will expand and must be allowed to do so without constraint – though later you may want to use clips.) Now, before painting, read through the process in advance to prepare for painting because the paper may not stay wet for very long.

Take your largest soft brush, which will hold the maximum amount of water and not damage the paper. Soak it in the water and, holding it at an angle, gently wet the paper moving your whole arm in one direction rather than swinging the brush back and forth from the wrist (this varies the surface contact pressure and friction and can flick water around). The aim is to wet the paper completely, right to the edges, as quickly as you can (so that it is not dry at the top by the time you reach the bottom) but, equally importantly, slowly enough so as not to leave dry gaps as you go. The best way to see where the paper is wet is to position yourself low to the paper so that you can see the light shining across the wet surface. Reload the brush frequently, and always travel in the same direction, with each painted strip of water slightly overlapping the previous one.

Continue this process until, having evenly and thoroughly covered the whole sheet of paper, you reach the bottom of the page. It is important at this stage to make sure that the top surface stays wet long enough for water to soak thoroughly into the paper. The best way to do this is to hold a loaded brush vertically over the middle of the paper and squeeze, not paint,

more water onto it while it is still wet, without wetting it again with the brush. (Expanded paper fibres are vulnerable to abrasion and sizing may lift off with too much friction when wet.) The top wet side will expand and the paper buckle upwards so pick up the paper by the edges and, away from the working surface, tip it to evenly distribute the water. This gentle approach stops the surface of the paper from getting roughed-up and sizing being washed away and is the best way to learn to feel the wetness of the paper. When necessary, squeeze on more water to maintain the shine. If, however, the paper does look matte or dries out in places, it is important to quickly repaint the drying area with a brushload of water. The paper should, by now, be flattening out as the water soaks further in, expanding the paper more evenly. It may be necessary to slightly bend diagonally opposing corners up and towards each other to encourage this flattening process. Continue to 'drip and tip' until the paper is soaked but still dry on the back (about 10 minutes).

When the paper is ready to paint on, it should be internally soaked, dry on the underside and wet, but not puddly, on the surface. So, hold it up horizontally and, if it is nicely 'drunk', it will feel limp (compared to the crisp and 'cardboardy' feel of the same paper when dry). Then, holding the paper vertically, pour off the excess water through one corner (back into the water-pot) and lay it flat on your board. Now the paper is ready for a wet in wet session.

Experiment

Now, note the time and don't delay! Stir the prepared paintbrush in the blue paint mixture again and load up the brush. Make a big, single mark in any random shape on your wet paper and watch it. What is the paint doing? What is happening to the darkness of your mark? Is this a controllable event? Now tip up the paper and watch what happens. You can certainly control the direction of the flow. Make more single marks, holding the brush at different angles and varying the speed and the pressure. Then, load up your rigger and chisel brushes and watch the marks you make with them on a wet surface.

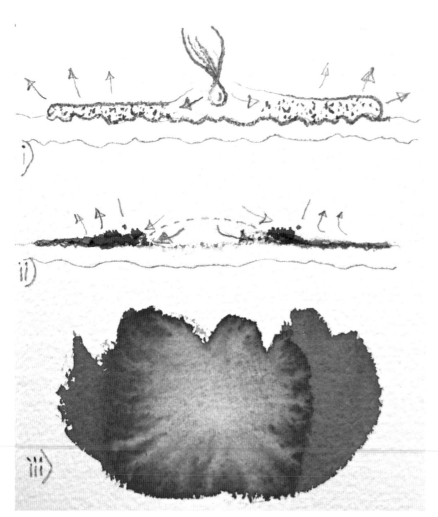

Diagrams of oozle in progress and example. An oozle is created by variation in the wetness of the surface.
i) Side view – clean water drops onto a naturally-drying blue mark.
ii) As the central higher water level lowers to become flat it moves outwards; in time, evaporation (upward arrows) causes the dried edge to approach until the wet mark can no longer push outwards (exclamation marks) but as it continues to dry it pushes pigment particles to the dry boundary, which silt up, creating a random darker edge.
iii) Overhead view.

Lifting off a WW mark

It is easy when the paper is still wet to wash away the paint. Take a clean, wet (not dripping) brush and keep a paper tissue in the other hand. The aim is to wash out a mark and leave that place as wet as its surroundings so that your 'repair' or change of mind will never be seen. By a process of firmly stroking out the paint, washing the brush and using the tissue to balance the wetness of the brush, your mark can be lifted out. Check the evenness of wetness by getting down at a low angle to the light.

If the paper is still shiny continue to make single blue marks and as the paper becomes less wet, note the time again and watch how marks, wet on less wet, differ to the early marks, both in appearance and behaviour. They will spread less far and retain more of their tone. If you continue painting as the paper dries, study the surface shine and ensure that your brush is less wet than the paper.

BUT, when the paper becomes matte and begins to dry you must stop painting, for the reason described below.

Oozle/tidemark/sunburst/ cauliflower/runback

I like the word 'oozle' because the centre of these marks ooze outwards, are usually rounded (OO) and have zigzag edges (Z).

This is not a WW mark but the result of a wet mark meeting a drying edge (which can happen when laying washes). Although it looks pretty, an oozle can easily happen accidentally and make a very 'loud' statement. Also, once formed, it is not generally eradicable. So, it is wise to know how to create them in order to recognize the conditions that cause them to either avoid, or use them deliberately.

Find a blue mark on your page that is satiny, damp-wet, and drip a single small drop of water onto it. Watch, and note, what happens over time. A wet mark in a wet surface naturally spreads outwards to form a soft, gradated edge. However, a mark like this that is wetter than its surroundings will spread only until it meets an approaching drying edge. As the wet mark dries at the edge, the wetness in the middle (which has a higher surface) falls and travels outwards, taking some pigment with it. This silts up to make a darker zigzag edge.

If your paper dried before all the different WW marks have been thoroughly explored, then soak another sheet of paper and play some more.

WET IN DAMP IS OOZLE COUNTRY

By learning to judge the matte wet surface, this mark can be anticipated and used. If the underside of the paper feels cool to the knuckles it is usually still damp. Whatever happens, it is impossible to put brush to paper without learning something; subconsciously the eye/brain/arm/hand/result information will be logged and the results can always be cropped, collaged, woven or turned into cards.

WW – what can it express? Ten questions

This process will enable you to quickly call to mind the appropriate brushstroke when looking at a subject, planning an imagined painting or working on the spot. Look at your marks from all directions. Take a pencil and ask the following questions. Let your mind wander to visualize the answers and add as many words/ideas as possible to those listed here by writing in the margins.

- What sort of an edge do WW marks have (e.g. soft, fuzzy)?
- How dark is this WW mark compared to the original test mark in the sketchbook (e.g. lighter when very wet or painted onto a very wet surface)?
- How controllable is WW? Did this mark travel? How far? 2cm at the beginning when the paper was very wet but only 1cm later. Not completely predictable but the direction can be altered and the mark washed away.
- What sort of textures would it describe well (e.g. furry, misty, smoky)?
- What objects, moods, ideas, could it describe (e.g. background tinting, stormy clouds, spray, fur, mystery, movement)?
- What distance does it describe (e.g. far, but, if foggy, near)? Note: objectively speaking, an object in the distance appears more blurred than a similar object near to you when you look first at one then the other.
- What sort of focus does it describe (e.g. peripheral, unfocused)? Note: subjectively speaking, an object, though further away, may be more clearly defined to you than a close object simply by focusing on it. Hold your finger close to your face, then focus first on your

finger then on the background next to it. You may choose to paint a hilltop in the distance as clear-edged and the close leaves surrounding you as blurred. The image and experience are both yours to convey as you wish.

- If this mark were a sound, what noise would it make (e.g. swish, sea, waves, dissolves)?
- If this sound could be uttered by animal or human, what noise would it make (purr, hum, sigh, whisper, ssshhhh)?
- If this mark were a statement, what would it be (e.g. vague, suggestion, idea, non-committal)?

Anticipating the behaviour of pigment, water and paper through WW is fundamental to handling watercolour. All for want of courageous risk-taking or practice, so many watercolourists miss out on both the subtle and exciting uses of this brushstroke. Yet it is the key to a wealth of expressive techniques from atmospheric tinting to plotting the factual foundations of a composition. These marks not only have the capacity to express the nuance of suggestion, they can also hint at, remind or make visible a palimpsest. They describe not just what is but what was and what may be.

The concept of texture runs like a vein through the total, not just visual, sensory experience of life.

THE MONOCHROME PAINTING (WW)

This will be a separate imaginary landscape painting built up, one by one, of the four basic brushstrokes on one sheet of paper. After each play session with a new type of brushstroke, that 'layer' will be added. To concentrate on the tonal and textural values, it is best painted in one colour (monochrome).

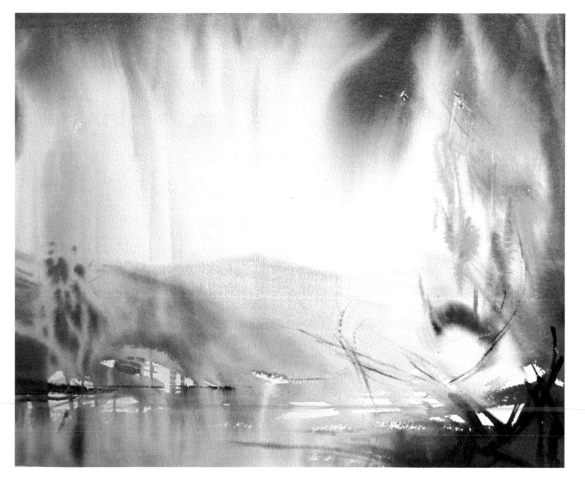

Airlight Morning. Subjective focus – searching through trees and sunlit mist towards the far bank of a river, where there are sharper distant shapes. This image 'grew' on the paper and only now, after a second visit to the Nile, have I realized that it was unconsciously influenced by my thwarted eagerness to see and get closer to the whitewashed dwellings on the opposite bank at Aswan.

What will you learn?

- To immediately try out a technique while the experience is still fresh in your eye- brain- and muscle-memory. This is good for practising each mark and flexes the imagination for its uses.

Materials

- Sketchbook
- Chunk of charcoal
- Eraser
- Half-sheet 300gsm Rough cotton-rag paper
- Winsor Blue (Green Shade)
- Brushes
- Water
- Tissue

Method

Imagine a landscape and the elements of it that could first be painted in WW marks. Look at the list of ideas in the previous 'Brushstrokes' exercise. For example, clouds, mountains/hills, a forest in the distance, water/reflections; or anything that you would like to gently 'suggest' now and firm-up later. Visualize where the sun is (though it may not be in the picture) to determine which side of all reflective shapes will be light or dark. The nearer a shape is, the bigger it usually is and the biggest clouds are usually at the top of the painting.

Now take a chunk of charcoal and try out a few ideas for paintings in your sketchbook, to include clouds and hills or mountains without too much complicated detail. Use the tip of the charcoal to gently draw the largest shapes then turn the charcoal flat onto its broad side and block-in, smudge and erase so that your image appears as areas of tone (e.g. dark, medium or light) meeting other tones, rather than shapes separated by lines.

When you have a broad idea of what you want to paint blocked-out in shapes of tone, keep the sketchbook drawing at your side for reference. Don't worry about copying it perfectly. This exercise is about experiment and play so be prepared to change the plan completely when you are painting.

Take your brush and prepare a large puddle of dark, not syrupy, blue paint because when painting wet in wet, the paint lightens a lot as it spreads. Also, if a mark is too dark, it is quicker and easier to lighten it by adding water than it is to mix darker paint. (This is a good habit to adopt, especially when, later

POSITIVE AND NEGATIVE DRAWING/PAINTING

There may be shapes, such as clouds, which are white in front of darker, sky shapes. When you draw the edge of the cloud with a line you are making a positive statement and when you block out the background sky around it, you are making a negative statement. It is important to identify these light-in-front-of-dark shapes because, with pure watercolour, you cannot paint light on top of dark. So, to 'paint' the white area of the cloud, the negative, blue sky shape and cloud shadow are painted around it, leaving the wet paper white within that shape.

on, you will be mixing several colours). Now, make a lighter mix in another mixing space by taking paint from this source and adding water to it. The tones can be varied during this WW process but, although the paint will spread and dry lighter, it should not be too dark because it will form the soft basis, or underpainting for other firmer, sharper marks to come.

Then put your paper on the board and prepare it as you did for WW, so it is really floppy, soaked and flat. Tip off the excess water and, standing up if possible, you are ready to paint. Holding the brush near the end, load up with the lighter paint and, remembering how far the pigment will travel in the water, paint the sky around the clouds, leaving much bigger gaps than the final cloud-size, knowing that they will 'shrink'. Paint the shadows on the clouds. Remember that you can tilt the paper or wash away the paint if necessary but also remember that these marks are meant to be fuzzy-edged so don't try to force them into a neat edge.

You will need to paint quite swiftly to finish the whole underpainting before the paper dries so move on to paint your hills or mountains in the distance. The paint for these may be a little darker but think of the sun direction and leave out, or wash out, some paint to describe the light planes. Continue painting down the paper, referring to your sketch for the large light areas but feeling free to change the plan if you want. Maybe some horizontal marks for ripples on water, an island, some small trees or a forest in the distance; maybe a light layer of paint for the grass on a clifftop with darker, large bushes on top or a copse of trees in the foreground etc.

BUT: when the paper begins to dry you must stop painting. Don't panic to finish or make oozles by fiddling if the paper is drying; it can be re-wetted later but only when the paper is completely dry.

What does this method convey?

Lay the painting down on the ground if wet, or pin it up on the wall. (Put the pins alongside the edge of the paper, not through it. This way, the paper can shrink naturally if it is still damp, and it is easier to put up and take down).

At this stage, the painting may be a suggestion, an open-ended idea, a series of marks or a nearly finished image. Whichever it is, remember that no WW edge is finite or fixed and can either be made clear or left as it is. Stand back to allow the mood of the whole painting, not the separate marks, speak to you.

Leave your painting on the wall while experimenting with the second brushstroke – DW.

EXERCISE – BRUSHSTROKE: DRY (DAMP) IN WET (DW)

This mark is very useful because although it is visibly clearer and more controllable than WW, it is still soft and non-finite as a statement. This balance gives the artist a freedom to explore and clarify ideas without final commitment. I view DW as a central lynchpin to the understanding of watercolour; a pivot point on the balancing scales between the extremes of wetness and dryness of paint and paper. This is not to say that it must be used, more that it is worth having a key skill that lies at the heart of watercolour.

But, although it is relatively easy to explain in words (the physics of soak and suck are logical) it is only with practice that an intuitive feeling for this mark arrives. This depends less on time and more on the quality of engagement.

What will you learn?

To create a mark of limited diffusion without picking up or flooding in too much water and by experience, to understand and work with the natural behaviour of water as it responds to the other basic factors: brush capacity, paper capacity, solution quality, pigment quality, ambient drying conditions of heat and wind, time available and artist's mood. Yes, dawdling, panic and impatience can all change the outcome. DW can only be learnt by look, feel and practice but is well worth the playtime because once you understand it you hold the key to such subtle variants as very dry- and slightly wet into a satin wet surface.

Materials

These are the same as for monochrome painting (WW) above.

Method

For this type of mark the brush needs to be damp and the paper will again be wet.

Brush preparation

Load up the brush, making sure there is paint right up to the neck, not just on the tip. Then scrape off as much as you can on the side of the palette and take off more moisture by dabbing the side of the brush on a tissue (dab, lift, turn the brush and repeat) to evenly remove moisture. Check that the brush is not too wet by stroking it across your thumb. If the brush leaves a small blob then dab it again on the tissue until the mark streaks and feels damp. Lay the brush to one side while you prepare the paper.

Paper preparation

Prepare the paper in exactly the same way that you did for wet in wet, keeping it wet for long enough to be soaked and feel floppy. Then drain off the surplus moisture and make a damp blue mark without hesitation, with a firm, decisive stroke. You may be surprised to see how faint it is but remember, that not only is this mark, to some degree, spreading and diluting, but more significantly, it is paler because a lot of the pigment was removed by drying the brush. It will also dry lighter. This process is an exchange of pigment (from brush to paper) for moisture (from paper to brush). A damp brush will drink up water when it is on the surface of the wet paper and become wet or very wet, depending on the speed of the mark and the wetness of the paper. So, because the brush will soon become wet, to continue painting dry in wet, re-prepare the brush frequently. (Simply dabbing the brush to take off the excess water only takes off more diluted pigment.) After a little practice you will know the feel and look of a brush for the dampness and tone you want.

While the surface of the paper is wet it is possible to wash out any recent wet mark. Practise taking out part of a mark, remembering to leave the washed area as wet as its surroundings by controlling the dampness of the brush with a tissue, sometimes

TIPS FOR DW

- Make paint mix strong enough because most is taken off to render the brush damp plus the mark will spread and dilute and dry lighter.
- Make sure that the brush is always drier than the paper.
- Make the mark firmly to leave enough pigment, rather than skating across and drinking water.

Avoiding blobs

During the mark the damp brush sucks up moisture and you will notice that each time the brush is lifted it leaves a wet blob on the paper, unbalancing the drying factor. To avoid this:

- Make 'aeroplane' marks, landing and taking off from the paper as smoothly as possible.
- If one end of a mark must be thin, e.g. stratus cloud, leaf, church steeple, prow of a boat, incisive statement, then start the damp mark at that point and any end-blob will be lost into the broader area.
- Avoid dab-painting, which absorbs, then drips and creates localized puddling.
- During a DW mark, keep the brush on the paper while referring to your subject before moving on.
- Work decisively – beware the thirsty, timid tip of the brush.
- Paint quickly – a slow, damp brush has more time to drink.

even adding a little water to retain that balance.

See how DW marks vary when you use different brushes and tones. The thicker the paint solution, the less it spreads. Remember to stop painting when you see that the paper is beginning to dry.

Do not be tempted to wait till the paper is damp – this is unsafe 'oozle country'. Successful DW is determined more by the damp condition of the brush than by the wetness of the paper. If the brush is drier than the surface, e.g. damp on wet or very dry on a satin surface, the mark will not 'oozle'.

DW – what can it express? Ten questions

Look at the marks and compare them to WW.

- What kind of edge – softer or sharper than WW (e.g. sharper but still fuzzy)?
- How dark (lighter than the original but is it darker or lighter than wet in wet)?
- How controllable, how far did it travel (more controllable than wet in wet, did it travel less far)?
- What texture would it describe (soft but defined, fuzzy)?
- What objects, mood or idea (e.g. trees in mist, speckles on cockerels, spots on Dalmatians, reflections, stratus

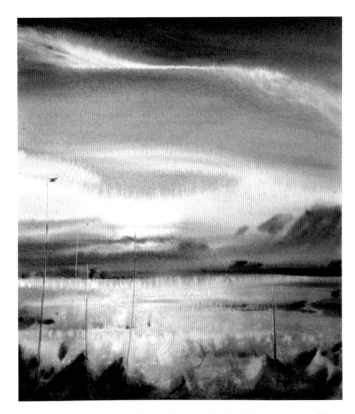

Sunset at Roman Landing. Painting the dark blue surrounding the thin strip of cirrus cloud at the top involved estimating prevailing conditions but it was a cool (slow-drying) evening and the paint stopped drifting just in time to leave the thinnest white gap. Circular sun after-images were scratched in and yellow spattered on the water.

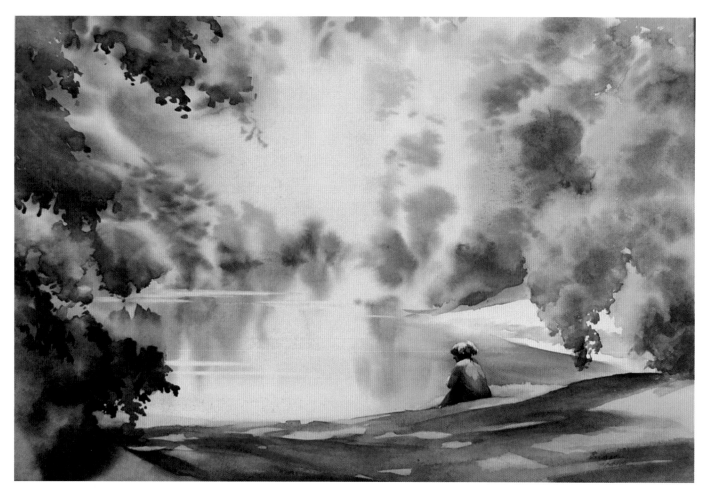

River Dronne. Painted on the spot, the underplanning here was all WW and DW. When dry, clearer elements were added according to focus and stability.

clouds, twilight)?
- What distance (middle distance)?
- What focus (peripheral)?
- What sound would it make (rustle, waves on shingle)?
- What sound might a person or animal make like this (e.g. murmur, buzz)?
- What kind of statement (e.g. formed idea, whispered command, 'appearing')?

DW is the most useful of marks because it is possible to make a visual suggestion with some clarity but without commitment and still change your mind by washing it out while the mark is wet. Because this mark depends upon a fine balance of wet/dryness of both paper and brush, it is a most important mark to practise at this stage to develop your water-judgment. Experiment with this mark to express some of the visual ideas you have listed above until you feel confident using it. Also, com-

pletely re-wet several now-dried sheets of WW and firm up some marks by adding DW to their edges.

THE MONOCHROME PAINTING (DW)

When your monochrome painting is completely dry you will be able to re-wet the surface to paint more defined DW marks on top. The paint underneath will not smear providing it is not too thick and that you re-wet the surface with very little friction (like a butterfly's wing).

Remember that DW creates a clearer edge than WW and use that quality wisely to build up the underpainting. DW can strengthen the shadows of clouds, distant mountains or soft foreground tree shadows which lying across the ground express the form of its surface. DW can develop form and sub-

stance and add clearer detail, either in the middle distance or as new visual suggestions, anywhere. For example: smaller trees on hillsides, reflections in water, fence posts, smoke, houses, waves or leaves in the foreground.

EXERCISE – BRUSHSTROKE: WET ON DRY (WD)

This, the most commonly used mark, is, like WW, paradoxical in terms of its safety. Though WW and DW spread without warning or guarantee and have no fixed or precise edges, options are at least left open. WD, by contrast, once placed, stays in place (unless the wet mark is spread, tipped or shaken). But, although it is predictable, it is also the mark of commitment with an edge which (unless pale) will be visible once dry.

Because of its clear edge, it is the ideal mark with which to study different brushes and the shapes they can make.

What will you learn?

- To add speed variation to your mark-making.
- To make clearly defined and luminous marks with confidence to avoid 'muddiness' in your painting.

Materials

As for the earlier exercises.

Method

Speed: slow, fast

Take a medium-sized brush to mix the blue paint, and load it up. Then make a mark quite slowly on the paper. Study the nature of its edge, then reload the brush and make a similar mark but this time, very fast. As the brush skims over the tooth of the paper it usually leaves a broken mark.

Achieving transparency

Using the whole brush and delivering the paint wetly and decisively to the paper are important brush skills that are vital for achieving luminosity in your WD painting. The secret for making a translucent mark and avoid 'muddy' painting (which is about texture and not to be confused with the colour of mud) is to allow the pigment particles time to settle naturally without disturbing them. Varying amounts of pigment on the white paper texture will reflect more or less light at different angles, giving it a lively 'sparkle'. (Layered washes create matte, not 'muddy', painting, because each thin coating gradually absorbs more light, diminishing this irregularity of reflected light.)

It is therefore important to note:

- Use a loaded brush so that the pigment particles can freely float around and find their natural resting-place on the paper – a drier mark evaporates more quickly and obliges the pigment to settle where it's put.
- Using a blow dryer can also dry the paint too quickly for a luminous look.
- Hold the brush at an angle between 45 and 90 degrees so that the liquid fluidly 'funnels' down the hairs of the brush onto the paper.
- Use natural hairs, which have tiny scales on the surface that hold more liquid than shiny nylon fibres.
- Make the mark once and leave it rather than pushing the paint backwards and forwards on the paper; this smears the paint and stops it settling. Also, rubbing or scrubbing the paper when it is wet can easily abrade the surface. (When paper expands and is stretched by the absorption of water, the filament bonding becomes vulnerable.)
- Take care when painting larger wash areas not to leave an edge drying for too long because, if it does start to dry, two overlapping layers will show a darker stripe. For this reason (unless you are very quick) try to paint shapes directly rather than painting an outline and filling it in.

Brush control for 'luminous' marks

The aim of this exercise is to paint a complicated shape as evenly and quickly as possible and leave it to dry naturally. With a pencil, draw any shape (approximately 5–10cm) with randomly pointed shapes. Now, paint it in using both the tip for the fine points and the body of the brush for broader areas, moving from one side to the other. Then leave it! Don't be tempted to chase extra wetness round the mark with your brush. If, how-

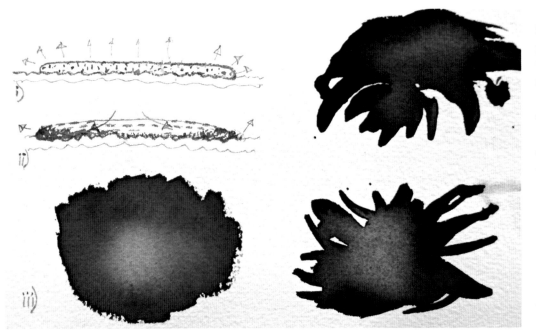

Diagrams of edge acutance in progress and examples.
i) Side view – a mark drying naturally.
ii) As the larger surface area of the edge dries faster, its level drops, causing the central wetness to move outwards and taking the more lightweight colour particles to make a clear and predictable dark edge.
iii) WD mark held in place by its dry edge and hand-mixed marks also showing separation of colour during this process.

ever, the mark is so wet that it will dry leaving an oozle, then briefly tip the paper and suck up the excess with a tissue or damp brush from one place only. When it is dry, compare your 'luminous' mark to other drier marks.

Edge acutance

As you have seen, water has a surface tension which, when a wet mark is painted into a wet surface, causes it to push out, mingling and spreading into it. However, when painted onto a dry surface, the same mark will stay within the confines of the dry edge. Because the edge of a mark has a larger drying surface than the middle, it evaporates more quickly there and the level drops. But because water naturally wants to form a flat surface, wetness in the middle of the mark moves outwards, taking pigment with it. For this reason, if a mark is very wet and drying conditions are slow, the outside edge can have an almost linear build-up of pigment which over time has drifted there from the centre while the inside of the mark will probably be very luminous as the particles of pigment have a long time to drift around and settle naturally.

Isolated wet marks will also cause the paper to cockle up.

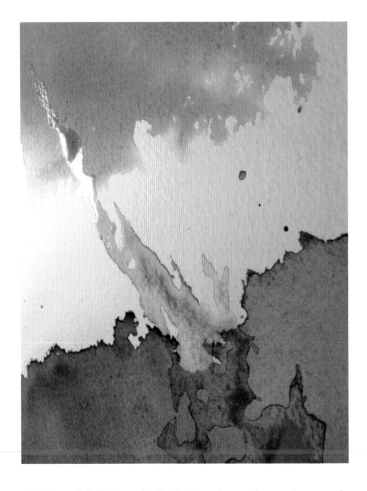

Taking a risk. Wet marks illustrating sharp edge acutance and paint transparency.

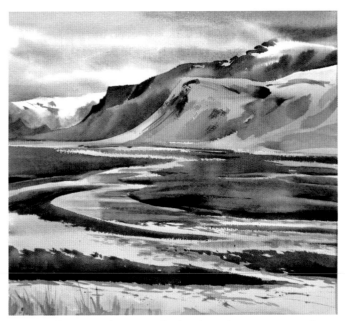

Towards Þórsmörk. WD marks dominate here to convey the cool, clean mood of Iceland and static nature of an old age river delta. Eyjafjallajökull is looming on the right.

Brush control: painting a straight line.

Draw two dots some distance apart, and load up the brush. Now, making sure that you can see dot 2, place the brush on dot 1 and, fixing your gaze on dot 2 (not on the brush) paint slowly towards it. If you work slowly at first with your eye focused on the goal, you will find that you soon have control, a sense of enjoyment while you are making the mark and a flourish that will surprise you.

Note: slow skill first – flourish later.

WD – what can it express? Ten questions

As before, pin up your wet on dry marks alongside the others and ask the ten questions, adding your own to this list:

- What kind of edge does this mark have (e.g. sharp, defined, clear)?
- What tone is this mark compared to the wash mix (similar, but it dries lighter)?
- Is this mark controllable? (Yes, unless the mark is very wet and oozles or the paper is tipped or shaken.)

- What texture does this mark have (solid, flat, hard)?
- What things, ideas, etc. would this mark be good for painting (rocks, houses, cartoons, trees)?
- What distance would this mark suggest (close-range, near)?
- What subjective focus (regardless of distance) does this suggest? (Focused objects.)
- What sound would it be (e.g. sharp, clear, distinct, bang)?
- What sound uttered (shout, whistle, bark)?
- What statement (decisive, command, committed, fact)?

Play with this mark to express some of these ideas.

THE MONOCHROME PAINTING (WD)

When the painting is dry, plan the sharp-edged marks that you want to paint on top. They may be light or dark in tone. While a soft edge that needs sharpening may be painted over, please be discriminating because it is easy to let the brain neaten and tidy every soft edge to describe it clearly. It is not physically possible to focus on everything simultaneously, looking is a chronological event. Indistinct and clear edges serve each other in a painting by contrast and offer a more realistic visual experience. A large shape like a wood or a tree may be painted WW or DW, then have smaller WD marks added later to add detail.

EXERCISE – BRUSHSTROKE: DRY ON DRY (DD)

This brushstroke should be, by rights, the easiest, as there is little water involved, but the amount of water and the way that the brush is held are both subtle and fundamental factors.

What will you learn?

- To make a controlled and even rough-textured mark on different surfaces and in varying directions.

Materials

As for the earlier exercises.

43

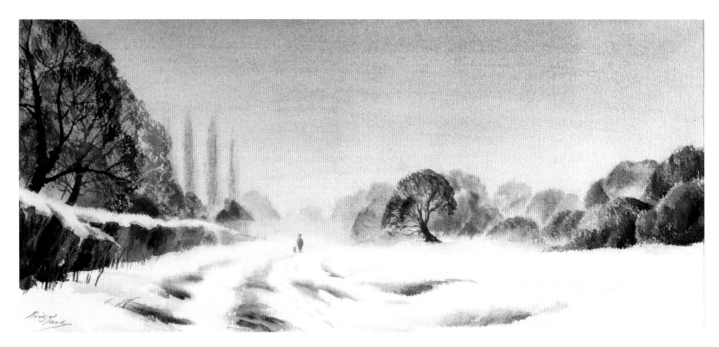

Imagined Snow. DD marks on top of a soft-edged underpainting accentuate the contrast between bare winter trees and soft snow. Many years ago, I heard one day that it had snowed inland. I visualized a particular place under snow, thinking it would be interesting to paint and drove twenty miles only to discover on arrival, that it was sadly under slush. So, I drove home determining to paint what I thought I would see. Though not entirely monochromatic, this painting illustrates a build-up of the four basic brushstrokes.

Method

The best brush for this mark is one with a pronounced 'belly'. Prepare the brush in exactly the same way as for DW. Then load up the brush, take off as much wetness as possible on the side of the palette then dab, lift, and turn on a tissue until it feels not wet, but damp.

With four fingers on one side and thumb on the other side of the brush, hold it horizontally well away from the neck. Lowering the brush slowly, gently stroke the side of it across the paper so that it leaves speckles of paint on the hilltops of the paper. Control the 'landing' of the brush by restraining its natural weight to achieve a painted area that is evenly textured. When you can do this, try varying the direction and the dampness of the mark. Vary the speed of the mark to achieve a more or less broken texture. Try making a mark that crosses both virgin and already painted paper. The mark will slide more easily and be less broken over the painted surface. Bear this in mind and prepare a drier brush when you want to superimpose dry on dry onto dried paint. Alternatively, you can paint the texture first, let it dry and gently paint a wash over it. (The benefits of either method depend entirely on the nature of the pigment, paper and brush.)

WATERCOLOUR – THE WEATHER LITMUS

Temperature, humidity and wind will affect the nature of the marks that you make. Watercolour painting is a process involving air (wind), fire (heat), earth (pigment) and water (the vehicle) and sensitively responds like a litmus to weather conditions so that drying speed often affects the outcome to reflect the appearance of the conditions. For example, if the weather is hot the marks will dry very quickly and render sharp, clear edges and shadows, while dank autumnal conditions delay the drying for so long that, painting into the damp surface, the image may stay soft and blurry-edged. Rain and snow will save you work by obligingly spotting your wet painting with small droplets that oozle. In sunny, windy weather, when the paper would dry too quickly for extensive wet in wet work, a pointillist approach is an ideal way to relax during fast drying conditions. (This method will be explained in Chapter 2.)

DD – what can it express?
Ten questions

- What kind of edge does this mark have (broken, rough, uneven)?
- What tone does this mark have? (Dark individual marks but overall visually lighter than the paint-mix.)
- What controllability does it offer, does it travel? (Very controllable, not necessarily predictable.)
- Texture (rough, gritty, gravelly, grainy)?
- Good for painting what (e.g. pebbles, earth, sparkling water)?
- Distance (close if dark, far if pale)?
- Focus (focused, detailed)?
- Sound (rasping, grating)?
- If uttered (giggle, chatter, growl)?
- Statement (jumpy, unfixed, excitable)? This can be a 'busy', 'noisy' mark and therefore, if in strong contrast to the ground, a little can go a long way!

THE MONOCHROME PAINTING – DD

If the painting is completely dry, consider adding rough-textured marks. The eyes cannot focus on more than one thing at a time and DD can suggest eye-catching detail, so aim to be selective. Also remember that a pre-painted surface is smoother than virgin paper so it is worth checking the brush dampness on another sheet.

Finally, review your painting, noting the tonal build-up and the textural contrasts that you have achieved.

COLOUR PLAY: UNDERSTANDING COLOUR

What does a landscape painter most look for when buying paints? Economy, portability and versatility in order to explore, carry very little and have the widest range of colour at the fingertips. I taught myself watercolour painting and have empirically discovered that for me, there are three useful colours which together can produce most visible colours. Simply depending on the quantity percentage of one, two or three of each of these principal colours in a mixture, the number of discernibly different colours that they can produce is a figure so

high that I do not know it.

Yet actually understanding colour mixing is very simple. Colour mixing with watercolour need not be a trial and error affair or require bags of paints, a library of 'recipe' books, colour wheels and formulae.

Please remember that identifying the colour that you see is your experience with your human eyes and brain, developed over thousands of years, for the survival today of which you are living proof. We may not see the same colours as other animals or living organisms with different survival needs but I believe that among human beings, our visual equipment is more similar than dissimilar. It is only necessary to understand, by using your own eyes, a little about the relationship between light and coloured pigment to put you completely in control of your colour mixing. Observing light is particularly important for watercolour (which has, in varying degrees, transparent qualities). I only accept the following information because I have questioned, observed and tested the evidence. I would urge you to do the same.

Colour mixing – light (additive)

White Light is a combined addition of the light (not pigment) spectrum of colours which emit light. We can see this reversed when white light passes through a prism, dewdrop, diamond or multiple raindrops, is spread to display the glorious rainbow of its component Light Colours. We also notably witness that spectrum separation as the earth turns and the colour of sunlight changes between dawn and midday and again towards sunset.

Colour mixing – pigment (subtractive)

A pigment apparently appears the colour it does because it absorbs, or subtracts part of the White Light spectrum and reflects the remaining colour to our eyes. If a 'transparent' paint, such as watercolour, has another colour added to it, or painted over the top, there will more absorption of white light and the combination will look darker.

Evenly mixing the colours of light produces White Light. This can be demonstrated by putting colour filters over separate beams of white light and observing the overlapping projected colour. Conversely, laying those filters over one light reduces light. In a similar way, evenly mixing the primary colours of pig-

ment absorbs all light and, by reflecting none, produces a mixed Black Pigment.

Light is the key factor and without light, colour cannot be perceived. Our human primate eyes have developed to respond to the reflected colours that are most crucial for our specific survival. Other animals' colour-sensing differs according to their environment.

So, back to painting, which paint colours are the most useful to cover the widest range? Basic ingredients which alone are bright like the colours of the rainbow, for painting flowers, butterflies, skies and sunsets and which when mixed, can make the greatest number of other more neutral colours. It is the nature of different pigments to absorb and reflect the colours of white light selectively. So, we are looking for a minimum of colours which each reflect one colour to our eyes. These are known as primary colours.

EXERCISE – FINDING AND TESTING PRIMARY COLOURS

What will you learn?

- By experimenting with the colours that you have, you will find out which three colours of the six listed above can and cannot be made by mixing others.
- By understanding the relationship between these colours, you will be able to mix any colour with confidence.

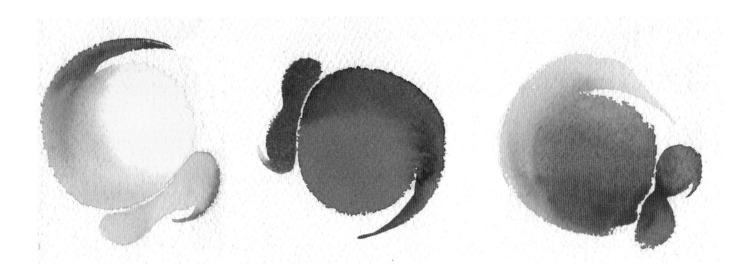

Finding the paint primaries. The central circles are the most useful 'primary' colours suggested in the materials list (reading left to right): Winsor Lemon, Winsor Blue (Green Shade) and Permanent Rose. Another primary colour (see the long tails) has been added to each primary to create a colour similar to the outlying colours New Gamboge, French Ultramarine and Winsor Red, which, having two colours in their visible makeup, are therefore secondary. An attempt has also been made to create the inner colours from the outer colours by adding another primary (see the short tails) but because these mixtures are tertiary (containing all three primaries) the resulting colours are absorbing more light, looking duller and are not matching the central circle.

The only colour that cannot be exactly recreated is Ultramarine but I feel that this attempt is a closer match than that of Ultramarine and Lemon to recreate Winsor Blue (Green Shade). Winsor Blue (Red Shade) PB15.1 would make a better match but in my opinion, its visible red content would dull a green mixture more than this gain.

Materials

- Six paints, squeezed or laid out in the following order (for colour names, see introduction):
 PV19
 PR188 or PR254
 PY150, PY153 or PY154
 PY175
 PB15
 PB29, PB73 or PB28
 (Note: if using the Liz Deakin box, leave gaps between.)
- All your brushes (to keep paint scrupulously clean just for this colour session)
- White paper
- Pencil
- Sketchbook/Notebook

Mixing purple … or not. Scarlet Lake and Winsor Red are nearer to a secondary orange than to a primary red and hold so much yellow content that even when mixed with Ultramarine will not make a bright purple. Compare these combinations to the purple of the primary star.

Method

Make a solution of each of the two reds and paint marks (minimum 1in) alongside each other. Now guess which colour will be a basic mixing colour, the indivisible one. Then to test this, try to match for example, Scarlet Lake (or Winsor Red) by mixing varied balances of Permanent Rose with either yellow (Winsor Lemon or Transparent Yellow). Either by mixing first in the palette or running each colour together on the paper, put the mixed colour alongside the edge of the Scarlet Lake to compare. Then, conversely, try matching Permanent Rose by mixing Scarlet Lake with Ultramarine (or Cobalt). Which of these reds is unmatchable? I am always excited by this result.

Then try to make each of the blues, to discover which is nearer to a visually indivisible colour and therefore the most useful. Can you match one yellow alongside the other by adding red or blue?

The paint colours that for many years were considered to be primary colours for painting (scarlet, ultramarine and yellow) are not. Add Winsor Red (or Scarlet Lake) to Ultramarine and the dull resulting colour – not bright purple – indicates that white light is being absorbed in nearly equal measure.

In watercolour pigment terms, Permanent Rose, Winsor Blue (Green Shade) and Winsor Lemon (or their equivalent colours, see list in the introduction, are close to those optically indivisible colours. These colours are unsurprisingly similar to printing

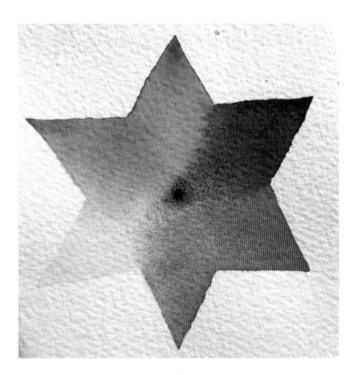

Primary star. Three useful colours and their three secondary mixes.

ink colours, internationally known as Magenta, Cyan and Yellow (also known as 'process red, 'process blue' and 'process yellow'). Yet many people, even painters, are not aware of this fact, or believe that (methodology apart) visual colour mixing for painters and printers is different.

I hope that you will experiment and decide for yourself.

For several hundred years, the assumption has been that red, yellow and blue are primary colours. As a child, I remember being disappointed that 'blue' and 'red' did not make the promised bright purple (because of the yellow content in the red) and that 'blue' and 'yellow' made, not bright green, but the dull green of overcooked cabbage (because of the red content in both colours). I do not understand why this model is still widespread amongst artists (surely a group known for challenging and questioning?). Blindly followed, it often prevails in practice and, sadly, in teaching thus continuing to confuse enthusiastic children and beginners to painting. Yet all around us magazines, newspapers and food packaging display test

QUESTION AND TEST RECEIVED WISDOM

During the 18th century, as theorists became aware of Isaac Newton's scientific experiments with light and prisms, red, yellow, and blue became the canonical primary colors – supposedly the fundamental sensory qualities that are blended in the perception of all physical colors and equally in the physical mixture of pigments or dyes. This theory became dogma, despite abundant evidence that red, yellow, and blue primaries cannot mix all other colors, and has survived in color theory to the present day.
Bruce MacEvoy, *Wikipedia*

It was the optics of the seventeenth century, notably the work of Sir Isaac Newton, that made the spectrum into the standard of 'colour' … Yet the number and even the order of colours in the rainbow has always been a matter of dispute. Newton's isolation of seven spectral colours had already been anticipated by Dante … and illustrated … in the Norman Book of Hours. But Newton repeatedly changed his mind during the course of his career, and opted for the seven-colour version only because he was anxious to sustain an analogy with the musical octave.
John Gage, *Colour and Meaning*

strips of these visually basic pigment colours. (Black is also apparently used in printing black print and dark colours because it is a cheaper ink).

Why has this misconception prevailed? Maybe for the following reasons:

- The red and blue of the 'old' model of primary pigment colours are similar to the scarlet orange-red and blue-purple primaries of white light (red, blue and green) and the concepts of light and pigment were mingled.
- Less bright secondaries (particularly greens and purples) produced by them are 'safer' for painting neutral skin and landscape colours.
- Before modern technology bright colours may not have been so available or ubiquitous in the past.

As a painting tutor, it is a challenge to use the word 'red' to describe a colour commonly known as 'pink', with a trade name of 'rose' and similarly, 'blue' for a colour which is often described as 'blue-green' or 'turquoise', and finally, 'primary yellow' for a colour often considered to be 'lemon'.

Primary means 'one', so, by definition, there cannot be two (or more) different pigment primary reds, blues and yellows (though there are other models of colour defined by different criteria, e.g. the colour perception of different animals, philosophies and therapies). I do not subscribe to the description of 'hot' and 'cool' primaries, as this only serves to further confuse many people regarding this relatively simple, though individual, visual event. When only three paints can make a multiplicity of mixtures, three words are enough for practitioners of any level, to identify what colour they see and how to mix it. The relative proportion of each is the key to the number of variables. As household paint manufacturers use percentages of red, yellow and blue, you also hold that key which lies in trusting your most useful painting tool – your eye.

Although Permanent Rose, Winsor Blue (Green Shade) and Winsor Lemon are near to indivisible (or single, primary) colours, they are not perfect. So I recommend also having Ultramarine (red-blue) for mixing rich purples (with Permanent Rose), Scarlet Lake (yellow-red) and Transparent Yellow (red-yellow) for mixing the zingiest orange. By mixing two colours that already lean towards each other you can access a wider range of bright secondary colours. These six colours will also mix any tertiary colours that you wish.

Opera Rose is a near-fluorescent pink but is only stopped from being one of my basic colours by its tendency to separate while drying. Because lightfast lemon yellows tend to be a little opaque, for mixing very intense, dark, tertiary colours and the rich, dark greens of closer foliage, I use Transparent Yellow, New Gamboge or Quinacridone Gold (orangey yellows).

Colour mixing

All colours can be mixed (either in the palette, on the paper or by glazing) by using one, two or three primary colours. Most colours in nature are tertiary (comprising three colours) and I believe that, if you can identify the relative dominance of each primary component in a colour, then you can mix it. (When identifying a colour, it is helpful not to stare at it but keep comparing it to other colours.) Simply ask yourself, 'Of red, yellow and blue, which is the dominant colour, which is the next most dominant and which is the least?' It does not matter in what order the colours are mixed, only the visual dominance factor. This is a game you can play at any time.

EXERCISE – MIXING BLACK

Mix a combination of the three primary colours to make black. Whichever colour you mix while balancing a really neutral black, paint a small shape so that you gather a collection of neutral greys and browns. If the mix is too red then the other two options, yellow and blue, need to be added. If the colour is too purple (blue- and red-dominant) then the third primary, yellow, needs to be added. If you mix a perfectly neutral black straightaway then add a little of each primary in turn to mix some other neutrals and make a sumptuous collection.

EXERCISE – MIXING NEUTRALS (TERTIARY COLOURS)

Find some natural objects such as leaves, stones and shells, the edge of your hand. Try to mix the colours that you see to such accuracy that, when equally lit, the edge of the object can be visually 'lost' against your painted colour. Add more or less water or paint to lighten or darken your paint solution. Make the mixture a little darker than you estimate because, when the mark is wet, some light is absorbed by the water and as it evaporates, it will dry lighter.

Try using the different brushstrokes WW, DW, WD, DD to mix colours, dropping in separate colours or overlayering.

Reasons for using only these six colours

Careful colour-mixing practice at the beginning quickly leads to

an understanding that feels instinctive and which is yours for life. You can then, if you need to, confidently handle ready-mixed browns and greys, accurately understanding their colour balance. (However, ready-mixed, convenience colours usually need an adjustment, which then entails mixing two or three paints. So, for subtlety and exactitude, why not use basic brights?)

Also, the brain is swift and, on identifying a tree trunk, can instruct the hand to stick the brush into a ready-made brown before properly consulting the eyes concerning the subtlety of the colour, which may actually be dominantly green (yellow-blue-red) or purple (blue-red-yellow).

Be wary of ready-mixed 'addictions' and formulae that can creep in unnoticed. For speed, which would you prefer: someone else's recipe or the skill to mix the colour that you want? It is fun to assess a colour in this way and infuriate lovers of poetic paint names when they ask, 'What is/how did you make that colour?' by answering, 'Just red, yellow and blue'.

Finally, a paint colour that has been created from brights can separate during the drying time and give a more interesting appearance at close range. This can be even di- or trichroic depending on technique, paper and pigment quality (see 'Quality of paint', later in this chapter.

Unlike some 'limited palettes', which include tertiary colours for producing mostly neutral mixtures, this palette of brilliant colours is limited only in terms of weight and size. With these six recommended paints it is possible to make just about any colour, whether bright or neutral.

This mixing approach quickly brings keen observational skills, which form a good basis for developing an artist's individual colour language.

It is possible to read a hundredweight of books on colour but ultimately, the subject of this book is the sharing of my experience with you for your painting. Using your best tools – eye and brain – ponder what you need and why.

Complementary colours

I do not accentuate the idea of opposing, or complementary colours (which together, comprise all three pigment colours to absorb most of the light) because I have noticed over the years, that many people feel that they should refer to a chart or, that to neutralize each other, the secondary colour has to be mixed separately first. Recipes can easily distract the learning painter from trusting their own eyes. With an empirical observation of how your eye and brain work together and personal identification of the properties of just three colours, then colour recipes are not necessary.

Trust your own eyes

Many a tutor can be heard telling eager students: 'Use this formula to make a lovely green by adding this to that, a bit more of that and a little of that ...'. All greens are beautiful in the right place at the right time and after a short while, you will, from firsthand knowledge, mix the right colour – that is, the colour that you want.

The same can be said about the 'rules of perspective' which rule, with straight rulers, over an extraneous land of vanishing points rather than relating to the everyday internal experience of the human eye. Your eye. Our world and our eyes are global. All information visually diminishes in size further away from the eye and causes the perception of ceiling edges above and floor edges below to be curved. Why should this be referred to as 'distortion' with a 'fisheye' lens effect?

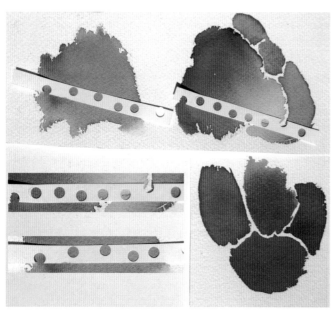

Mixing tertiaries. Top left: mostly red, then blue and least yellow will give a subtle pink-grey. Top right: mostly red, less yellow and least blue will create a rich brown. These are more easily described when isolated from their surroundings. Here, subtle colours are identified separately with hole-punched strips of paper. Bottom right: four Burnt Siennas, of which only one is ready-mixed. The others are made from combinations of red, yellow and blue from the recommended six colours. Bottom left: details of hole-punched paper.

EXERCISE – GREENS: DIFFERENT WAYS OF MIXING

Mix the following colours to begin to explore the range of greens that the human eye and brain can distinguish.

As primaries, Winsor Blue (Green Shade) and Winsor Lemon make a bright green. However, most greens in nature are more

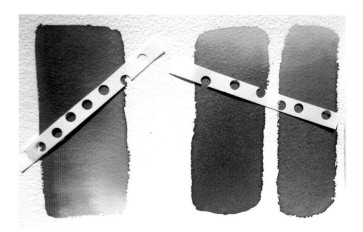

Different ways to mix greens. Left to right: gradated primary blue and yellow with a gradated strip of WW primary red to neutralize the bright greens. Ultramarine and New Gamboge blend to make very neutral greens. A less red combination of Winsor Blue (green shade) and New Gamboge is brighter.

Rose in Rain. To achieve the internal self-reflecting coral red, it was important to intensify the colour rather than adding blue to darken. The external sky-reflecting petals, however, are painted in Permanent Rose with Cobalt. Surrounding it with sky-sheen leaves and a final flash of opaque Cobalt Turquoise Light further contrasts with the rose colours.

Collage of greens. Find different ways of mixing to match these greens.

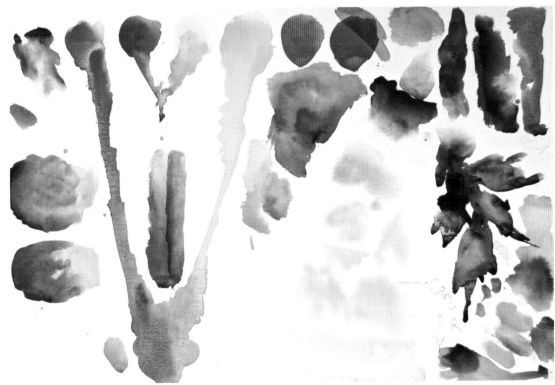

Colour play. A page of colour experiments.

neutral and need a degree of added red to absorb more of the coloured light spectrum.

Another way to add red when mixing greens from yellow and blue is to use a reddish-blue, e.g. Ultramarine and/or a reddish-yellow, e.g. New Gamboge (see colour swatches).

To compare all the different greens here, isolate them by looking through a small round 'finger-lens', made with forefinger and thumb or cut small holes out of paper.

Cut some strips of paper and using different brushstrokes or dripping in on the paper mix these colours to match.

Quality of paint

Watercolours each have their own particular textural behaviour which can be used descriptively. This ranges from transparent and staining to more opaque, flocculating, clumping or granulating heavy- or large-particle pigments. For example, the cadmium family tends towards opacity and these colours easily smear if overworked/painted (the cause of many muddy greens and disappointed beginners giving up on watercolour). Ultra-

marine creates a texture because the particles are electro-magnetically charged and flocculate, huddling together in the 'valleys' of the paper (as sheep form flocks).

I use a pigment 'rainbow' of colours. As to which brand, I have no preference, as long as the colour blends easily with water, is transparent, lightfast, non-toxic and reasonably priced. I often make a quantity of my own customized secondary colour (which by my definition is any colour mixed from only two of the previously mentioned basic colours) by mixing colour from tubes with a cocktail stick.

I usually fill all fifteen paintbox wells with colours which progress from a dark violet to Ultramarine.

And, despite what I have said, I have a 'Naughty Corner' or overspill of paints in my box, which can vary with my mood or may be new to try. For example, at the time of writing: Cobalt Turquoise Light, Cobalt Violet (for opaque flashes to lift flat green passages and add a touch of 'opal'), Green Gold (PY129) transparent, and sometimes Indian Red or Brown Madder, Neutral tint or Indigo or Paynes Grey (used only in panic when a brush can knock them together for instant darks or brown to blue-grey tertiaries).

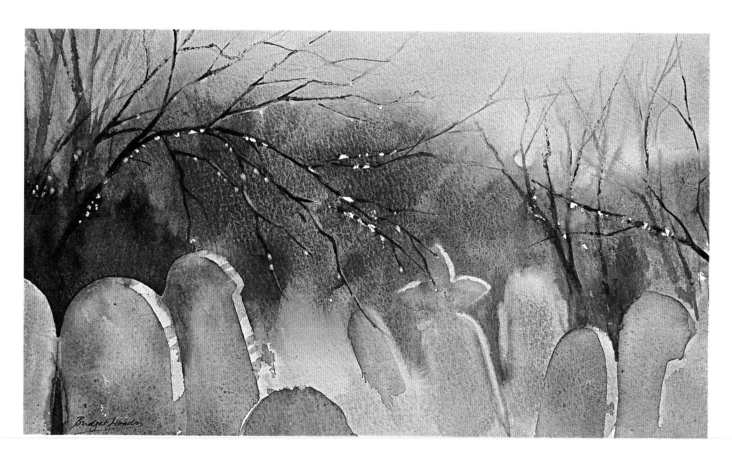

Soft Churchyard Sunset. For a gentle, quiet atmosphere, the greys in this painting were mixed using Cerulean and Manganese blues, which have an opaque and dusty quality. When painted WW they settle quickly while the other colours in the mix continue to leach out in a yellow-red halo.

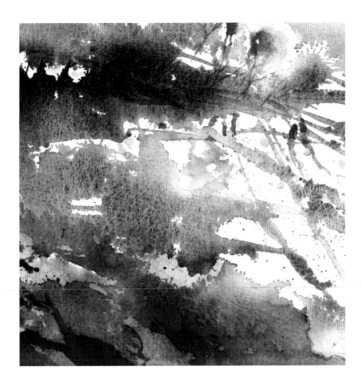

Tobogganing (detail). The flocculating qualities of Ultramarine give an icy, crunchy feel to this 'sun and snow' painting. A blue-green of finer particles has been overpainted in places to accentuate both colour and textural contrast to the distinct behaviour of this red-blue.

My current palette. From the left: Violet PV23, Opera Rose PR122, Permanent Rose PV19, Winsor Red PR254, Scarlet Lake PR188, customized orange of mixed tube colour (Indian Yellow + Permanent Rose), New Gamboge PY153, Quinacridone Gold PO49, Transparent Yellow PY150, Winsor Lemon PY175, Green (WK725 White Nights), Turquoise (WK507 White Nights), Winsor Blue (Green Shade) PB15, Cobalt Blue PB28, Ultramarine PB29. I occasionally use other colours and often mix my own secondaries from tube colour with a cocktail stick. This ordering of the colour allows me to easily access different blues and yellows (side by side) for a wide range of greens.

TIPS

• Generally, while mixing, I wash my brush infrequently. This saves time, avoids too much water getting into the mix and keeps the water clearer for longer. However, for preparing a 'spectral' colour, a clean brush is necessary.

• To thoroughly clean the brush it is important when the brush is in the water, to gently press the neck of the brush, without splaying the bristles, against the bottom of the waterpot. Just waving the brush around will not remove the paint from the neck of the brush.

• When adding water to dilute a mix, remember to scrape off the excess paint beforehand. Then use the brush quickly as a scoop. This will keep your mixing more controlled, the water cleaner and save paint!

• Ultramarine and Cobalt Blue flocculate, so, to achieve the clear blue of a high sky, using primary blue with Permanent Rose often gives a more transparent and distant effect than a blue which looks 'textured'. Conversely, to achieve a smoky or misty low sky (greener) blue, use an opaque, textured colour or mix.

• While supplied information about light-fastness is a good guide, I like to make my own tests. Paint small strips of pure and mixed colour, fix paper to half-cover them and leave them in sunlight. Some colours may fade or change character, for example Aureolin, which is at first a bright golden yellow but dulls over time.

• When mixing a tertiary: it doesn't matter which red, yellow or blue you use as long as you remember their visual colour composition (e.g. using Scarlet Lake will require much less yellow in the mix than using Permanent Rose) and their quality (e.g. Lemon Yellow can be opaque so use a transparent yellow for mixing dark tertiaries and rich dark greens).

• When mixing a tertiary: if you cannot decide which primary is dominant or second most dominant, it probably means that they are equally dominant.

• Winsor Blue (Green Shade) is a very strong colour. When mixing, add it little by little!

• Colour is only visible to us because of light. Is the red jumper in the closed drawer red or black?

EXERCISE – LIGHTING LOGBOOK AND MOOD SKETCHING

Primal responses to light and weather-surprises of the seasons trigger a desire for continual watercolour notation and also energize and flex your imagination and painting styles.

Method

Find one small area to paint that you can see from your Space – one that is ideally ever-present and subject to changing light, weather and season. Make a ten-minute painting, every day if possible, using any of the brushstrokes and colours in completely different ways, depending on weather conditions and your mood. Use this daily reference as the focus for your imagination.

I paint a eucalyptus tree which, while writing, I can see now. I keep an open agenda, using this subject simply as a stage, which offers a wealth of colour, scale and variety – playtools for my observation or feelings.

Light and mood conditions can be fleeting, so try to stick to ten minutes and don't fiddle, judge or rework but do give the painting a date time and title, however strange. Allow yourself to be drawn along by the visual factor or idea that seems dominant to you, completely departing from reality as the mood takes you. Visual movement, whether real or found in static linked shapes is important to me. Does your subject stand, lie still or dance? Which dance? Does it make you angry or feel like laughing today? It really doesn't matter at all what or how you paint, just that you engage with paint and water and you. This is not about striving, so relax and let go. I use old scrap watercolour paper, which adds an unknown twist, often reminding me why I use certain papers. If you have this 'splash' in the morning, you can also, or alternatively, include any residual dream that may be lingering.

EXPERIMENT AND RESEARCH

EXERCISE – PLAY HABITS

Researching the expressive qualities of colour and rhythm and the textural possibilities of transparent watercolour is rewarding. Only ever making a full painting can feel like a big investment of time; this can stifle a daring approach and cramp progress. If the conscious mind is occupied with open-ended experiment and play, however, the subconscious can begin to explore. This comfortable studio practice helps to tap into a wider vocabulary of marks. Then suddenly, on location, a new mark or approach, explored but waiting for the right moment, 'magically' appears. With skills in place, my aim is to respond freshly and openly to any subject as though it is a first time experience.

Method

Although we use our eyes principally for survival, develop the habit of simply taking pleasure in looking ('I like that colour/texture combination'), thinking ('how would I paint that?') and imagining ('I wonder if that would work?'). Whenever you have a visual idea, which may be triggered by a sound or a physical or emotional sensation, write it down on an ongoing list, or voice record it. Keep a big sheet of paper at your Space on which you can always play and experiment whenever you have five minutes free. I taught myself watercolour this way and feel that, although the techniques may be shared by painters worldwide since cave painters made handprints or spattered earth over their hands as stencils, my moments of discovery were, and are, always magical and personal to me.

Doodling produces marks that open up the imagination and makes links between ideas. Research scientists often find their breakthroughs occur away from the workbench. Because people and marks are never identical, you may discover a method no one has thought of before.

Eucalyptus logbook. I have known this tree since it was a sapling. This is a small selection from hundreds of portraits, each recalling a memory.

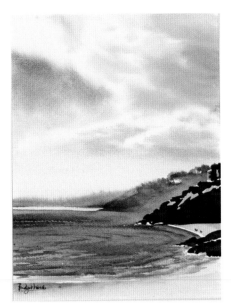

Monday, *Dawn Anticipation.*

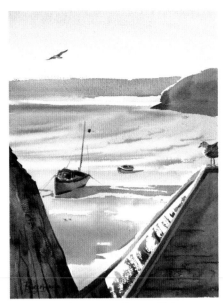

Tuesday, *Warm Dawn Light.*

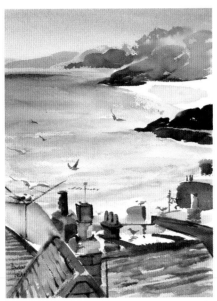

Wednesday, *Dawn Light Over Wet Roofs.*

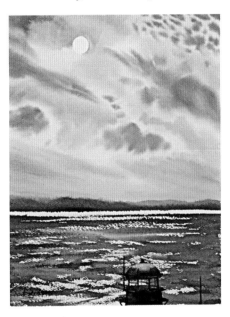

Thursday – *Eden Project Day.*

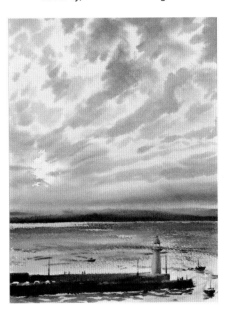

Friday – *Boats Return.*

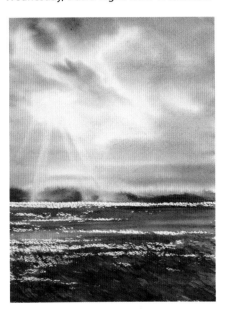

Sunday – *Dramatic Dawn.*

Saturday – *Looking Back, Pre-Swim 3.30pm.*

Six near-dawn experiences and a wedding. Paintings made each morning from a cottage in St Ives, Cornwall, and one on Saturday afternoon, which looks back towards the town. Surreally, a couple came to share the beach for wedding photos.

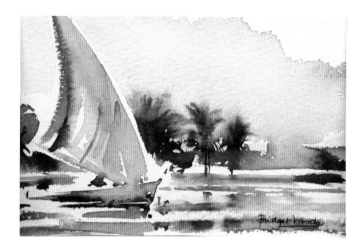

Nile logbook. It is exhilarating to be on a boat where the landscape is continually changing. Limber up by first painting a more constant, distant view from the back or front towards side deck sights which are closer but move faster. From 30 × 22in paper I cut a shape (e.g. 24 × 22in) which leaves a border for a homemade zigzag sketchbook or 6 × 4in (A6) postcards to send, and also fits in the luggage.

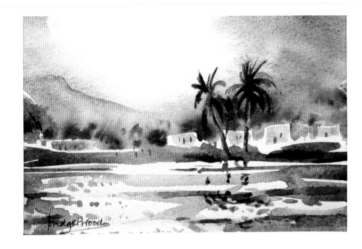

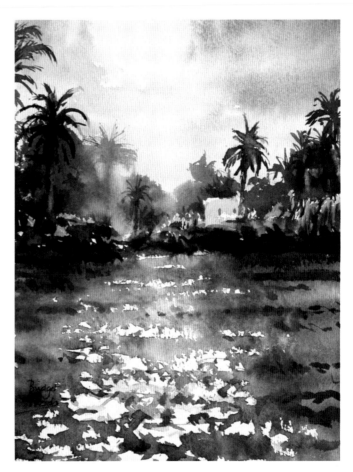

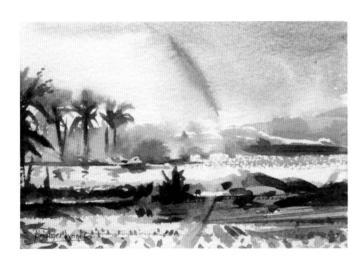

Sparkling Nile. I was woken at dawn by the flashing of low sunlight on the river reflected on the cabin ceiling. Exhilarated, I jumped out of bed and made this painting while the boat sailed by.

*If we knew what it was we were doing, it would not
be called research, would it?*
Albert Einstein

Give a little, receive a lot

Only five minutes covering a page with any practice paint marks of different textures and colour, overlapping or running together and noting what happens and why, will yield a skill and learning experience you will want to repeat.

Experimenting is about discovery and because watercolour shows every hesitation, untimely rush and indecision, trialling a new idea can look overworked at first. Fear not: with a little perseverance at the beginning, the process suddenly becomes faster and smoother until you are unaware of a skill that has now become a part of your painting voice. Also, an extra five minutes spent wandering off the intended path into the unknown often leads towards invention.

Remember, when preparing to paint, this is your sheet of paper, your space on which you can create any world/idea/message of your choosing, figurative or invented; a

Collage of ideas from play sheets. Referring to an ongoing list of 'what ifs' I cover pages like this, so that, having experienced it, a colour or technique combination might unconsciously appear when painting on site or developing an idea.

surface specially made for your response is there, waiting for you to engage with it and become an expression of your life.

The next chapter will extend your skills by exploring a fuller range of brush and paint handling methods. With these tech-niques you will be able to select and develop ways of expressing not just your visual, but physical and multi-sensory responses to the landscape in a way that is direct and instinctive.

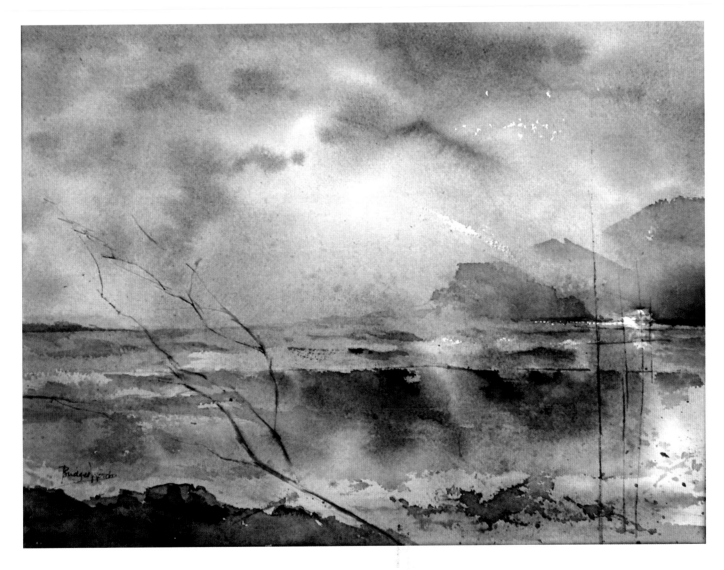

Stormy Sea and Sky. This painting started its life as a sky painted vertically (portrait). I was keen to try to intermingle the colours, vaporous and cyclical nature of sea and sky like the warp and weft of a weaving, so I turned it round and added sea and rock marks to make a horizontal (landscape) format painting. I would not have had the courage to do this without the spirit of continual 'play risk'.

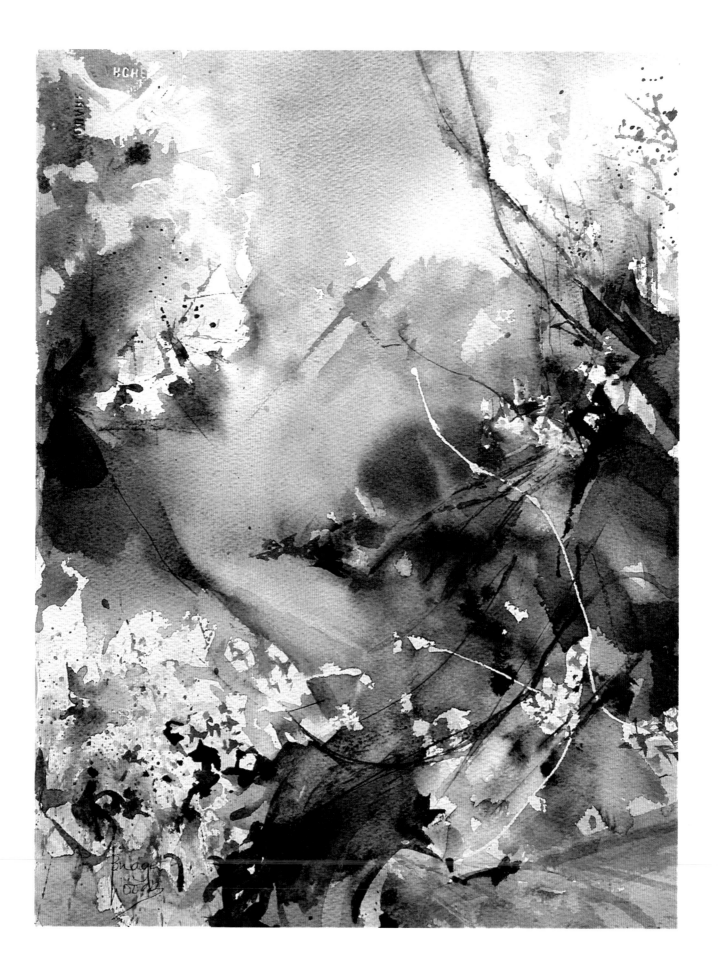

TEXTURE AND PATTERN

A physical response

MAKING YOUR MARK

The vital spark, the unique mark

The artist's sensation or remembered feeling travels through the arm to the hand and is expressed as a mark. The painting calls, the viewer approaches, comes in and contact is made.

If a painting calls across a space from a distance with its broad arrangement of colour and tone, then the marks within it lure the viewer closer, continually intriguing and giving, explaining a little more as the viewer approaches the painting.

Meanwhile, for the painter the creative experience is a very different one; after the inspiration, the feelings and memory are expressed outwards – from an inner sensation to the hands and physically to the mark. That moment of contact with the paper inevitably expresses our individuality.

When describing the process of painting in writing, the broad analogy of marks to words, process to syntax and ways of formalizing to sentences or phrases is clumsy. Painting, especially watercolour, makes intangible ideas visible by tangible means. It can then present them and their history at one time, not chronologically nor in a line, like these words – black marks

LEFT: *Buzzing and Blossom.* The magic moment when I hear and see my first bee of the year; sensory contrasts of texture, warm softness of early spring light, foamy whiteness, sharpness of blackthorn, fresh greens, rich browns threaded together by the buzzing of an imperative exploration for gold. I used WW, DW, WD, DD, spattering, thin masked lines, scratching, SOS roll marks.

on white ground.

Nevertheless, the grammatical link is inevitable and a wide 'vocabulary' (comfortable access to the handling skills of a large range of marks) increases the ability to express individuality and subtlety of feelings and memories. But more, the processes prepare the ground for you to describe the ideas of your/our future, the new marks of your unique style yet to be made, free from assumptions, derivative emulation and formulae.

There is only one way to develop an expressive watercolour language that is your own, and that is to experiment with different tools, play with water and inventively explore different techniques.

Impossible to forge – or repeat

In a world of stereotyping, speed-printing and copying, the individual mark now commands a high premium. The making of that mark is a decision in the moment. The way the mark is made lies within the character and mood of each person, skilled or not. To these, add the variables of different brushes, colour choice, transparency, weather and drying-time and you may contemplate and savour the knowledge that a watercolour mark is impossible to forge or make twice, even by the same artist.

Brush and tool discovery

The choice and handling of brushes and tools describes the artist. It is very easy to get into the habit of using only a limited

size and range of brushes and severely clip your personal expression for want of experimentation. Aim to get the feel of these different brushes and implements to find the potential they have in your hands.

Chinese/Japanese brush

These brushes are designed to act as a 'funnel' with the body of the hairs as 'holder' and the tip of the hairs as the 'feeder'. For spring (also known as snap) and water-holding capacity, the better quality brushes can rival sable at a much smaller price.

Brush shape: single and grouped marks

Make several marks by simply laying the loaded brush down flat on its side. Study the shape. Develop suggested visual ideas by changing the direction and grouping more of these marks into trees, water or any pattern. Then see how your small and large brushes perform when making the same types of mark. A Chinese brush mark has a pointed end and a rounded end, both of which can be used. To remember this, make several marks with the tip pointing away, then towards you.

Aeroplane marks

Hold a loaded brush vertically and make a vertical, circular movement in the air with your arm/hand, keeping the brush vertical at all times. Now gradually lower your arm, still circling, not too fast, so that, like an aeroplane, the brush is gently landing, tip first, on the paper then pressing harder and then lifting away again as it travels. You will have a straight, horizontal mark, which is thin at the beginning, fat in the middle and thin at the end. (The mark is often less wet in the middle, depending on the type of brush, paper, speed and pressure.) In order to concentrate on simultaneously controlling the movement and pressure, do it slowly at first. Practise this mark until you can achieve the maximum width-variation with your brush. Then see how short a mark you can make to still include this variation of width. Then vary the curve and direction. What do these marks remind you of? Water, grasses, ribbons, wings?

Floppy Chinese brushes with less spring or snap are ideal for rougher painting, raggy trees (like cedars and firs) and random, more haphazard, statements.

Coq d'Or. I was determined to make these tail-feather marks with single strokes. Also DW chest feathers.

Painting with water

This is the safe way to paint intricate shapes and luminous darks. Load up your medium-sized brush with blue paint. Then with a rigger full of clean water, paint three vertical lines and two horizontal lines across them. Now looking for the wet-shine of the marks, gently touch them at the intersections with blue paint and watch it flow into the water. If the paint has not spread throughout the lines, the effect may suggest light through a window frame. Now use the same technique for any shapes, either random and wild or figurative, e.g. twigs, leaves, fine machinery. Experiment with actually squeezing the colour into the watermark by holding the head of the brush over the paper between your index, middle finger and thumb to give it the 'Tricuspid Squeeze'. (Finger and thumb simply splits the hairs and pulling can dislodge the whole brush head from its neck, or ferrule.) Tip the paper if necessary to fill the shape with colour or leave the marks partial for a combined WW and WD effect.

This method is good for soft, limpid, translucent marks that can convey dappled or blazing light, describe form or indistinct objects or ideas. It also ensures a mark that is not muddy; particularly useful when painting dark shapes. Thick, syrupy paint solution, with a high ratio of pigment to water, can easily smear when over-handled or look dull if achieved by many layers. This method allows a freer flow of the particles. Any natural hair brush (it will not work well with a nylon brush) can be used for this method but it is fun to use a fine and slender rigger the first time you try it.

Blossom Tamarisk and Well. The fine tamarisk branches were painted with water first and colour dripped in. This painting also shows the effects of salt used at different stages and onto different pigments. It was sprinkled earlier onto more diluted paint for the larger blossoms and later onto the thicker consistency for the walls' smaller 'blooms' of lichen.

Chisel brush (nylon)

Load up and experiment. You may find that, in comparison to natural hair brushes, this nylon brush, because of its smoother bristles, releases its liquor more readily at first but runs out of mixture quickly. However, you will note the extra spring and friction of the nylon on the paper. This is why a nylon chisel brush is the best for taking paint off the paper (should you ever need to!).

Chisel brush (natural hair)

Load up your chisel brush and, as before, explore its potential. Try some straight, diagonal then curving or twisting marks with the brush held vertical and the bristles horizontal on the paper. This square-ended brush is useful for making decisive/geomet-ric/calligraphic/structural/man-made statements or pulling a 'floppy 'painting together. What kind of subjects do these marks suggest (e.g. paths, water ripples, rock, houses)?

Rigger brush

Load your rigger brush with paint and see what makes it special by laying it flat on the paper, holding the brush at varying angles and making single and grouped marks. Try some aeroplane marks and vary the pressure observing that the mark retains a similar width. Even with a wobbly hand, this brush is good for painting rigging, fencing posts. Conversely, rolling the handle produces random curly coils or tendrils.

This paradoxical brush offers martial regularity and cussed uncontrollability.

TAKING PAINT OFF

Find a dry mark and wet the area of paint that you wish to 'lift'. Wait for about a minute, making sure that the area is kept wet. During this time, the water is seeping in between the pigment particles and making it easier for them to be dislodged. (It is not advisable to scrub the surface straight away because if the paper surface is broken and the sizing lost, the paint will simply fix into the paper filaments for ever).

Then, with the nylon chisel brush held at a low angle to the paper, softly stroke the area in the same direction as the bristles. This gentle approach gives an idea of how easily the paint will lift. It is better to be in control of the removal of paint than be surprised by its sudden disappearance. If the paint is not lifting, then hold the brush more vertically and stroke again. If nothing is happening, for the roughest treatment, vigorously rub the mark back and forth with the narrow tips of the bristles, varying the direction. Then take a clean tissue and firmly blot the whole of the wet area.

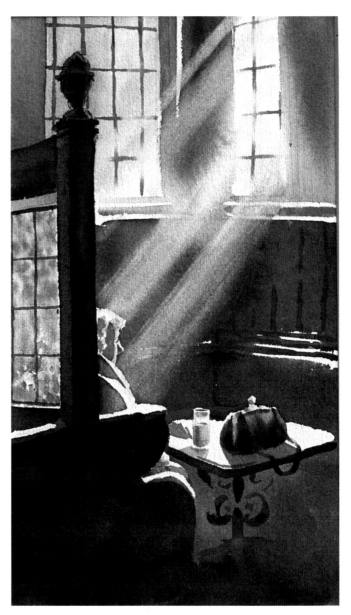

Winter Sunset. I used rigger brushmarks and scratching to unify a sharp rhythm, which seemed to dance as the sun went down, flashing between and onto different bare branches.

In the Snug. There were so many varying textures and wide-ranging tones to explore in this subject, painted from a photo. Mohair through Cathedral glass, light through the window, leather and gold. Three bars of light, painted in negative DW looked too uniform so at the top I very gently lifted the narrow bar of light with a nylon chisel brush. This painting also illustrates the previous technique on the window frames.

Poplars, Exhilarating Day. Incisive diagonal WD chisel brush marks were used to express the noise and wind through the poplar leaves on this warm, harvest time day in France.

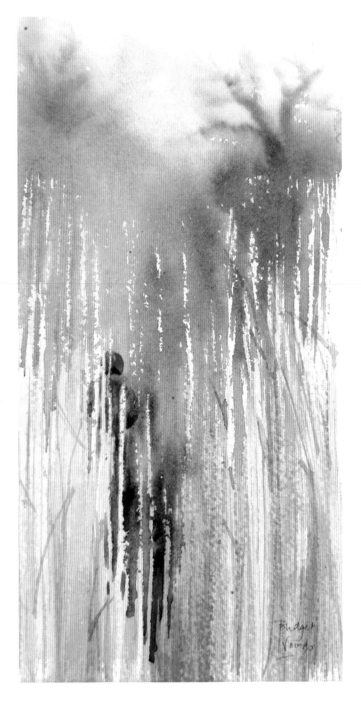

Red Hat in the Reeds (detail). DW split brush of cream and brown was dragged upwards for the underpainting (positive reeds). All background colours were prepared. Then when the paper was dry, an area was painted with clear water across the top and a split brush used to drag the water downwards (negative background). Immediately while wet, background colour was dripped in. The dog is at the bottom and positive trees were painted DW into this negative background. Finally the figure (my Mum) was painted in WD.

Split brush (positive and negative)

A soft, floppy Chinese brush is ideal for making fine but organic, irregular marks by splaying the bristles between index finger and thumb. The marks are more uniform with a firmer brush or designated fan-shaped brushes.

Positive and negative in one mark. This single WD mark will lie underneath a wash or WW, DW overlayer. Because some edge acutance will be subsumed, this order of layering could also describe misty or distant conditions or background sound.

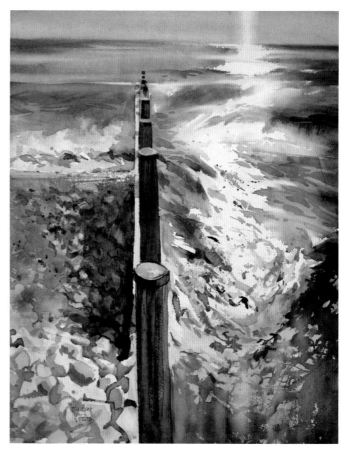

Holding Back. This image uses spattering to express the noise of pebbles and the splashing of water on each side of the groyne. This painting sums up for me the idea and long-term effects of trying to 'master' watercolour.

Thinking positive and negative simultaneously

The WD marks may be painted first. A wash of colour(s) or WW can now be painted over this (as gently as a butterfly's wing).

Splashing, spattering and spraying

With any kind of brush the paint mixture can be spattered onto the paper to give speckles. Other variations include spraying water or splashing contrasting colour onto nearly dry paint to cause tiny 'oozles' (see *Autumn Wind* later in this chapter).

A water spray can be useful when painting a bright glaze over a very dark pre-painted area.

Salt

Interesting surface texture can be achieved by sprinkling grains of salt onto wet paint. Salt is a water attractant (hydroponic) so the individual grains immediately soak up and hold water. As the areas surrounding the salt dry the inconsistency of the drying surface becomes visibly evident. Each salt 'reservoir' leaches its water out into the surrounding damp paint, spreading and usually silting up pigment like a mini-oozle, till a dry edge stops its progress. Do not rub the salt off until dry!

Final effects can vary greatly, dependent upon the timing of salt-sprinkling, wetness of paint mark, viscosity of paint, speed of drying and angle of paper. I find that small grains have more impact. Although the salt is brushed off when completely dry, please note that the remaining salt can still attract moisture in very humid environments. (See *Blossom Tamarisk and Well*, earlier in this chapter).

Sea Fret and Stone. Making a detailed drawing of this flat slither of lias shale at Robin Hood Bay, I realized that while many pebbles arrive from elsewhere, this fossilized stone was not only indigenous but also that it probably hosted 'life' within as well as outside its slender frame. Not to disturb the fine tracery of negative painting and let it 'lie' under imagined water levels, I used plastic sheeting to partially mask the dark underpainting before spraying horizontal bands of ready-mixed colour.

Stone Guardian. To express the texture of volcanic rock and lichens, fine grain salt was sprinkled onto the first multi-coloured wash. When totally dry, the salt was rubbed off. Then, to establish the darks, some areas were gently re-wet and the process repeated, oozling to reveal the colours beneath.

Masking methods

I usually reserve dry areas by simply not applying paint or water there, using methods still to be described in this book. However, I do use masking fluid to reserve the paper or underpainting when appropriate or necessary, in the following situations.

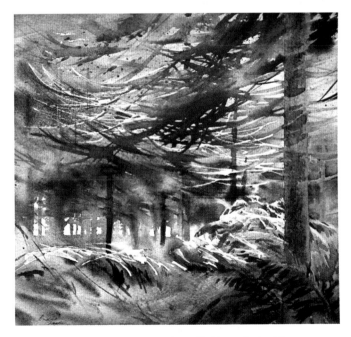

Scorching Forest. I chose masking fluid applied with a pen to evoke the sharp pricking heat and feel of dry spiky pine needles and bracken rasping on the skin.

For fine, needle-thin brights and lights

For narrow shapes surrounded by either dark or complementary colour, I use a dip pen or Masquepen Supernib, which contains and feeds masking fluid to the paper in a fine line. When dry it can be painted over and removed later when the painting is bone dry.

Straight and rough edges

Low tack masking tape which will easily lift after painting without leaving glue is good for reserving straight edges, while torn tape or cartridge paper edges laid on the paper leaves a more random edge.

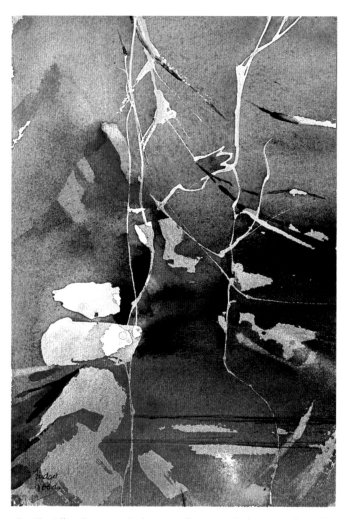

Exotic. Allowing my mind to wander to a rainforest and exotic plants, the underpainting on selectively wetted paper was a rose-tinted expression of glamorous colour, reminiscent of 'captured' orchid corsage. When dry, I used a nib, Copydex and my nail for spreading, to mask the fine and broad shapes. Then I could paint the heat and mountains before revealing the rich, fresh colours underneath.

Card by Jill Breeze. Soft chisel brush marks, masking tape and scratching created this semi-figurative image.

Ragged random brights and lights

When there are rough, speckled lights or brights to reserve, I like latex glue such as Copydex which is a good low-cost masking fluid and, neutral creamy white, it does not influence decisions when spontaneously composing and adjusting colour over the top. When dry, it rubs off easily without tearing the paper and the blunt, stiff nylon brush in the lid of the pot delivers a raw quality to a mark (which may also be smeared while wet) and so prevents finicky application.

Palimpsest – wash away masking

Using the paper almost as a printing block, this masking method yields an edge quality that is different to other masking methods – perhaps more akin to some printing. The painting is started with a WW composition and while it is wet, objects are laid onto it. The visible areas of the painting will then be allowed to dry, so if you are using a blow dryer to speed up or manipulate this process make sure that the masking objects will not move. As soon as the visible areas are dry, the objects are lifted off and the painting is then rinsed under the tap. The still-wet paint will run off, leaving a white ghost, soft visual impression, or palimpsest, of the object. This process can also be made over a dry undertinted paper and may be repeated.

Life Book Walk – June. I used Copydex for reserving the sunshine and for the lazy feel of hot summer and the sensation of sand on skin with colours in blazing opposition. There was some scratching while the paint was wet and patching after lifting the reserve, to loosely hold the proportions together! An arc here represents the idea of time; a whole day on the beach.

Frozen Pond. I used the masking and washing method to suggest the illusory qualities of glass and ice. This painting was built up with three subsequent layers of WW. At each stage the paint was masked from blow-drying and the whole painting rinsed under a running tap to reveal negative shapes of the masking items: the first layer, brushes, the second layer, my hand and coins and lastly, brushes again. Some shapes were tentatively developed by minimal scratching and painting. It is just possible to distinguish the palimpsest of my hand on the left, showing hand lines.

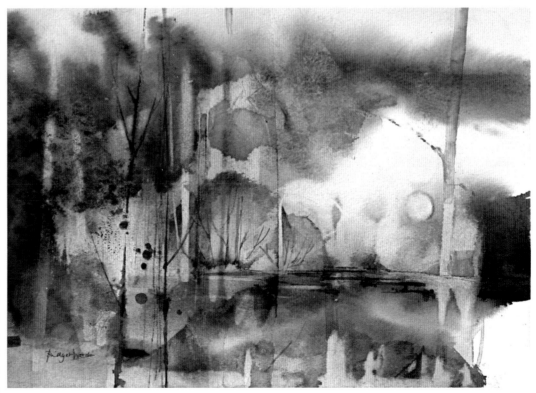

Sgraffito/emery board

Fingernails can act as portable italic pen nibs – in different directions for wide and thin scratching into wet paint or preliminarily into dry paper, broadly responding to the subject before applying water or paint. Depending on the paper and sizing, dark or light lines may result. If the paper is broken, the paint will sink into the mark and leave a permanent darker mark but if the back of the nail (or tool) skims the paper at a lower angle, the pigment may be pushed away. I also use this mark as a ha-ha to slow down or stop colour spreading. No nails? Use the handle of a brush, plastic card or blade.

Following an invitation to students to bring, share and compare any type of mark-making implement, one person who arrived late brought nothing, but fished into her handbag and produced an emery nail file. With one end cut diagonally like an italic nib, it made a rasping, abrasive mark on the paper, ranging from very fine to rough, and thin to broad, which into wet paint, like scratching, holds and fixes the colour. Many varied tools were shared but the emery won the vote for the most useful, either dipped into paint, WD as well as WW. Now I never travel without one.

Drying methods

Slow drying

A very wet mark when allowed to dry slowly and naturally will have a luminous quality because the pigment will settle into the valleys and express the texture of the paper. Also, a colour, if mixed, will have time to separate (more or less, depending on the pigments that are used – staining, chalky, flocculating, granulating etc.).

Fast drying

If the same mark is dried more quickly, the pigment will be obliged to settle where it is and the resulting, more even, distribution of pigment will give a more matte appearance. This can happen in hot weather and when using a dryer.

Two-level pose. After random colours were dropped onto soaked paper, this short, close-range painting was scratched, blotted and finished before the paper dried. It illustrates the dark and light effects of paint on both broken and unbroken paper and the ha-ha effect.

EDGE ACUTANCE

A wet paint mark has a curved surface at the outer edge which dries faster than the middle of the mark because it is next to dry paper and has a greater surface area. As the surface at the outer edge lowers, to maintain a flat surface, water in the centre of the mark moves outwards taking pigment particles with it. This causes a build-up of the lighter, more mobile, particles to produce a sharp dark edge, sometimes a line. This effect can be accentuated by dripping in more, or different, paint or water.

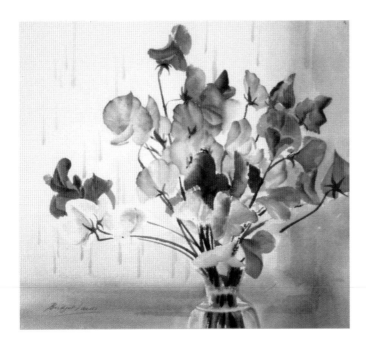

Sweet Peas and Rain. When I was just exploring ways of adding more water to my painting practice, this subject and appropriate conditions were presented to me. Dropping water into the middle of a paintmark or touching the edges of a water mark with colour was still a novelty at the time.

support and for economizing on stacking space.)

- Distinguishing individual forms – once dry, an area of WW colour(s) may be easily separated into individual rounded forms (e.g. trees, bushes, fruit, limbs, petals) by superimposing this gradated shadow mark.
- Escaping calmly and 'quietly' when you suddenly have to stop painting – for example, when wash mixture runs out too soon, panic sets in as you approach a complicated edge or the phone rings. Using this technique avoids leaving a finite WD edge that is unintended or ragged. When the soft edge is dry and composure restored you can carry on with the method described.
- Invisible mending – whenever there is a need to continue or overlap one area of paint with another without creating a jumpy edge, for example, when painting separate complex pieces like bright/light flowers which may share a common background, like a continuous cloudy sky.
- Making a quiet transition between the layers of a painting – this mark allows images and ideas to subtly appear in a painting. Rather than making a stark jump from WW to WD or 'ground to figure' (which can look flatly stuck-on), edges can gently 'come into being' as suggestions, hints or compositional try-outs.

IN-BETWEEN BRUSHSTROKES

EXERCISE – SOS ROLL MARK

This mark – sharp and clear on one side and soft and fuzzy on the other – has a wide repertoire of uses in watercolour painting. I discovered that after seeing my 'conversion' demonstration students had nicknamed this technique 'the sausage roll mark' – an inelegant title but I eventually capitulated because 'SOS' also suggests a cry for help, which this multi-purpose mark can supply in a moment of panic or need.

What can it express and achieve?

It is invaluable for the following situations:

- Describing the shadow caused by rounded form – with the exception of crystalline, rocky forms, most things in nature are rounded. (It is we humans that use rectangular shapes for reasons such as architectural

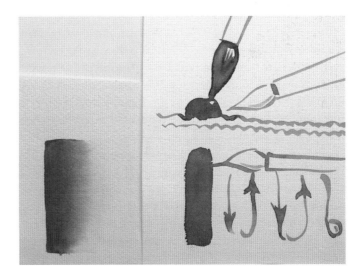

SOS roll mark. Side view showing the angle to hold the colour brush to deliver a wet mark and the angle of the clean water brush to paint a wet area alongside without too much paint getting into the brush. Note the blob when you lift the brush. Squeeze the excess water off the brush with a tissue and soak up that blob immediately (whether you can see it or not) before it drifts back into the mark and causes an oozle.

Freda (underpainting detail). Eight small SOS marks gently bring form to a portrait which has been underpainted only in WW and DW. Incidentally, the diagonal line in this working demonstration also shows that, correctly done, removing paint is possible (even Winsor-blue based grey) when dry.

Method

It is practical to use two natural hair brushes of similar size for this useful mark. Load one with well-mixed medium solution paint, the other with water. Have a tissue to hand.

Gently paint a dark, wet mark with Brush 1 held nearly vertical (to use the funnel factor of a brush). Remember to move your whole arm to deliver an even, wet mark. Immediately, with Brush 2 held low to the paper, paint, at right angles, along the edge of the mark with water, just touching the colour with the brush-tip. Without lifting it from the paper, zigzag the brush firmly and quickly away from the mark. On lifting Brush 2 a water blob will be left, so soak up the excess water from the brush with the tissue and suck up that blob with the damp brush, otherwise it will drift back into the mark and oozle.

This technique looks easier than it is to perform. Its success depends on balance of wetness, speed, pressure, ambient heat, paper and paint type. However, it is worth practising over several pages to get the hang of it. Once you have it, it's yours.

In a landscape, the light source of the sun usually lights the subject from above, making the darkest area lower in the subject graduating to a lighter tone above, so it is often necessary to hold the wetting-off (water) brush with the point facing towards you then zigzag your arm away from the mark and your body. You will be so glad that you are not in the habit of resting your hand on the paper (see box 'Physically relaxed and ready to express yourself' in Chapter 1).

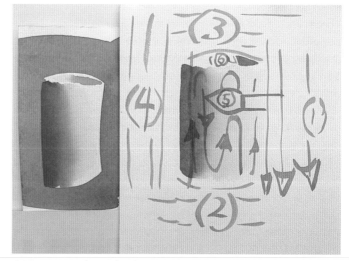

SOS converted to cylinder. By painting the background over the foreground object it appears to stand forward. Both ambient reflected colour and shadow, darker tone, can be painted in one visit.

EXERCISE – SOS: CONVERSION TO A CYLINDER

The paradox of this process is still as exciting to me as when I first experienced it. By painting a negative background mark over another mark the first one appears to come forward.

Materials

Make plenty of wash mixture to match the tone of the original mark. (Note the only golden rule I can think of for watercolour: Always mix more wash mixture than you think you need.) Then prepare a water brush but a little less wet than before.

Method

Paint a wash with a loaded brush, first from the outside towards the 'sunny' edge. Repeat from the outside towards the lower, short end, closing it with convex edge. As before, paint towards the top short convex edge leaving a white space.

Then paint again from the outside towards the dark edge and overlap the original mark by approx 5mm. Immediately take the water brush and zigzag away from it without touching the surrounding wet paint. Soak up water blob with damp brush. (Note: this wetting-off brush must not be too wet because dried pigment lying in the paper valleys causes the surface to be smoother.)

When dry, paint a small triangle for the inside shadow and SOS again.

This whole process gives you opportunity to practise making SOS marks (× 3), laying a flat wash, and positive and negative painting. Also, if the first SOS roll mark is not perfectly gradated, do not worry: the background mark usually neatens it up when it overlaps to SOS again, making a double layer of tone. Try with different background colours to overlap.

The same effect can be achieved by wetting an area of paper and painting a mark along one edge. While this can be appropriate for some broader situations (more to follow), the SOS (mark first) is an invaluable skill for understanding, handling and balancing different degrees of wetness. Using two wet brushes is a first-hand experience of the power of water to draw in, mingle with or push away other wet marks. It also tests and develops a trust in water to carry the pigment for you. How far? Watch and learn and do not push, tip and tickle, but let the paint run into the wet playground.

Note: at first, resist trying this with too many types of paint, paper and brushes because they will all give a different result.

Autumn Dawn at West Dean. I have used the SOS on tree shadows (left), to separate some of the trees up the hill (right), very gently on the hill and in the foreground overlays of green.

Later, however, examine the responses of different materials, like heavier sluggish pigment, greater saturation of thick paint or smooth and rough papers.

DRIP AND TIP – PAINTING WITHOUT FEAR

WD painting is considered to be safe and predictable compared to WW because the wetness will not run over a dry edge. Nevertheless a clear-edged finite statement once made is a commitment and will always remain visible. Knowing this when painting complex detail, I found it too easy to peck, dab and dither while finding the exact shape (especially when painting commissioned portraits of anything from dogs to houses to cars and children). Half-dry, smeared paint is a recipe for muddy, matte paint quality. I was an expert – until, inspired by a student who paints very wetly (and calmly), I decided to consciously take action and find a way of making marks that could be developed while still wet, dry comfortably and thus quell my 'whitefright' of wet paint on dry paper.

I realized that the very fixed quality of WD could paradoxi-

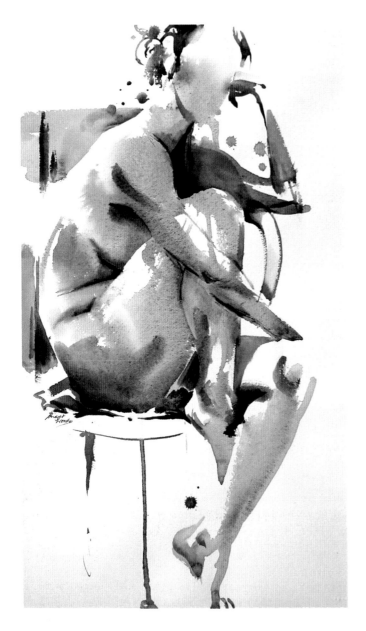

paper before the mark runs. Depending on the paper surface, temperature and thickness of mixture, the angle is surprisingly steep. Use this property (water confined by a dry edge) to confidently paint complex or important shapes in water first. It is practical, fun, allows a more expressive approach, time to ponder and as an extra bonus, produces deliciously luminous marks. I called it 'They Can't Throw You in Prison for Painting with Water' but found the title a little cumbersome so for practical reasons, I now call it 'drip and tip' (DT).

DRIP AND TIP (DT): COMPLEX DETAIL/SPECIFIC/POSITIVE

Mix plentiful puddles of primary and secondary colours, or colours appropriate to the subject. Choose or invent a finely detailed subject, then draw it with a fine pencil. Now carefully paint the shape with a fine brush and water and immediately drip colour into the mark by squeezing the colour brush. Don't pull the brush-head but use the 'tricuspid squeeze': two fingers and a thumb. Now, tip the paper to let the paint run through the shape. Blot back if the water runs too far (do not dab – really firmly staunch the flow).

All the time that the mark is wet you may change the colour by rinsing through with dripped clean water then drip in other colours, scratch into it or paint DW into it. Keep the mark wet for as long as necessary by adding more water or paint mix. Invite the paint to flow to fine exact edges with a nail, either end of a brush or pointed tool. Adjust the colour mixing and then leave to dry. Avoid oozles by absorbing excess water with the corner of a tissue rolled to a point between the fingers (not a nervous 'dabfest'), or if you prefer, leave them to spread.

Relaxing in Sunlight. At a workshop, my first painting of this 'last pose of the evening' was dull. Packing up to leave, I decided, instead of wasting the very wet paint, to use it frivolously. With no drawing, I used water to paint the body shape, which was already familiar, and tipped my paintbox of spectral colours into the mark. The freedom of this painting could not have happened without lack of time to doubt, a thrifty nature and the original 'sacrificial' painting, which gave me courage.

Window Sill. Most of the shapes in this painting were drawn then painted using DT both positive and negative to enhance their innate colour and give a sense of stillness and weight.

cally offer the solution to my problems. Just to see how stable a WD mark can be, make a very wet small circular paintmark (look from the side to see how rounded the top edge is); then, very gently, slowly tip the paper to see how far you can angle the

Blob development

Another way to maintain luminosity while painting complex marks is to make a small, very wet puddle of colour in the centre of the subject area, then drag and spread from that source with a fingernail or the end of a brush handle, without scratching, across the paper. The glory of this process is that the mark can be developed to create an accurate and exact shape directly in paint with no previous drawing. It also allows you the luxury of taking time to really observe your subject without worrying about the drying edge because more colour or water can be dripped in as before, to keep the mark shining wet. More intense or different colour can also be dripped in. While the area remains wet all the list of available 'into wet' marks can be applied.

DT: COMPLEX DETAIL/SPECIFIC/ NEGATIVE

A complex subject already painted or drawn often needs a background that does not underpaint or overlap it, for example when the subject is lighter than the background (tonal) or when the background colour is not a component of the subject colour (orange/red leaves in front of a blue/green sky, for example).

Draw or invent a complex shape or make a painting of a fine, bright or light subject and make sure that it is dry. Then wet the paper around the subject near, but not exactly up to the existing positive subject edge and DT the background paint. While it is wet you can easily find the exact edge as before.

Note: if the transparent water is difficult to see, add a little colour as a guide. Also note that pointed shapes (like a funnel) are more likely to run over the dry edge when tipped.

DT: counter-attack

If, within a mark of water, the paint starts to run too far in one direction it is possible to 'push' it back by dripping in water at the edge of the pigment. The more powerful wet mark will drive the paint back without you having to blot and scrub the paper. This also applies to spattered colour or water onto wet or damp paint. This leaves a very complex but not overworked textural mark as some edges will spread, some not.

Dettifoss. This waterfall in Iceland shakes the earth and the excitement was for me to express the millisecond (photo) stillness and exactitude of splashing foam amidst the different powers of rock resistance and the raging power of water. Colours were glazed in layers on the rocks and dripped into the water to achieve a virtually monochrome painting but the central chunk of rock was wet around the foam, precisely pre-drawn, and dark colours dripped in around.

Applications

To control, balance and change colour and tone when painting, for example, fences, brambles, ferns, rigging, window frames, lace, feathers. Also where, like light through branches, a range of soft and sharp edges is required. Structurally, for fine geometry, and synaesthetically, to express different sounds, single or complex.

Family Day Out. Here, the individual figures, leaves and foreground rhododendrons were drawn and then painted DT and WD. When dry, I wet the background except a strip of light on the far bank and underpainting colour was dripped in. Then, while still wet, distant trees and reflections were painted in WW and DW. When dry, some light glazing was added to the water surface WD.

DT: NON-SPECIFIC POSITIVE

To discover your response to a subject, what it looks like in terms of rhythm and shape or to unlock how you feel about a thought or idea, physically go through the motions with brush in hand in mid-air. I usually either do this or paint directly onto the paper with water then drip in colour. The moment of first mark 'whitefright' has then passed and an engagement with the paper has begun. This method allows me to paint without fear. Sometimes I end up completely covering the paper with water but still paint into the surface knowing that I have physically tuned into my subject.

EXERCISE – PAINTING DIFFERENT TYPES OF TREES

The best way to learn about the shapes, patterning and clustering of different tree types in leaf is, while painting, to look at the tree not the paper. Doing this will give any artist the freedom to

Narcissi in France – Snowlight. The transparency of watercolour makes glazing backlit overlapping petals easy. Working in individual areas, the background around the painted flowers and fruit was painted DT using greys and darks of mixes that separate when wet. Water was dripped into the thick paint mix (window frame) around the narcissi and along the sill when it was just still wet. A question of timing.

respond to the tree at least as much as, or more than, the look of the painting. This mental freedom transfers to the arm, which, in greater comfort, will express good 'growing' marks painted with ease, not lop-sided, stifled and tight with anxiety.

Method

To prepare for this, paint with a clean, wet brush on old newspaper without looking at it – 'caressing' and 'stroking' the tree with your eyes to 'feel' the shapes and texture, varying the marks' direction, pressure and angle. Do several to become relaxed. Then, without stopping and still not looking, transfer that practice immediately to water on watercolour paper, and immediately DT colours into the wetness.

Then paint a tree directly with brushloads of paint and drip other colours into it. Then try this technique, from the beginning, with both hands and two brushes.

EXERCISE – FLIRTY BELLY (FB): POSITIVE

This wonderful mark gets its nickname from the process I originally described when teaching, as 'flirting' with the 'belly' of the brush over the top of rough paper. Again, as with SOS, I attempted a more eloquent description but the technique was already branded by my students.

Although describing this mark is not straightforward and the results can look very complicated it is, in fact, very easy to execute (compared to the SOS roll mark). It looks like DD but has the properties of small wet marks (for WW and DW potential) so is very useful for expressing random areas which have a close range complexity, speckling or texture but, with DW, can imply an overall softness (for example, leaves, blossom, surf, all of which are composites of tiny events massing together in larger rounded shapes). This mark can be freely used to suggest complexity in one process, saving the need (or temptation) to paint tiny, individual elements separately.

Additionally, compared to DD it has the greater luminosity of a slow-drying mark and can of course be painted with water using the DT method.

Swirl of Fish. An example of specific positive DT. Feeling that the change in perspective of the water movement would look too laboured if the ellipses were drawn before wetting, the water pattern was painted freehand with clear water, gradually widening to the nearer curves. Standing to paint allows this freedom. Only shining water showed this positioning of shapes until the dark blues and brackish browns were dripped in at the top of the tilted painting.

What can this approach express?

- A feel and recognition for the different characters of not just types but individual trees.
- By your instinctive prioritization of the subject you will be able to simplify thousands of leaves. More detail can always be added later.

What can you learn?

- To see the structure, shape and character of a spring tree in sunlight as a whole without getting bogged down by the myriad leaves.
- Also to describe something which distinctly describes volume but also hints at detail.

Materials

- Many different pre-prepared greens, reds and browns, very dark and light
- Paper: newspaper/newsprint and watercolour paper

Materials

- Two natural hair brushes which have a pronounced 'belly'
- Rough watercolour paper

Preparation

Prepare two brushes in advance:

Brush 1: Wet-ish light 'spring' green. Transparent Yellow or New Gamboge + a very tiny amount of Winsor Blue (Green Shade). Prepare the wet-ish brush by loading up with this light-toned pigment mixture then stroking off some wetness on the side of the palette.

Brush 2: Dry-ish dark green. Winsor Blue (Green Shade) + Winsor Red will make an indigo colour if the blue is still a little dominant. Add Transparent Yellow to make a very dark, rich green. Load Brush 2, stroke off some more paint this time for a dry-ish brush and keep it in waiting.

Note: generally, the greater the contrast in tone, the stronger the implied light.

Flirty belly: brush angle. This shows the way to hold the brush to just tickle the surface of the paper with its belly.

Method

To plan where your shadows will be placed, decide in advance where the light source is in relation to your subject. For example, if the sun is up and to the right the shadows on clumps of leaves will be down and to the left.

If a brush acts as a funnel when held tip-down like a pencil, holding the brush at a horizontal angle restrains the paint from flowing through the many hairs so that, on rough paper, a wet but broken mark can be made.

Hold Brush 1 (light green, wet-ish) at the end (not the neck) at a horizontal angle to the paper with four fingers on one side, not under, and thumb on the other. With a horizontal circling movement, lower the brush slowly, gently stroking the belly of it across the paper so that it leaves speckles of wet paint on the hilltops of the paper. Control the 'landing' of the brush by restraining its natural weight to achieve a painted area that is evenly textured. Vary the speed of the mark to achieve a more or less broken texture. Block or broken marks can be made by either staying in one area or seriously 'flirting' and moving on.

Immediately take Brush 2 and, holding the brush in the same way, FB darker colour into the shadow areas of the clumps of leaves while they are still wet. The darker colour will run a little to give a soft, rounded edge. Visually, this acts as a foil to the detailed and hard-edged small marks.

Paint a light green sward underneath and FB dark shadow into it.

Turning the dark brush vertically, to give a wetter mark, paint the branches by 'threading' them through the foliage, only sometimes visible. Use the aeroplane brush mark to distinguish the finer branches from the main trunk travelling from fine, using the tip, to broad, using the body of the brush.

Note: If the first marks have dried before the DW mark is applied, either touch them again with the wet-ish brush while still damp or speed up next time, or paint smaller areas individually.

For other applications: When you can do this, try varying the direction of the mark for different trees.

FLIRTY BELLY (FB): NEGATIVE

This mark can also be used for negative painting around textured positive marks, which may be trees, flowers, snow or rain etc. It is wiser to leave too much than too little paper dry because there is always time to drag the wet mark across the paper with the back of a nail or brush handle while the surface is wet. All the wet surface marks can be applied at this point so it is worth mentally going through the checklist before that speckled edge dries.

1. *Flirty belly*: light then dark green. Shadow areas are immediately stroked into wet paint, DW.

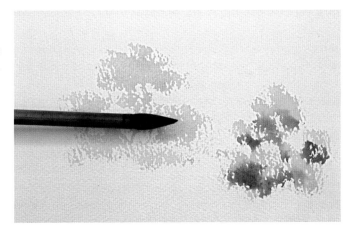

2. *Flirty belly:* branches and trunk. Extra pressure of the aeroplane mark describes a broader trunk mark.

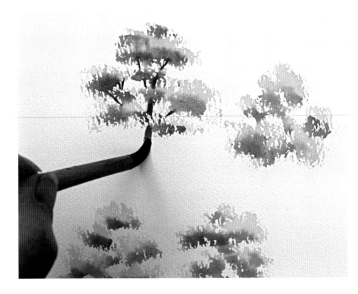

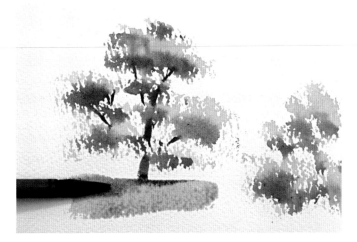

3. *Flirty belly*: shadow on sward. A light green grassy sward is painted WD with corresponding shadow painted DW.

4. *Flirty belly*: positive and negative. Right: sample FB tree positive, finished and dry. Left: negative background painted in water with FB edge. Water may be painted over very dark shapes e.g. trunk. Colour added using DT and, while still wet WW, DW and scratched marks showing trees behind.

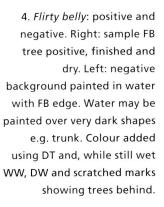

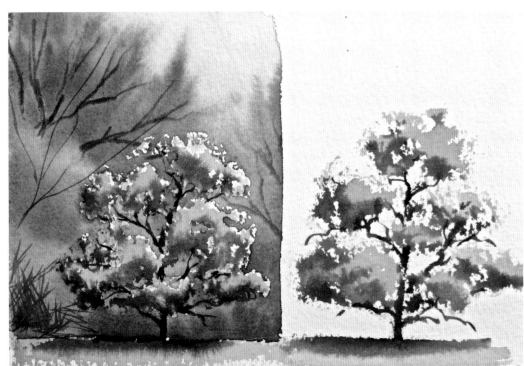

DT: NON-SPECIFIC NEGATIVE

This technique is terrific for revealing swathes of wild flowers, boats in harbour, leaves, light hillside villages, sparkling water, any subject which is fine, bright or light without finicky painting. It gives an idea or suggestion of the subject when exactitude is not a necessity. It can be used for tonal reasons, when the subject is lighter than the background, or colour reasons when, regardless of tonal values, areas share no component colours.

The subject may have been painted previously as an underpainting which will be revealed by negative marks or painted afterwards in spaces left blank.

This really does require a free approach and broad identification of the negative shapes surrounding the subject. I find that some free mid-air painting to familiarize myself with the negative darker marks between the subjects helps me to both learn in advance where I will paint with water and to relax. (Detail can be added when wet, or later, if necessary.)

Note: if the paper will be partially wet on the painting side, it

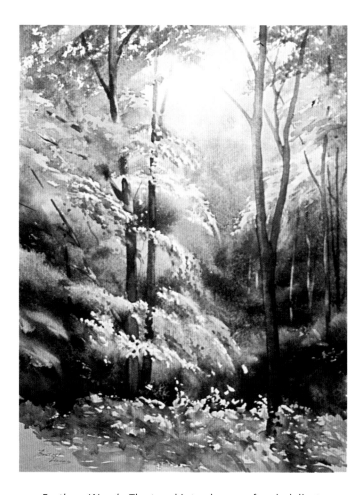

Eartham Woods. The tonal interchange of such delicate complexity was the lure and challenge for this painting, which illustrates many techniques. In order of application: FB negative wetting to leave whites, then DT, WW and DW. At the time this was the darkest DT I had dared and, very viscous, took a long time to dry but just before, the distant silver birch trunks were lifted with a damp brush. Then leaf clusters were painted FB positive and negative, and WD losing the edges with SOS edges.

'INTO WET' CHECKLIST

Use the following list to plan before 'wet' painting or to see if any more can be painted before leaving a wet painting to dry, especially if clouds or ideas are scudding by. Say it now!

All the marks that can be made on a paper surface between very wet to dry are listed below.

MARK	PAPER WETNESS
TINT	very wet
WET	into wet
LIFT OUT	from wet
DAMP	into wet
SCRATCH	any wetness
FINGERS/HANDS	any wetness
SANDPAPER (EMERY)	any wetness
SPATTER	any wetness
SALT	any wetness
NEAT PAINT	any wetness
DRY	into a satin sheen surface
COUNTER ATTACK	into wet and non-sheeny wet paint
ENFORCED OOZLES	into damp or drying

is possible to wet the entire back of the paper beforehand to compensate for cockling.

Fingers and hands

I increasingly use my hands to paint because I can, more sensitively, feel the pressure with my fingertips and, holding the back of a nail horizontally, invite a wet mark to a new area or, with the vertical sharp edge, actively scratch narrow or wide marks into a dry or wet surface. The narrow edge of the hand or the palms and knuckles all offer a range of different marks. This

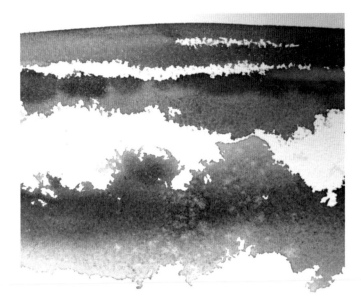

Waves, stage 1. These are standardized waves, using methods that can be adapted for painting real waves. The implied 'sun' is at top right in front of us. The negative shapes between the waves are painted one at a time, either using water and DT or directly painted WD and FB. Each wave has a DW shadow underneath. Note thinner, more transparent water at crest of wave and a little spatter when damp-dry (optional).

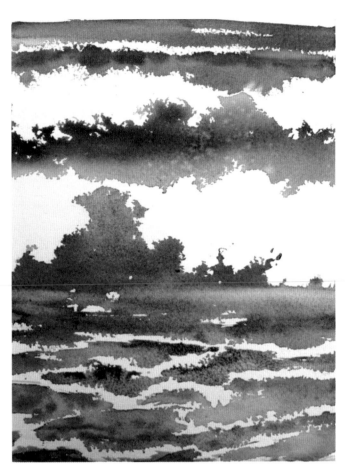

Waves, stage 2. The foreground shape incorporates the shallows with limpid foreshortened foam patterns, leaving ragged elliptical islands of sandier colour.

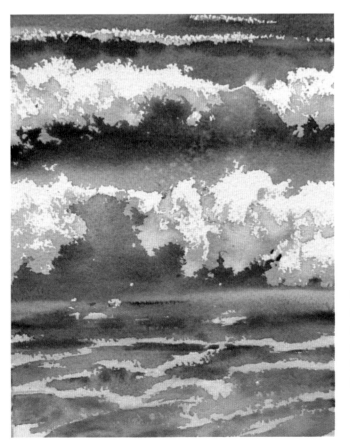

Waves, stage 3. When bone-dry, the lilac-blue shadows on the foam are painted with a mixture of Cobalt (which adds a milky quality), Permanent Rose and a little Yellow. Again the top edge of the mark is FB but the bottom edge is dispersed into the blue sea area with SOS except at the foreground where it is gently washed all over the less sparkling shallows.

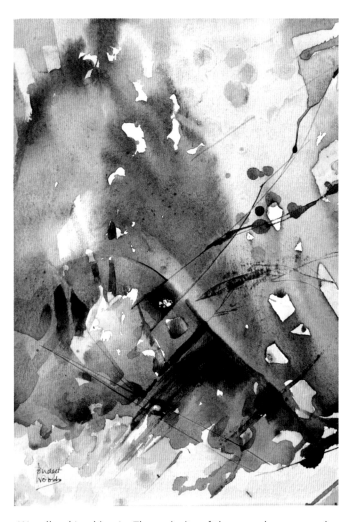

Woodland Looking In. The majority of these marks were made with fingers and nails. By contrast, some discrete shapes were filled in later with a brush.

swifter arrival at the substrate gives a fledgling idea a better chance to reach the paper intact without the intervention of tools, doubt or over-intellectualization. Allowing a more instinctive response, this physical contact with the surface offers a direct frictional sensation, more visceral than a brush, but it does require a well-sized, fairly robust paper.

THREE PAINTING PROCESSES

In general terms there are three different watercolour painting processes which, separately or in combination, contribute to every artist's signature, their response to the subject or mood in the moment.

Here, I have painted the same subject using the three different methods described, to be used as a guide for painting your subject.

Find a landscape subject that you really love: one that has enough interest to show off the special aspects of each method without being so complicated that you worry more about the accuracy than the paint.

What can you learn?

- By trying alternative methods you may further develop your own style or break through some unwanted habits. I strongly recommend that you get all three methods 'under your belt' so that you can flexibly choose how you want to express your response to any subject, condition or mood.

Method: glazing

Overlaid WD marks, from large (like an overall wash) to small, combine like layers of coloured glass to make new colours and progressively absorb light. This can take time to complete, considering the light and subtractive colour absorbency of each stage and waiting for each one to dry completely. And yet, paradoxically, a layer can be painted when you have only 5 minutes to spare. (Ready-mixed paint solutions or primaries can be left in screw-top pots.) This method allows a degree of control because it is effectively WD. Finely ground, non-flocculating and transparent staining paints are ideal to use as they will allow the previous pigments to show through. Also they will not lift as easily in the latter layers, as long as you:

- Float the paint on like a 'butterfly's wing', applying as little friction as possible.
- Hold the brush at a diagonal angle to the paper.
- Move your whole arm (not just swinging your wrist) in order to apply an even, light delivery with lack of pressure.
- Have the paper very gently angled to catch the bead along the edge of the first mark and make a smooth blending.
- Use a loaded natural hair brush.
- Work fast enough so that the wash won't dry at the top by the time you get to the bottom, which risks that the wet paint will run back and cause an oozle.

- Work slowly enough to fill in the tooth of the paper as you go.
- Do not make, then fill in, an outline or leave a drying edge for too long.
- For the same reason, work in one direction not, in this case, zigzagging back and forth.
- Soak up the excess bead at the bottom of the wash with the twiddled corner tip of a tissue, rather than blotting.
- Lay the wash flat as soon as possible.

Method: textural brushstrokes

Different textural marks, which in one stroke (premier coup) or in layers accentuate rhythm and texture, this method is expressionist and fast. A whole painting can often be completed in one wetting session, painting WW then DW into a selectively wetted surface and finished when dry with WD and DD marks. This method requires decisiveness, understanding of the wetness of the paper and fluency of handling. It is equally good for quick sketching, impulsive painting or a long, considered piece.

Method: patchwork

Here, individual shapes are painted separately WD, and the image is constructed piece by piece with gaps between to avoid bleeding, if necessary. This method can look flat and patchy and hamper spontaneous compositional decisions but for the same reasons, by bringing shapes together on one plane it counteracts the effects of recession, introducing an aspect of two-dimensional design on the picture surface. It is safe because each shape is divided from the next and there is less need to wait for successive layers to dry. Also colours can vibrantly sing alongside, without neutralizing each other by overlaying or running into each other when wet. It is also useful for dripping in any colour separately into a wet area (for example, for mixing the final colour on the paper or deciding at the last moment which colours to juxtapose). Addition of colour or water while these marks are drying gives rise to sharp edge-acutance, enhancing pragmatic description or a stylistic choice.

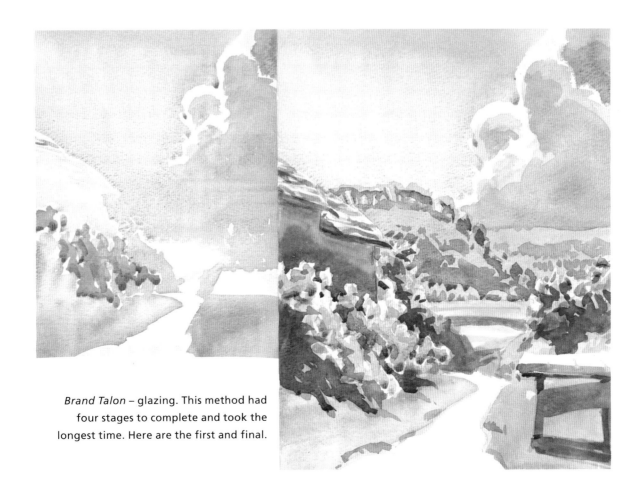

Brand Talon – glazing. This method had four stages to complete and took the longest time. Here are the first and final.

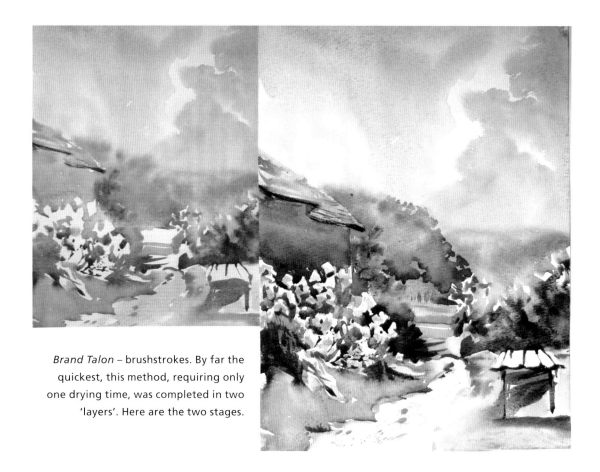

Brand Talon – brushstrokes. By far the quickest, this method, requiring only one drying time, was completed in two 'layers'. Here are the two stages.

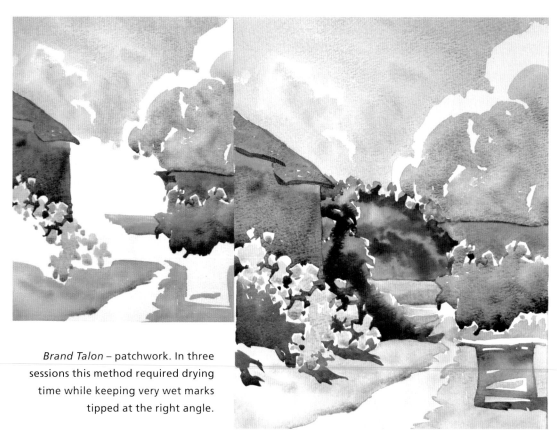

Brand Talon – patchwork. In three sessions this method required drying time while keeping very wet marks tipped at the right angle.

I experienced all the benefits and disadvantages mentioned and found that staying with one method throughout each was very challenging because I naturally tend to choose all these approaches in different circumstances. For example, distant hills and skies recede better if they are overlaid and/or painted WW and DW, whereas bright, light foreground flowers will stand out with a piecemeal approach.

Regardless of visual preference, what was striking was the variation of stages and time for each method. Glazing took the longest, then patchwork but the fastest of all by far was the two-stage (both illustrated) brushstrokes, which was almost premier coup with only one wetting session.

EXERCISE – 'AQUA-POINTILLISM'

This is a marvellous method to use when you want to paint but not to plan, draw or galvanize to the dynamics of quick-drying WW and DW techniques. It is especially good for hot conditions, understanding colour or short bursts of studio work. Because it is possible to start and stop at leisure, it provides an opportunity for legitimate dabbing, spattering or spraying and allows the artist to paint and simultaneously enjoy a refreshing drink, even conversation. Drying edges will not cause muddy painting and, if you are given to dabbing (and who cannot claim to have this technique in their repertoire?) this process is all about making small marks and actively encourages a 'dabfest'. The principle is one of optical mixing: the distance between marks and unmarked white paper and the preponderance and ratio of colours will affect the colour and tone information seen by the eyes which is then 'mixed' by the brain to make an average reading.

What can you learn?

- To relax while painting watercolour. This process really helps tonal and colour observation in a gentle way because there is time for reflection. If necessary, erroneous blobs can be blotted while wet or more dabs added later, for example, to 'find the form' or the exact colour of a shadow within the subject.
- Seeing and naming: making monochromatic images using this method greatly improves tonal awareness because it requires identifying variations regardless of the distractions of colour and hits the spot between the experiences of vision and interpretation or 'naming'. For example, a 'dark red' cloth in sunlight and 'white paint' or 'pale blue daisies' in shadow may share the

same tone. Any brain can be a little abashed at first but with experience, find this factor exciting.

Materials

- Mixed puddles of the three primary colours, equally balanced in saturation. (That is, if each colour were glazed over each other, a neutral grey would result. To create a longer painting with a more refined build-up of tone and subtle colour, make the puddles more dilute.
- Note that yellow can look deceptively pale regarding saturation (strength) because it absorbs less light. Less chalky Transparent Yellow is recommended. Also, PB17 blue is very strong.
- Brushes designated for each colour.
- Hairdryer, if conditions are cool.

Method

First, dab blue marks in every place that contains that colour (including browns, greys, even neutral reds, yellows and oranges), leaving greater or smaller spaces according to the proportion of blue. Then do the same with yellow and then red. Repeat the process till the desired tone and colour is achieved. If the mark is still wet when another is put onto it then the combined colour will 'speak'; if the mark is already dry the two colours will overlay as glazes to make a third colour. Either way, the colour will look lively and any mistakes will be small, local events.

There are specific qualities to this method, as discussed below.

Visual

If, for example, blue marks have been made, random yellow dabs painted nearby may achieve green in several ways:

- By optical fusion, if the marks are separate.
- By glazing, if they overlap with some unregistered edges showing blue, yellow and white.
- By pigment fusion WW if the previous marks are not dry, combining to give a range of greens. The overall message will still be green but the effect is far more sparkling than a flat mixed wash. Optically intrigued,

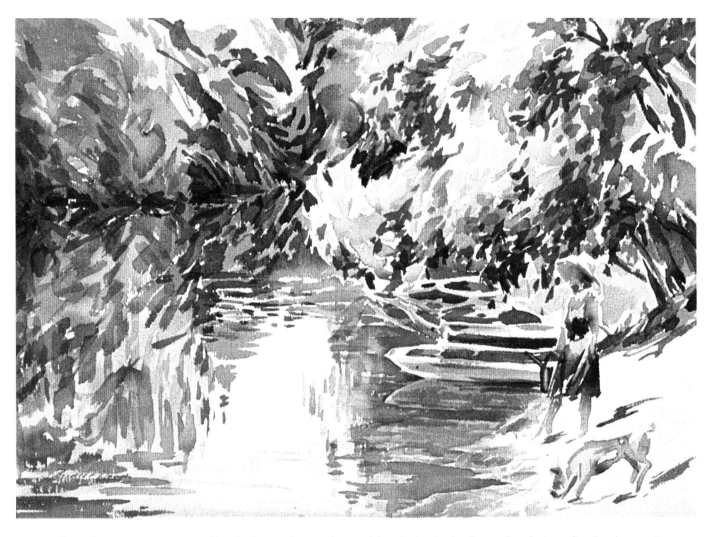

Hot Afternoon – River Dronne. Teaching in the Dordogne, I began this painting in the drowsy break time after lunch. Wanting to paint the complicated trees and their reflections, I developed this pointillistic method. First it helped to underpaint rather than using WW and DW (too hot) because there were few underlying links in the jumpy arrangement of shapes and sparkling tones. I began dabbing and wandering around the painting, tentatively seeking out the shapes in dots; starting with a few dabs of blue, then yellow, green, purple, then red and repeating to build up tone and achieve accurate colours. The woman arrived with watering can, secateurs and boxer dog, standing still for long enough for me to paint them in before returning to the riverscape; from a shady spot, in my own time and unstressed.

the brain is stimulated to make sense of the combined marks which hints of form, therefore, good for painting hot, sparkling, hazy days or chattering or murmuring ideas.

Practical

With only three primary colour puddles it is possible to build an impression of the subject.

Relaxing

It is possible to start anywhere with this pointillist approach and 'find' the subject without drawing first. Though exact precision is not a requirement of this method, smaller dots can describe precision if desired. A dotted edge is not a commitment and a seriously misplaced dab can be easily blotted while still wet.

Expressive

Changing the shape and size of mark, like dashes or commas, can convey variation of subject weight, direction, energy and personal style.

Disadvantages

This method can take time in cooler conditions.

EXERCISE – WIDEST RANGE OF MARKS: VISUAL

I like to feel that I have a wide vocabulary of marks at my disposal for the spontaneous expression of concepts, as well as objective visual reality. These might be mood, weight, tension and rhythm or an idea, music or my own feelings, emotional or physical.

What can you learn?

- This preparation helps all the senses – not just visual – to prioritize in the moment of painting.
- This practice will increase your enjoyment of watercolour and nourish an expressive use of marks in figurative painting.

Materials

- Large full sheets of paper
- Plenty of paint (old, unused tubes)
- Any mark-making tools
- Big sturdy brush(es) firmly attached to a long stick
- A bucket for water

Preparation

Gather everything beforehand. Although this is a non-representative play exercise, plan to put this liberated approach immediately into practice afterwards. To avoid too much conscious thinking while exploring and delay in choosing, put several varied images (real or photographic) to one side in advance for the moment when you are primed and ready.

Choose three colours that you use frequently, for example, one primary, one secondary (anywhere between two primaries) and one tertiary. (Later, choose three that you would never normally put together.) Mix plenty of strong, just short of syrupy, solution. If you need a lighter version you can take from this source to dilute elsewhere. Have the stick-brush ready to allow you a more distant view when the paper is on the floor.

Method

The aim here is to make the widest range of marks imaginable by covering a sheet of paper with different marks ranging from soft, shining and blurred to wrinkly, spotty, rough and jagged marks, putting colour onto both wet and dry paper, using any tools, including fingers and nails.

Remember also to paint areas where the mark may be the negative surrounding ground to a shape. For experimental freedom, make marks that are not overtly representational. The brain loves to make sense of marks so, to avoid being caught up in figurative development, frequently turn the paper or walk around it. Make a design which pleases your eye but above all, of the Big Five, play with texture!

Make several sheets like this and then without stopping take two images and place them upside down. Using them only as a jumping off point for shape and tone, start working from them simultaneously as two paintings, keeping the marks expressive.

Understanding the containment and flow of water is crucial and can only be achieved by risk, observation and experience. Practise these playful methods under the time constraints of a sunrise, sunset, stormy weather, waves or galvanizing presence of a model to learn about the behaviour of pigment and water and unlock a more direct, instinctive response. There is no time for 'white fright' or wrestling with the self-conscious notions of doubt, perfection and outcome.

EXERCISE – AN EXPRESSIONIST RESPONSE: AURAL, PHYSICAL, MOOD OR SUBJECT-LED

This process develops a freedom of painting by going beyond the purely visual towards expressing other senses. This synaesthetic approach flexes the links between the senses to make painting a richer, fuller experience while developing a multisensory enjoyment of the process. Instinctively choosing from any of the mark-making techniques you will be able to express sensations like sound and touch and the essence of feelings and ideas in ways that words alone cannot.

Instinctively choose any of the preceding techniques in this book or invent new ones to express the rhythm, sounds, flavour and feel of life and nature.

PROCESS AND OUTCOME

When I first started painting in watercolour, I focused on the visual quality of the outcome, asking, 'How can I make beautiful marks which will look like that?' Now I simply revel in the process, asking, 'How can I express my response to, or the feeling of, that subject or idea right now?'

My self-teaching process has not radically changed, however, and still involves cycles of reflection and controlled study followed by bursts of spontaneous painting. My aim is to be primed with skills that I can 'forget' in the moment, enabling me to respond with an open mind.

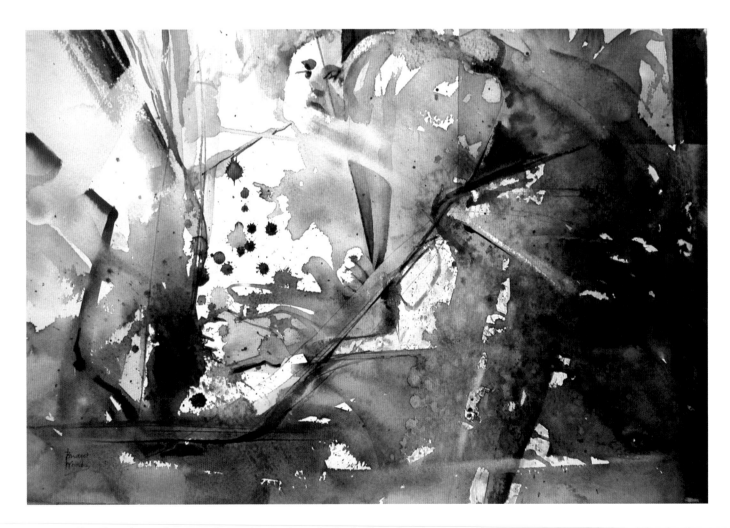

Neon City. The edgy excitement of experimentation raised a feeling of contrasts: interior, exterior light and dark and the visual debate of surface and distance, which helped to maintain a sense of freedom on the paper. Towards the end I felt drawn to the memory of rainy nights in a big city. Much of this was painted with the paper on the floor and using a brush on a stick. Final tiny marks were added at close range.

Materials

- Use scrap paper, the backs of old paintings and different paper textures to limber up.
- Pre-mix strong paint puddles to be ready to act.
- Remember to include your fingers, nails and both hands.

Method

Using any brush stroke, enjoy the physical feeling of making marks that express your response to the rhythm and sounds of your life and surroundings.

Aural response (sound)

Regular sounds – ticking watch/breathing/waves
Irregular sounds – traffic/rain/wind/barking
Physical vibration of music – that you like/don't like

Now paint a subject, either real or imagined, which has an aural quality, like 'paddling', 'trains', 'woodland', focusing on its sound for your choice of marks. Then paint a landscape to a piece of music and then, just paint music.

EXERCISE – PHYSICAL RESPONSE

Now use any of the marks to describe different physical sensations. Temperature (hot, cold); texture (hard, soft, gritty, smooth, furry); liquid (dry, damp, splashy, still).

EXERCISE – SUBJECT/RANDOM/ MOOD-LED

Then paint a subject in a way that feels interesting to you sensorily. The process may be:

- Subject-led (e.g. mountain-climbing, riverside picnic, trees in wind etc.).
- Random choice with no planned outcome (i.e. self-expression in the moment).
- Mood-led. Take a word at random from the dictionary and see where the associations take you.

TIPS

- If necessary, use The Big Five checklist (e.g. what colour? what tone? etc.).

- Avoid visual colour assumptions by using basic six colours for mixing.

- Be ready to act. Always have scrap watercolour paper to hand.

- Remember to include fingers, nails, and both hands in your 'toolbox'.

- See your 'inner screen' more clearly by closing your eyes when you listen, feel, smell, imagine.

- Don't worry if your mark either looks like/does not look like the source of the sensation.

An aural response. Response in paint to: ticking watch, car passing on a rainy road, small dog and large dog barking at each other, automatic kettle coming to the boil (twice).
Which is which?

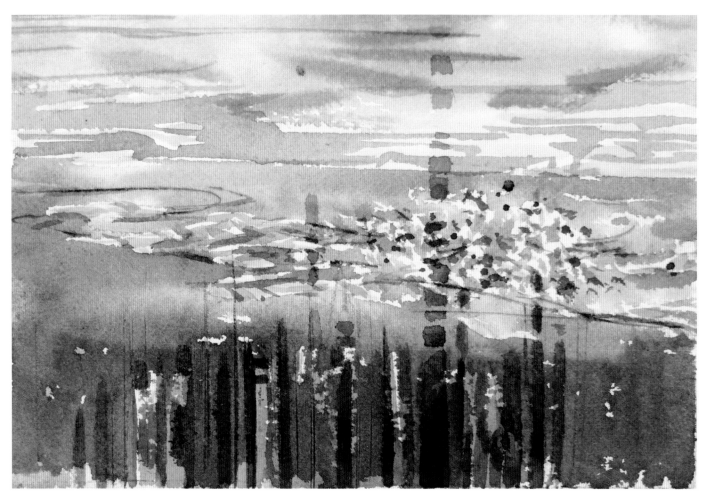

Paint the Music – Shostakovich Piano Concerto No. 2: Andante. As I was making the previous sketches, this music began to play on the radio and took me to another pace and place to paint, showing me again that attention and engagement bring connection.

Dawn Chorus. A glorious summer sound, here featuring finches, sparrows, two rooks, a gull and a wood pigeon.

AN EMPTY STAGE

In a teaching situation I had a student who felt that it was not possible to paint the music. Later, when we were all admiring the successfully communicative and expressive qualities of this person's paintings the reply was, 'Oh, that doesn't mean anything! I just painted the first thing that came into my head.' What a lucky person. With less than no expectations and unsaddled by years of developed technique, this student was possibly more able to respond directly to the music than a professional.

- Write a list of mood words, separate them and without looking, chose one to express in paint, e.g. mysterious, lively, etc.

The advantage of developing this approach is that the artist can truly let go, responding to any subject, thought or dream with no concern for visual likeness or external criteria. As visualization, it is an exercise that can be done anywhere. The only challenge is that it offers a whole new world of subjects to choose from!

Logic will get you from A to Z; imagination
will get you everywhere.
Albert Einstein

TEXTURAL ELEMENTS OF LANDSCAPE/NATURE

Our perception of the elements of landscape is strongly affected by our cultural links and circumstances. The eyes of the person for whom the key to survival is the relationship between the land and the weather cannot have the same interpretation as the eyes of a city dweller on holiday, who rarely sees the countryside.

Yet we are all the descendants of those tribes who, driven by extreme heat or cold, frequently moved on over thousands of years to find food, water and shelter from the land. Shining, sharp, precious and forged metals and minerals have enabled hunting, tribal survival and cooperative exchange. But however sophisticated some societies may become, there remains an innate sense that our personal survival lies in the hands of climate and weather; the effects of the sun and other planets on our own planet, Earth.

We lucky survivors are sensitive, often subconsciously, to the relationship between sky, earth and water and many religions affiliate metaphorically or literally with the elements of nature to a greater or lesser degree, using symbols or personages to represent them. So for the artist it is crucial to consider the textural aspects of these elements when painting because a landscape can convey a message of conditions that strikes us all, touching our primal senses, telling us to react or allowing us to relax.

Word associations

Please add your own.

Sky = home of light source, heaven, spirit, soft, airy, transparent, blues, purples, whites, grey, black, infinity

Earth-based = hard, stability, gravity, safety, fear, solid, sharp-edged, rough, reliable, structure, browns, greens

Below earth = molten volcanic reds, emotions, physical desires, unexperienced mystery

Water = fluid, the most chameleon element can be no colour or visually reflect of all the above with its

A physical response in paint to hot, hard and bitter cold.

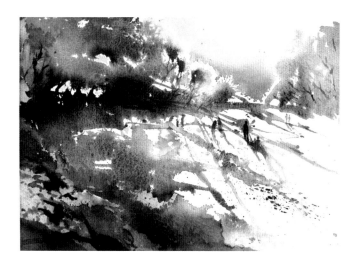

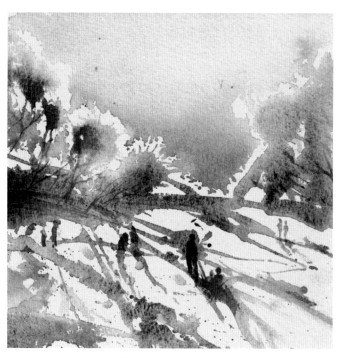

Tobogganing. I wanted to express the exhilaration that combined contrasting physical sensations: cold snow and the physical warmth of exercise in warm company. For the external sensation of cold, crunchy texture I dragged a clean wet brush across rough paper with uneven and bumpy movements, then added fast diagonal strokes for the excitement of speed. Remembering flying snowballs, I threw on more water with my fingers and then dripped rich colour into these water marks. Ultramarine quickly flocculated to give an underlying texture but the other colours in these wet marks slowly separated, floating outwards to create the crisp edges of snow-laden trees lit by a low winter sun. By keeping the paper slightly tipped, the marks stayed luminous at the top. Finally, I gently glazed the foreground with a cool blue-green shadow.

Tobogganing (detail 2). For a feeling of internal warmth I wet the sky area, leaving a halo around the trees and dripped in an orange glow.

Autumn Wind (response to mood). I was wandering down a local lane one day in late summer and with a light breeze came the first whiff of autumn. I wanted to express that exquisite awareness, soon taken for granted, when we first notice a change of season. To express the underlying warmth and gentleness of a waning summer, I completely wet the paper and dripped in a tint of gentle blues and stroked in soft, warm apricot and cool magenta violets DW, using first a brush and then my fingertips, As the paper dried I blotted one curve of white sunlight and spattered clean water into a satin surface for the hedgerow of dry seedheads. For the sound of wind through brittle leaves, I put the painting on the ground, took a large raggy Chinese brush filled with clean water, and onto the bone-dry rough paper, made fast, vigorous, erratic but barely visible marks with a brush on a stick. Then a range of neutral greens was dripped into these marks of water and the shapes developed with my hands, fingers, knuckles and nails to describe dry foliage in a breeze. There was no transitional stage between the soft and hard layers because I wanted the painting itself to express that bittersweet jolt of season change.

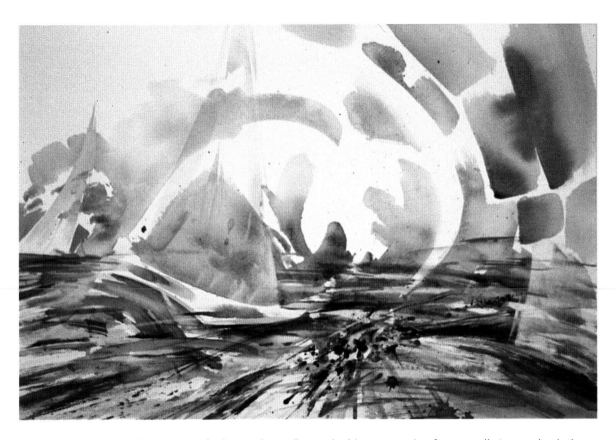

Sun, Wind and Water (response to feeling and mood). I made this on returning from a walk. I started painting with no intention other than to simply respond in paint to an exhilarating atmosphere and upbeat mood rather than any representational facts and it was named in hindsight.

Moonflight (response to subject-led dream). A tree-covered road triggered this semi-waking dream of flying with birds at night.

The Downs from Duncton. Vapour hangs in the air and low clouds drift over the rough surface of the winter hills. Dark, dry, organic matter survives.

A Rough Sea – Ladies Skerrs. A wild wind blows against an incoming tide to create an exhilarating extravaganza of diagonals and counter-curves. The extremes of water, sky and rock textures are exaggerated by their tonal contrasts of light, medium and dark.

reflective mirror-like powers, mutable, horizontal, vertical, diagonal, still, busy, patterned, shining, foaming, can be physically non-resistant or resistant to touch, invisible, visible as vapour, wet, and hard as ice

EXERCISE – THE RELATIVE SENSATION OF EARTH, SKY AND WATER

With these thoughts in mind, use your range of marks to express the physical differences between the elements of sky, land and water. If you live in the city find a nearby park and if you can't get outside, use a photo and your imagination or memory. Another alternative is to construct a texturally wild and surreal still life 'tablescape', using (for example) crumpled paper, soft, fluffy, shiny, wet, sharp, rough objects. Touch and feel with eyes closed.

Pattern – symmetry/asymmetry

The rhythmic quality of repeating visual patterns can feel equally comforting and reassuring or irritating and relentless in different moments. Within the body, walking, breathing, blinking, heartbeats, hairs and pores all have a more or less regular pattern. Externally, nature displays leaves, waves, soil, crop patterns. Finding linking patterns can also give visual pleasure – similar shapes that may be of widely differing size, colour, tone and texture yet which may be there, like birds, for a fleeting moment or part of a larger permanent integration that is not accidental.

An asymmetric and random scattering of shapes may give a sense of mess, chaos or untidiness to one person yet feel relaxed and natural to another. The process of organic growth and change contains cyclical order and disorder within the differing time and lifespans of human consciousness alone. Our individual perception responds keenly to this paradox where, as regularity and habit-breaking can calm or unsettle, a visual mesh and pattern may represent protection or trap.

Comment? Here, I was fascinated to spot the pattern of the carved interlinking circles of the ogees on the church repeated in the bicycle spokes and the shadow cast on the jeans of one man by the other; all unwittingly linked together for a moment by a hanging garland while a subject of hot debate raged on in the French noonday sun.

EXERCISE – SPEED AND MOVEMENT

This exercise is about creating or expressing a sense of speed. Watch sports, people talking, walking, animals, trees in the wind, waves etc. First focus on the subject as though you are following and holding it with your gaze then fixing the back-

ground as static with the subject moving past it.

Consider how, with the full range of brushstrokes, these events could be conveyed or expressed. Would you blur the background or subject? Depending on your mood or objective or subjective focus, the choice is yours.

An exciting exercise is to paint a moving subject in both ways by choosing brushstrokes and marks that indicate the states of movement and stasis.

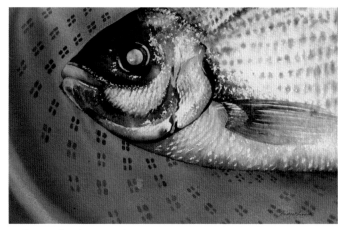

Fish in Colander. Regular patterns, bent by 3D form, are given a fish-eye perspective. I enjoyed experimenting with brushstrokes to represent the sensation of dry plastic, shining wet scales and a glaucous eye of several blues. Organic and manmade order caught in time.

Yellow and Black. Wanting to optically revolve movement round the black dog, I retained a (carefully drawn) space for dogs and fallen branch before selectively wetting the whole of the background, scudding over foamy patches with FB. Using DT, the paper was held at different angles for colours to follow the same slalom course around the unpainted branch. With structure established, darker colours were added WD and SOS before the final DT darks of dog and branch: visually static but diagonally linked amidst contrasting action.

Merry-Go-Round. A variety of soft and clear-edged brushstrokes are used to express different speeds and distance. This painting was made from a photo and I chose to focus on the turning (but fixed) central mirror column and the meeting place between 'startled' house and (though turning) visibly constant edge of the merry-go-round.

CONCLUSION: THE UNIQUE AND UNFORGEABLE MARK

With the Industrial Revolution, great store was set by artefacts that could be replicated; a mindset that lasted for a long time. Now with technology to speed the process of identical product-making, the value of the individual mark is at a premium. Many more people are considering a return to individuality and craftsmanship but this time, by choice. Rather than making a product for a patron or for a purpose, commissioned by others, many people can now create in order to please themselves. Where the paradigm of the craftsman in the past may have been, 'Can it be repeated?' now we celebrate the unique mark and ask, 'Can it be forged?' There is no medium like transparent watercolour for honestly and patently expressing the individual. I am excited to know that digital photography and computer-assisted painting gives everyone the chance to enjoy and create images but though a finger on a touchpad may be a direct contact, for me, no sensation can match the feel of making an original mark in paint: 'picking something up and sticking it onto something else...'.

We are all unique, just like everyone else.

RESULT!

Tutor at beginning of course: 'What would you like to achieve this term?'
Student: 'To be able to paint like you.'
Tutor at the end of term: 'What do you feel you've achieved during this term?'
Student: 'I don't want to paint like you any more. I want to paint like me.'

Daybreak. Thin, gently overlapping washes in Opera Rose, Quinacridone Gold and a mixed green suggest a happy midsummer dawn. My intention was to play languidly between disparate notions: differing horizons (I walked around the paper between layers), rising heat and light on a slowly turning world, the simple visual, tactile pleasures of watercolour and its paradoxical ability to 'create' light by gradually absorbing it. White here allows each colour a small area of personal identity.

Clarity. Individual and unforgeable.

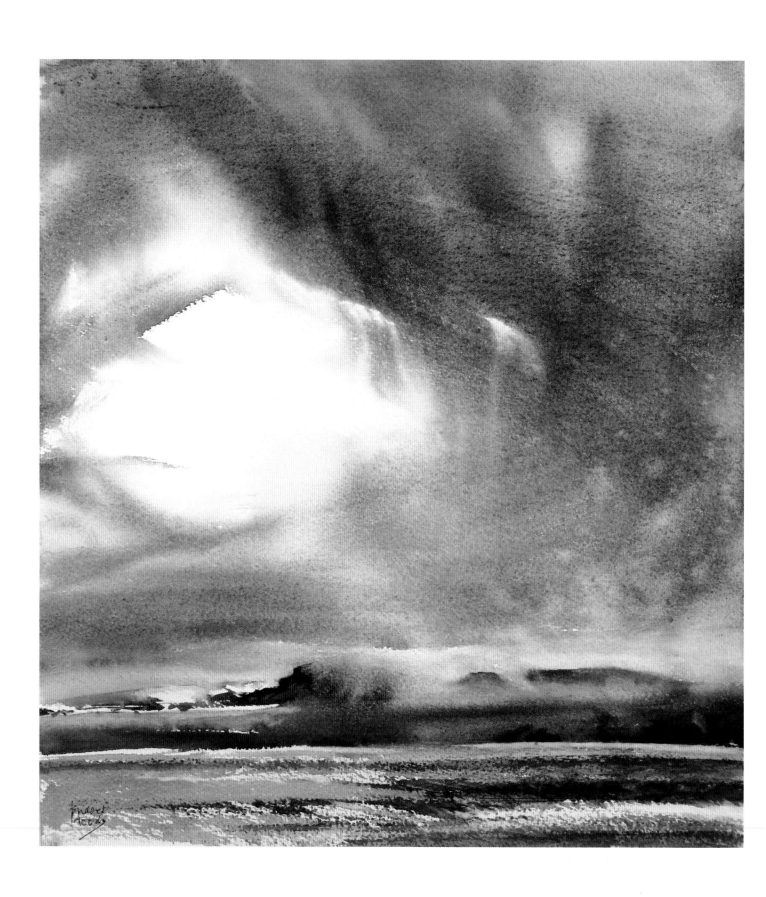

TONE

A primal response

IN THE BEGINNING WAS THE LIGHT

Light is so crucial to the survival of the human animal that our response to its messages have developed an eye-to-brain viewing system that is sophisticated and fast. Programmed to keenly monitor our world for many reasons – necessary nourishment, fresh water, the seasonal cycles of plant growth and fruiting, hunting conditions, reproductive bonding opportunities, personal and tribal threats – our visual processing and interpretation has become very efficient.

Natural light occurs and reoccurs so reliably with the turning of the earth in relation to the sun and moon that it is easy for us to take this daily phenomenon for granted, especially since the advent of electric light. Yet the option of 24-hour lighting, offered by this discovery, is nevertheless relatively recent in the history of human evolution and habitually, most humans still choose to work by day and sleep by night, even in polar regions where daylight hours are extreme.

Visual recognition is a two-part process, which begins with the gathering of information by the eye. The interpretation by the brain to find meaning is virtually immediate. So fast, subtle and deeply embedded, in fact, that we are not always conscious of the original visual information.

Until we paint.

In painting terms, tone refers to the amount of light emitted or reflected. Any object or area looks lighter or darker to the eye because of these main factors:

- The light source(s), its direction(s) and intensity.
- The planes of a surface in relation to the light.
- The light-absorbing or reflecting pigmentation and texture of an object.
- Where the observer is in relation to all these.

The relevance of tone to the artist

Without light we cannot see colour and detail, yet, in importance, tone is often bypassed, even by artists, in favour of colour. While bright attracting colour offers cone stimulation like a sweet full of instant energy, it is tone which acts first as a pointer, driving us around our visible world and then offering the subtler substance and atmosphere of an image, like the protein and vegetables of a meal.

It is worth considering how much information tone and colour can individually convey. Imagine seeing the world or a colour photo presented only in monochrome, ranging from white to black and then the same image with its different

LEFT: *Dynamic Sky – Iceland.* This painting, looking across Elliðavatn, just outside Reykjavik, was intended to demonstrate courage, freedom and speed of painting when the elements will not wait. The last few, darkest land marks were made just as a little rain speckled the painting before I turned it face downwards to protect it. Most of the painting was made within 45 minutes (including 10 minutes to selectively soak the paper and make the sketch). Through tone and texture, I relish the manifestation of water in its many chameleon guises. It appears here as vapour, rain (visually distant then physically present), lake, glacial ice and deliverer of colour to paper.

Demonstration: paper surface. This photo shows the quick preparatory charcoal sketch, one clip used to fix the painting, getting down to see the shine, selectively wetting the paper using a large brush point, sceptical students and reflected weather conditions behind.

Demonstration: dripping in. A small gasp as a very dark, syrupy colour mix is dripped in and, to enable handheld contact with the painting, no clips.

Demonstration: nearly finished painting. Colour sampling on the previously cut off strip, painting nearly finished, patient onlookers, slightly tipped board causing colour to run vertically, slightly dilute and describe falling rain, plus the effects of real raindrops.

colours but no variation of tone. The first idea is possible (after all, we were well-informed by black and white newspapers and television for years and colour blind people have successfully survived) but the notion of colour with no tonal variation is difficult to imagine.

Stimulated by light, retinal rods at the back of the eyeball feed the brain a wealth of information about tonal variation to decipher. Not just about the edges and form of shapes but also, using our ability to compare and remember, much about the time of day, year, weather and climate. This is key to both the evocation and description of mood and atmosphere.

Developed tonal awareness, a skill that never leaves, brings an additional facet to life which, like food, continually enriches it. An artist may be conscious of the tonal qualities of their subject and choose to prioritize other members of the Big Five. However, if the painter is aiming to express 'atmosphere' without tonal observation, the onus will weigh heavily upon those other factors.

I believe that light response is the most powerful visual skill we have to describe the external conditions of our world and, therefore, the one which most influences our animal reaction to them.

In West Dean Gardens: the original photo showing authentic colour and tone.

The same photo in greyscale.

The same photo with as little as possible tonal variation.

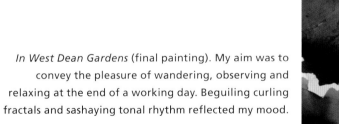

In West Dean Gardens (final painting). My aim was to convey the pleasure of wandering, observing and relaxing at the end of a working day. Beguiling curling fractals and sashaying tonal rhythm reflected my mood.

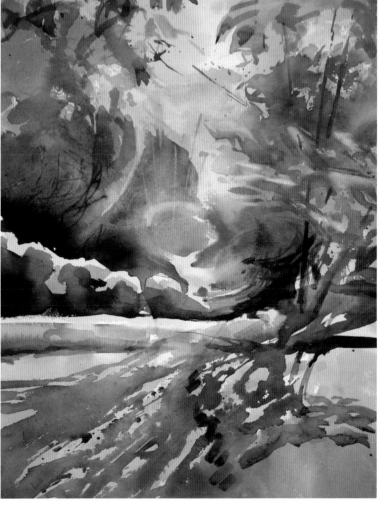

This is a subjective non-argument because the human eye has developed refined sensitivity to both tone and colour. But with age it is colour (mainly central retina) vision which in general, is the first of the two to deteriorate. This causes, as does colour blindness, a greater reliance on tonal (mainly peripheral retina) awareness and could indicate its hierarchical importance for survival.

Tonal contrasts and passages

Compositionally, it is also important to know that it is our peripheral vision that leads our eye around not only the external world but also a painting. So, a contrast of light and dark is literally eye-catching. We glimpse it at the edge of our vision and our eyes jerk towards it, making a saccadic movement, to better focus our central, more colour-aware, gaze upon it. Meanwhile, tonal passages, in an image or environment where the change of tone is less contrasting, allow the eye to drift around. Unless our eyes are unfocused or we are drugged, vision naturally jumps from edge to edge, beckoned mostly by peripheral, tonal messages. Check this now by looking around you to observe the staccato eye movement and what catches your attention. It is possible to consciously drive attention around a painting in the same way with tonal contrasts of excitement and wandering passages of quiet.

The factor of light is so important for the description of weather, form and mood that the exercises in this chapter have been designed to integrate a sensitive response to tone into the artist's visual awareness. (Also to settle the watercolourist's fear of 'white-fright' or paper-darkening.) By developing a greater tonal awareness of our surroundings, where dark is often the background for lighter subjects, watercolourists will be enabled to confidently let go of methods that involve 'draw-around-things', 'fill-in-the-shape', 'paint-round-the-thing' and white-paper-reserving gizmos.

This technical fearlessness to paint your world in any tonal shapes, both positive and negative, allows the freedom to move on from painting like others towards genuine self-expression.

TOENAIL SKETCH – THE SMALL SKETCH GIVING TONAL INFORMATION

The importance of light for survival is fundamental. Imagine any hostile or uncertain environment (for example, a jungle, unfamiliar city or interview). The response of the human eye to light is so primal and immediate that our reading of the relative tonal values which describe form (including facial expression), light direction, weather and mood are often leapfrogged, as we scrabble to find detail, colour, objects and 'action'. We take this light-reading skill for granted yet without light, there would be no visible story.

So, for painting, it is useful to gently rewind the looking mechanism and ask our eyes, 'What am I seeing?' before the brain eagerly rushes to identify ('I know what it is!') and sidelining tone, instructs the hand to create a painting, devoid of atmosphere, form or tonal structure but full of different-coloured objects.

How useful is a line drawing for painting reference?

A thumbnail line sketch, which is a translation of the Big Five reduced to line, though speedy for recording shape and scale, is not much help as reference for a painting of tone and colour, unless there is a plan to paint a black line around compositional elements. Line is an abstract concept which (apart from thin shapes and shadows) does not visually exist and, though widely used as an artificial edge-descriptor or separator, it is far removed from visual likeness. So, even if an artist has a phenomenal memory for tone and colour, a line-only drawing can be more hindrance than help because, as a painting reference, it will need to be re-translated back into tone and colour before painting. While a line is useful for broadly placing edges and shapes, it can also over-focus attention on the edges of an object rather than its body, volume and the shapes between the objects.

As humans, we subliminally scan the scene for specifics: food, prey, friend or foe. As landscape artists, we learn to notice and describe the weather and both the things and the scene around and between them.

SHADOWS
At the outset, it can be a challenge to the watercolour artist to see shadows as the conveyors of mood but as they describe depletion or lack of light they also, by contrast, describe the light.

The quality and shape of a shadow can immediately describe the time of day, weather and climate and separately, but very importantly, frequently has more compositional dynamism than the object, however subjectively meaningful, that causes it.

EXERCISE – THE TOENAIL SKETCH

Though bright colour may shout for central attention, it is tonal interest that most attracts the eye peripherally and gives an image expression and mood.

With a toenail sketch, of the Big Five, you can quickly record tone, shape, texture and size. By acquiring the tonal information that describes not just 'things' but mood and atmosphere, the artist can plan the structure that underpins subjectively 'right' composition and personal 'message' before painting.

What can you learn?

The toenail sketch is an excellent basic practice and useful for:

- Simplification of a complex subject or idea.
- Sketching, gathering information: tone, shape, texture and size – indeed, everything but the colour.
- Painting reference in the absence of paints or time.
- Usefully taking the artist through a 'practice run' for painting, mimicking a glazing build-up by progressively darkening the paper.
- Identifying whites and lights, thus developing the skill to know where to leave relevant spaces if necessary and understanding the rhythm of the darks, even before painting.
- Identification of broad compositional structure of your original choice.
- Feeling of freedom to easily improve and change an image by extending and exploring the options of format change.
- Quickly developing bold tonal design and compositional skills by arranging shapes and tonal blocks not just for describing 'things' but for their potential to create pictorial interest or assist expression.

Tip: if you have never made a toenail sketch before, take time to do it properly and you will soon find that it can be done very quickly. The methodical process has a neat controllability that quickly comes to feel therapeutic and before paint meets white paper, it can be very galvanizing to have a dynamic plan in the pocket. The eye starts to attune automatically to the tonal structure of any subject choice and like many good practices, it has an almost inbuilt obsolescence as the skill to accurately read tone becomes instinctive in the moment of direct painting.

Materials

- Mechanical pencil, preferably with 2B lead, or softer wood case pencil
- Sketchbook, smooth surface
- Plastic eraser

Method

Choose a subject with your portable finger frame. There is no need to carry frame-finders which can be formulaic in both shape and height/width ratio. Hold the index finger and thumb of one hand apart, but held parallel, and add the index finger of the other hand, behind them to make the fourth frame edge. Now, close one eye and, looking through your finger-frame, vary your image by turning it from vertical to horizontal and moving it in and out from your eye. Change the format of the image from square to panoramic or circular to find the image that appeals to you.

Then look at the frame and note the limits of your chosen image and its frame ratio, height to width, e.g. 1:2. Using a fine, soft pencil, draw the frame first in the correct ratio, very small in the middle of the paper.

'Break' the whole image into two or three major shapes, asking, for example, 'Is the horizon more or less than halfway between top and bottom?' Mark these divisions carefully and quite strongly with a drawn line. Subdivide these shapes into smaller shapes with clear lines.

Draw a key column on the very edge of the paper. Lightly this time, mark off four boxes only. The top box (1) will be white. (The fourth box will eventually be black.) Diagonally hatch over boxes (2), (3) and (4) with your assessment of the second tonal step towards black. Then, in the other direction, hatch in (3) and (4) for the third step towards black and finally hatch horizontally so that the fourth box is a completely dense black.

Stand back and look through half-closed eyes. Is there an uneven jump in tone? Adjust, if necessary with more drawing and an eraser. Take your time: most people, timid to overdarken, make (2) too light to progress evenly to black. Correcting and understanding this can embolden the watercolour painter to approach underpainting with courage.

Each tone of the key will represent the following:

White will represent all the tones you see which are 0–25% tone
One layer of hatching, 25–50%
Two layers of hatching, 50–75%
Three layers (black), 75–100%
Now, referring to your tonal key, construct the drawing in the

Cottage and Mountains – toenail sketch. Overlaid hatched 4-tone key and simple line drawing in middle of paper.

First layer of hatching covering key tones 2, 3 and 4 (25–100%).

Second layer of hatching covering key tones 3 and 4 (50–100%).

Third layer of hatching covering key tone 4 (75–100%).

Trial addition of landscape to the left.

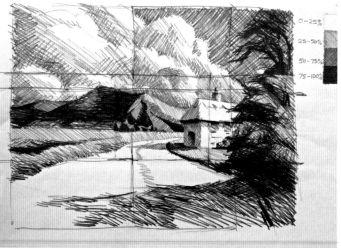

Cottage and Mountains. After several additions to the original, this process has explored the different moods and messages of each 'reading'.

same way. Hatch tone (2) over everything that is not 0–25% tone towards black. Then tone (3) over everything that is not (1) or (2) and finally, describe the darkest tones as black (not grey).

If the intensity of the light on your paper is the same as the light on the subject you can hold up the key against the edge of the real image to find the correct tone by seeing where the edge of the key appears to be 'lost' next to the subject. There may be some hard decisions to make. (Remember that if a tone is 24% dark it will be described as white and 76% dark described as black). As happens in reality, there will be edges that are not tonally visible in your drawing. Do not hesitate to let one shape of tone occupy more than one adjacent 'thing' if the tonal grouping deems it. Shadow has no compunction about sliding over people, houses and trees, for example, without stopping to announce an edge, often swallowing them equally into one collective tone. It is the clever brain that, having identified separate 'things' within that darkness by subtle tonal and colour differences, may complain at having to instruct the hand to sweep over all with one tone. Ignore it for this exercise.

Creating the right composition

It is now possible to see the image not just as individual 'things' which may tell a 'story' but also as a collective tonal arrangement. Do the rhythms, balance, counterbalance, symmetry, asymmetry of the shapes (both negative and positive) within the frame shape feel right for the subject and help the story? For example, if the size of a shape, whether large or small, is important, are the other shapes helping that idea by accentuating it?

Now, add more of the landscape in any direction and cover parts of the drawing with white paper to compare the different message, mood and story that can be conveyed. Even if you feel content with the original sketch, do this to explore other compositional ideas, maybe break a habit or challenge a 'rule' (which does not exist for a person who is playing on paper and is preparing to make an individual statement). Alternatively, you could photograph the sketch in different formats. Here, it could say for example, 'What a view', 'Small and cosy', 'What space', 'Fine weather', 'On the way to...', 'Coming out of the woods'.

Do not worry if you cannot immediately make up your mind which image you choose to paint. Just the practice of comparing develops your personal taste and ability to express the reasons for your response.

When you have decided, cover the unchosen areas and remember to use the same height/width sketch ratio for your painting, regardless of the manufacturer's paper ratio. I have seen many original, incisive compositions wasted or lost by sprawling to fit the image to the paper, or simply ignored.

Tip: make a separate permanent tonal key (either four or five tones) to take with you when painting – a really useful tool. Pencil can be silvery at its darkest so use paint or ink on both sides of card strip.

Like physical exercise, this warming-up process is a great preparation for direct response because it keeps the look/feel/identification of links well-oiled. Gentle observation allows the space and time to get beyond the surface image to your response to it. Sketching is vital for instant recording and a subject can appear at any time so always carry pencil and paper with you.

Although using only four tones may simplify the subject, the decision-making is challenging. A greater tonal range of five or six may be easier for identification but can be more complex and confusing. Also, viewed as a preparation for making a watercolour, there is an advantage to limiting the number of paint layers for speed, luminosity, accuracy and avoiding scrubbing up underlayers. (Not all papers or time will allow the number of layers that Turner possibly used when painting the Blue Rigi!)

Making regular toenail sketches improves observational skills and naturally develops personal style and imagination until the artist can paint expressively with no construction work.

ATMOSPHERE WITH GLAZED LAYERS

Absorption of light

Building a drawing in layers gives a deeper understanding of tonal composition and leads quite naturally to the process of progressively darkening the paper with paint.

EXERCISE – MONOCHROME GLAZING

After making a toenail sketch and extending, cropping etc., choose one image format and on watercolour paper, draw a frame of the same ratio but larger scale. If necessary, draw minimum information, remembering to scale up by eye.

Method

Mix plenty of wash mix with transparent (not opaque or granulating) paint, which when dry is identical to tone 2 of your

tonal key. Paint the first layer (equating to 0–25% tone) everywhere except where you have designated white. Leave to dry completely.

Mix the solution well, load the brush and lay the second wash very wetly, not only to lay the colour on gently with no scrubbing, but also to accommodate what I call the 'buttered toast effect'. (Dry virgin paper, especially rough, holds more solution than smooth paper. As paint dries, pigment particles settle in the valleys of the paper making the painted surface smoother.

So a little more paint solution in the brushload is necessary to deliver the same amount of pigment particles and make an equally dark layer.)

When this second layer is bone dry, actually add a little more pigment to the wash mix for the last layer to make a really dark tone, remembering the paper ('toast') surface is now even smoother. Then paint the final layer where you have marked 75–100% tone.

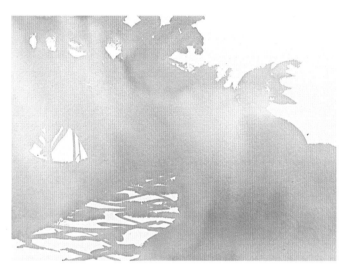

River Lavant (1). Painted in indigo, pre-mixed with red, yellow and blue. Although the first painting looks dull and misty, progressive layers bring out the sunshine by adding darkness. A Toenail sketch is the basis for this type of image which was painted without underdrawing; the first tonal layer will often cover most of the painting so the very light shapes act as a broad reference. If at any time I see a shape that I have missed on a previous layer, I simply add it on the next. The process is designed to develop tonal observation.

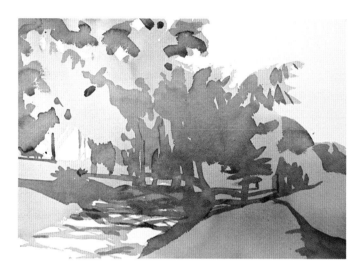

River Lavant (2). Immediately this second layer gives enough information to guess at the elements of the landscape

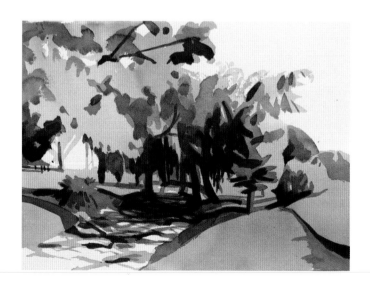

River Lavant (3). The final layer adds enough range of tone to express sunshine and indicates the deepest recesses within the foliage and their dark reflections.

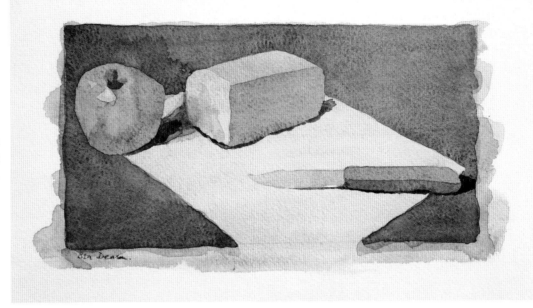

Still Life by Bea Deason. A study made in her first watercolour class.

EXERCISE – VEILS OF SATURATED COLOUR

Using only two or three wash mixtures of colour from the paint spectrum, enjoy the same build-up of tone to express a subject or idea. With a greyscale photo, simplify an image with a toe-nail sketch, then either choose colours which suggest the mood, rather than the appearance of, the subject and watch how the tones build up.

Alternatively, choose any colours and see light gradually absorbed and new colours created with each additional layer. Allow the freedom of play, rather than accuracy, to direct this exercise.

WORKING UPSIDE DOWN

It is easier to achieve accurate shapes and tone if both sketch (or photo) and painting are upside down because when the information is less recognizable, observation, rather than assumption, will lead the process. By faithfully concentrating on just three layers of tone on white as they are seen, this approach works even with portraits. Also, the pleasing compositional quirks and asymmetries of likeness are less likely to be 'ironed out'. Take a digital photo. This image can be converted to monochrome greyscale then compared later with the painting.

Charcoal and pastel play

Hatching with graphite (particularly a 0.3 or 0.5 mechanical pencil) gives a satisfying sense of control while the rigours and surprises of 'real' observed tone seep into the conscious mind. But when these skills are acquired, to explore and maintain broad awareness of tonal balance in a faster way, making big-

The Day Unveiled – Hot Summer Dawn. A minimal statement using thin, layered washes in primary and secondary colours (Opera Rose, Quinacridone Gold and a mixed green) give a gentle feeling of dawn in high summer. Each of the colours and white have only a small area.
This was intended to be a landscape that may be read in different formats.

Torso. Here I first made marks in pearlized gold and duck egg blue and matte lilac oil pastel before wetting the paper and working WW within the figure and then in the surround. The oil pastel marks have prevented main areas of paint blending (notably around the pelvis and buttocks) and accentuate the warm and cool areas of inside and outside backlight.

ger pre-painting sketches with charcoal or pastel encourages freedom of tone and colour experimentation. Both media are easy to alter with a sweep of the hand, stiff brush and plastic eraser and can remind the watercolourist who is seizing up to let go and be 'brave in the dark'. They also add friction to the physical sensations of mark-making. For the same reason, I have enjoyed vigorous but selective oil pastel marks (made first as a water resist for fast painting).

TONAL VIEWING DEVICES

When I began painting, I found a blue glass framed tablet in a junk shop. I was excited to think that, by absorbing some light, it would enable me to view relative tonal values directly, like a Claude mirror (a sheet of glass painted black on one side with which to study the tones in reflection, back to front). However, I was shocked to see that stripes of light orange and medium blue (reflections in a Monet painting) were reading dark orange and medium blue. The tones were reversed because the blue glass was absorbing the orange light while allowing the blue light to pass through. I now have two effective lens devices which allow me to assess accurate relative tones which are (crucially) calibrated to part-block daylight. Both are from photographic lens suppliers. One has a tinted lens and eyecup to block extraneous daylight and the other is a variable polarizing fader (55mm).

TIME, WEATHER AND CLIMATE

Look at any three-dimensional object, preferably natural, in daylight and your eyes are being stimulated by tone and colour changes. But, the tonal feedback alone, excluding the colour information, is probably sufficient for your brain to deduce the form, texture and identity of the object, your position in relation to it and the time of day and weather. Your brain has instantly analyzed the tones around and between the edges of the object. It does this unobtrusively because, rather than over-crowd your conscious mind with the data, it wants to give you only survival information.

However, to express time and weather in a landscape painting, you want to be conscious of the tones that you see. By rewinding from the brain's interpretation back to looking, the following processes will develop your ability to recall and paint these crucial, but often underestimated, visual signals which express atmosphere.

EXERCISE – SUCCESSFUL REFERENCE SKETCHING

Time limit: 15 minutes to sketch, 30 minutes to paint. Time to correct if necessary.

What can you learn?

- To improve tonal awareness and effective sketching as a visual reference.

Method

Make a full toenail sketch from a colour photo. Add colour notes if you wish using personalized shorthand to remind you. I have a very simple code for colour: bl, br, r, pk etc., p for pale, p'er and p'est, and dk, dk'er and dk'est. (I use 'Lt' to refer more to light source, direction and effect.)

Then hide the photo and make a painting using only your sketch for reference. When you have finished, take a photo of your painting. If you paint in a group, ask the other artists to deduce from your painting: what time of day, season, climate and country and discuss the reasons for their answers. (Some light conditions are more descriptive than others and some subject matter more informative; camels may be disallowed.) Then compare the painting to the colour photo.

Make a monochrome (greyscale) print or photocopy of both your original colour photo and the photo of your painting and compare them to each other. Note your powers of tonal observation and ability to distinguish tone from the tempting distractions of colour. Both are important but although the hungry human eye gathers visual information like a meal, the brain often gives colour information precedence over tone, cutting to the 'end goal' like eating a sweet before the nourishing main course. Having used tone as a stepladder to swiftly identify the type e.g. dog, hat, flower, it races to identify the specific colours: brown, turquoise, magenta.

Then correct your painting, reminding yourself consciously what to look out for next time.

THE INNER SCREEN

With the skills to identify the visual building blocks of the world outside our physical selves, it is possible for us to paint it. The visual world is, after all, only a combination of the Big Five: colour, tone, shape, texture and size.

The look of our world and experience is carried in our memory – sometimes noted consciously, sometimes not. We use these remembered images for various reasons: as the results of personal experiment to help our current survival or, based on those experiences, to envisage and construct our plans for the future. These re-run images appear on the 'inner screen' of our perception throughout the days and nights of our life to con-

Dell Quay – Dawn to Dusk. This painting attempts to capture the quiet book-ends of a busy harbour day, beginning and ending with high tide. Painted later, each section was created separately with the help of two toenail sketches made on the spot.

DRAWING IN TO OPEN UP

The eyes convey an immediate associative prompt to the physical senses. So, in the case of objective abstraction (working from reality), sketching allows the space and time to get beyond the question 'What am I seeing?' to 'What do I feel about it?' and reinterpret and synthesize the visual facts accordingly. While studying the shapes and stretching out to the subject, related feelings and thoughts can become clearer and deeper associations begin to surface. Like physical exercise, drawing can prime the artist for spontaneous response because it keeps the eye–brain–respond mechanism flexed and ready for action.

I often find that when my conscious mind is occupied with some other activity or when it is resting, dreaming or dozing, less figurative images arrive, unbidden and fully formed on my 'inner screen' so I carry a pencil and paper at all times.

St Émilion – Midday. Before I painted, the exploratory tonal sketch helped me, compositionally, to accentuate the idea of oppressive midsummer heat. By adding the downward-curving band of darks in the distance and at the sides to my original sketch, the light was 'pressed into' the streets and square.

Two preparatory sketches, morning and at nightfall, for Dell Quay – *Dawn to Dusk*.

Toenail sketch for *St Émilion*.

tinually remind and warn us of what to avoid, choose or ignore. It is comforting to think that we are the survivors of the best practitioners of this subconscious image-holding and filtering process.

EXERCISE – THE 'FILM DIRECTOR'

By drawing and painting we are taking conscious note of our surrounding visual world. With this skill it is not only possible to paint stored images with confidence, re-presenting our past experiences, but also to use them to convey our imagined thoughts, feelings, ideas and to decorate and explore ideas. Time: 40 minutes maximum.

Method

Choose a view (subject) and photograph it. Look at the reality for only 5 minutes, paying particular attention to the tonal qualities that express its mood. Then face the other way and paint it directly from memory in 30 minutes. (Set a timer if necessary.) The methods you choose will have to be adjusted to the time constraint. Do not refer to your photo. Do you find it easier to remember colour or tone? If you can't remember an area simply leave it blank. Don't be tempted to look back but shut your eyes to recreate the image on your 'inner screen'. With a pencil, list the lacking information as you go.

After 30 minutes look back, using your photo for reference (as the light may have changed) and compare the reality to your painting. In order to copy what you see you will soon be paying more attention to the necessary information and become more aware of the aspects of reality which strike you as being important.

Finally, add the elements from your 'needs' list to the blank areas that you feel most express your response to the view. After making several of these, note if you are aware of repeating factors that indicate improvement or style choices.

Regardless of the outcome, this very practical exercise really can link the artist with the environment and is fun to do, especially if done with others for comparing notes.

TEST THE BIG FIVE

In a painting session when asked to imagine/visualize her husband, a woman said that she really could not 'see' him. When she returned the next day she was able to describe and paint him because the previous evening, for the first time, she had really looked at him, identified and mentally taken note of the Big Five. Drawing a family member, friend or celebrity from memory then comparing to reality is an interesting and useful experiment.

What can you learn?

* To further develop your ability to identify what you are actually seeing, what you feel about it, your powers of visualization and ability to recreate any image that you choose.
* Trusting and understanding how your eyes seek and select visual facts and how that information is interpreted by your brain will also strengthen your skills of observation and ease the eye–brain–hand pathway. By prioritizing you will be able to personalize an image to develop your style and, when speed is necessary, simplify information. This not only links you to your environment in the moment but will also be held in the memory as an experience.
* Although this is a colour exercise, it acknowledges the importance of tone to express a likeness, response, mood or idea.

What can this method express?

* An authentic sense of engagement and personal style.
* Full attention is galvanized when only five minutes are available to study the Big Five and the visual knowledge received and stored far outweighs that attention in return. As a result, you may be surprised at the accuracy of results and the fluency and confidence that this practice lends to your other painting. You are choosing from your subject what you want to say and how to express it with no middle stages and little time to doubt yourself.

Cherish your 'inner screen' and listen to it when it flags up the thresholds between boredom, stimulation and bombardment from external information. What do you really like to look at? Is it always the same or does the eye or brain tire? Does mood affect this? Conversely, can you recognize and create optimum visual awareness?

Materials

* Camera (optional)
* Watercolour materials
* Pencil
* Watch or timer

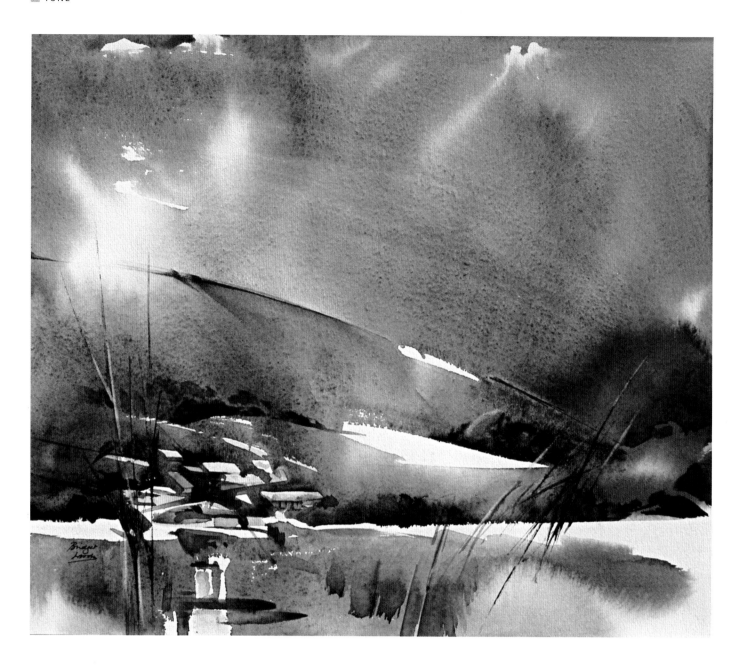

Winter Downland. The idea of this view was often frustratingly glimpsed before my train went into a tunnel, thwarting yet another attempt to sketch it. With no conscious intention to paint it, I found one day that this painting happened. It looks very little like the reality but everything like my memory of it. It may have been easier to re-see and fix the image while the eye-brain mechanism was less stimulated, resting in the blackness of the tunnel. After gestation it naturally popped out. Method: I selectively wet the paper leaving small areas dry for sunlight and bright roofs. The imperfect sizing caused streaking which (only with hindsight) has, I feel, added a dynamism to the 'labour' of this sudden birth. After pouring taupe greys onto the near-vertical surface I added some DW marks right and at horizontal river level and scratched a few reeds. When dry, I made an SOS roll mark on the hill and put WD colour on winter trees, roofs and water.

ATMOSPHERE WITH TONAL MARKS

By simplifying colour choices, you can focus on the texture and tone of marks that are appropriate to your awareness of time, weather and climate.

ing orange, from red to yellow, this will of course range from cream and flame-colour to intense dark orange and white). Mood can be also expressed with tonal balance, e.g. light as a visual metaphor for optimism, bleached, dry conditions or purity, depending on the context.

EXERCISE – TEXTURE, TONE AND MINIMAL COLOUR

Painting – choose two opposite or complementary colours. Each colour may be painted in any tone and any balance, for example using two primaries that make a secondary (if choos-

EXERCISE – CANDLEWHITES

Make a still life with three or four white objects in a stage of white, then light the event with a white candle. (Have several spare candles to preserve the original light-height.)

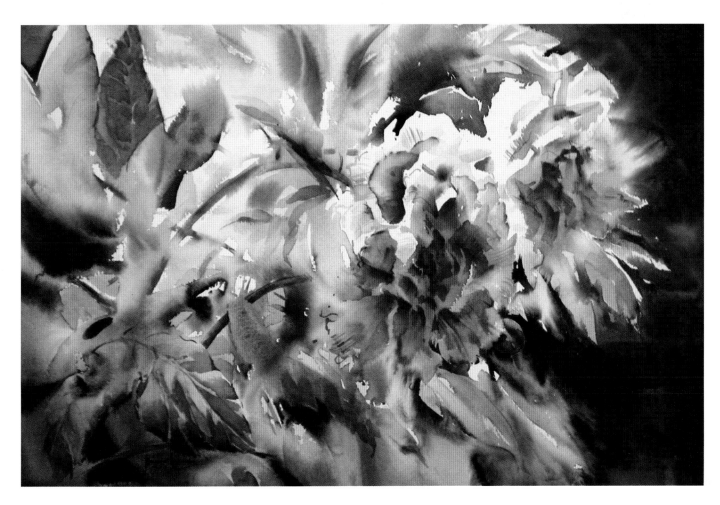

Peonies After the Rain. Two bronze-orange peonies were lifting their heavy heads again after a summer shower. To convey a sensation of this gradual movement, I planned to exaggerate the contrasting textures and tones between the piercing light above, sharp WD, the heavy dark weight of the flower heads and the background of moisture vapour, WW and DW. To do this, I wet the paper except for the sharp edges that I wanted to retain before working into the surface, WW and DW. When dry, selected white marks were filled with colour, a rigger used for fine, broken line work and some split brush marks added.

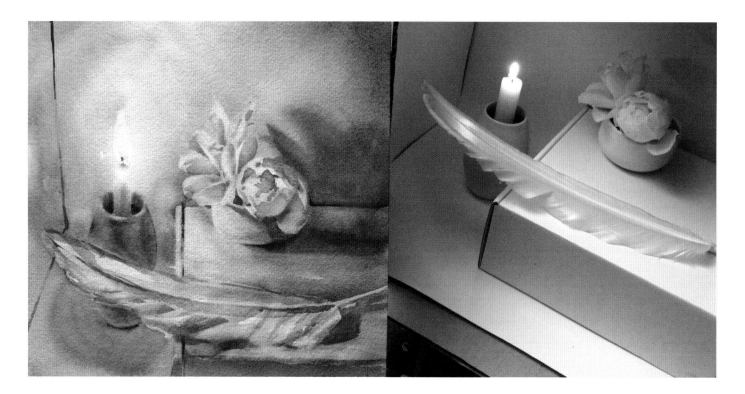

Candlewhites (painting and still life box). A conundrum of tonal experiences and a feast of learning. This exercise really highlights the difference between the eye and camera. Making a white still life lit by candlelight, painting it by white light and subsequently photographing both by white light are different worlds of perception. Firstly, establishing just enough balanced white light to paint by, without spoiling the perception of the still life. Very soon after starting to paint, complementary colours and tones 'appear' as the eyes move around the surfaces and the after-images of yellow candlelight, darkness and colour affect the eye in contrast to the external white light. Colour distinction is quickly heightened: creams and blue-whites become richer and more varied as cones and rods struggle to identify colour and tone. The pupil dilates and contracts to let in more or less light and the cones are in a constant state of readjustment while the brain's notion of 'white' is challenged. To have sufficient light to be able to take this photo it was necessary to intensify an ambient halogen light. The result illustrates well that a camera is not able to record what the ever-adapting eye and brain see. Only one shape was left white in the initial wetting of the paper. There was no underdrawing but the 'vertical' of the box was scratched early into wet as a useful reference point for all that is above, below, right and left of it.

EXERCISE – ACHIEVING LUMINOUS DARKS

A shadow denotes depletion or blocking of the light rays. Our eyes have the capacity to react to the quantity of light. The pupil can widen, or dilate to let in more light, allowing us in one moment, to look into a dimly lit cupboard to distinguish items and then in an instant look out of the window at a sunlit garden and by contracting, or closing down just like the lens of a camera, to let in less light, and detect various flowers and plants. Although this is useful for the adjustment necessary to our survival it allows us to erroneously imagine that the dark, medium and light tones of each area are similar.

Comfortably cosseted by the pupil's ability to react to light like an automatic 'torch and sunglasses' kit, we tend to take this developed skill for granted and thus underestimate light variation. Yet, if the tonal range between perceivable extremes of light within our visual capacity were to be measured it would prove to be incredibly wide. Without filters, a camera struggles to incorporate sky and earth tonal information within one photo so, when using a camera for reference, I 'bracket' the image by taking shots focused on several areas.

While this factor can challenge painters to paint adequately dark shadows it is exacerbated for watercolourists by hesitation and fear of the 'uncorrectable' mark. However, this must be balanced by the galvanizing knowledge that wet paint will dry

so much lighter. Also, when aiming for the appropriate contrast, remember that paper can only reflect, not emit light and that virgin Not and Rough surfaces are already speckled with little grey shadows so, if you want to speak of light and atmosphere, be bold.

If a shadow is painted too palely it will not, through lack of contrast, convey a sufficient degree of light but will need to be repainted when dry. Equally, timid dabbing of a shadow can result in parts drying before it is finished and the paint overlapping or getting muddy. Rather than a subtle absence of light, both give the impression that there is a dark 'thing' on the painting. Never let a shadow become a 'thing' but gird your loins to paint much darker than you imagine with a loaded brush and if possible, in one juicy sweep. If the mark is too dark it will only convey more sunshine. It is easier to 'rein back' from an overstatement (in the next painting) than to change the habit of timidity.

Method: Drip and tip, premier coup painting

Find a subject which features intense light travelling between an interruptor, like the tracery of leaf clusters falling on a complex or foreshortened surface. Imagine black lace around an arm or the shadow cast by railings onto a flat or curving surface just below eye level.

With DT, it is possible to achieve the exact shape of darks by first painting it in water on dry paper. If complex or very large, the shape can be drawn first, if necessary. Then by dripping in colour and tipping it in the right direction, the darkness and the colour can be monitored by adding, rinsing through or soaking up without fiddling and scratching the surface of the wet, vulnerable paper. This is particularly useful for shadows, which have the following properties:

- They are typically sharp at the source of light interruption, and become softer and paler further away.
- When lying across three-dimensional surfaces, they are distorted by their form.
- On flat planes they are obliquely affected by influences of foreshortening and perspective.

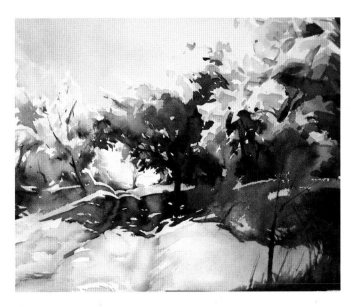

Track to Kingley Vale. Within interlinking dark and light shapes, the sun and reflected green light gave an intensity such that the orange-brown of the ruts, near the blue 'eye' of this painting, could only be seen in the darkest shadow. To me, shadow tone and colour are so individual that to use a formula is a travesty, detracting from the richness of life and imagination. Here, cast shadow and unlit subject are painted in water together as one mark with darkness DT and different colours added WW and DW while still wet.

PATTERN OF LIGHTS AND DARKS

Light shapes, associated primevally with sun, day and fire, create upbeat moments that stand out in a painting. Different factors can cause these visible lights:

- Texture – shiny, smooth surfaces like glass, metal, water and many leaves.
- Pigment – intrinsic local tone, like many flowers, people, snow, seasurf.
- Projection – elements that may even be of dark local tone, which stick out to 'catch' the eye and the light.

What these all have in common is their ability to reflect light.

Watercolourists focus on these often-small shapes, in order to reserve them throughout the construction of a painting and often unnecessarily opt for masking fluid. While finicky drawing, dried up masking fluid, old brushes, and drying time are assessed, it can 'allow' time for the artist to fiddle, overfocus on the lights and even miss the subject, if painting on site. Even

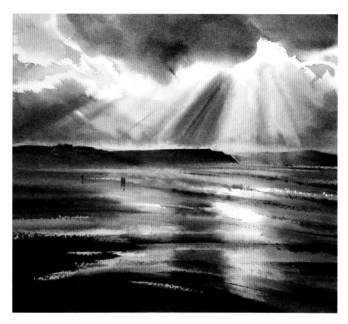

Powerful Sky. Low sun and heavy low cloud together are forcing light and dark towards their extremes causing an intense battle for power even in their two-dimensional structure on the paper.

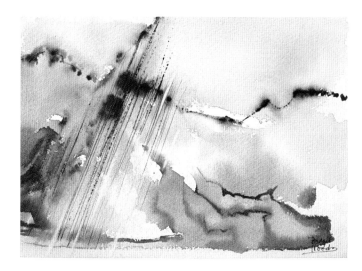

Sun and Showers. As its name suggests, here is a mild, temperate ambience of even tones with skitters of sun and shade. I used my nails, fingertips and undiluted paint in this weather sketch of the South Downs.

before consideration is given to the more important compositional role of the structure of the light in the meaning of the painting, this approach can become habitual and at worst, almost obsessive.

Meanwhile, the 'poor' darks are often placed where the structure of a nearly finished image inevitably decrees them to be. Sadly, at the last, this can often ruin the composition of a painting. Yet ironically, it is often this pattern of darks, at first sight of the subject, that most inspires an artist to paint. If middle tones make the quiet stage-set of a painting, then both highlights and intense darks are the performers that more noisily drive the rhythm of the event. While lights project, shine and reflect light, the darks are hidden, like crevices, internal, shadowed and in the absence (or absorption) of light, they reveal less visible colour. More difficult to discern, they provide intrigue and mystery for the eye and brain of the observer.

Relative and mutually descriptive, the pattern of darks and lights set the yardstick for a painting's intensity of mood. Developing an awareness of its importance and the courage to find and describe its rhythm is, for me, one of the greatest pleasures of painting and drawing. Recognizing links in nature: crystal, organic and animal. The pace of space, action and time in visual terms is not a cold, clinically observed metaphor but the actual experience for me of being alive.

EXERCISE – PLAY COLLAGE

Time: Three minutes to all day!

What will you learn?

- This process is guaranteed to improve your sense of tonal design and clearly illustrate why certain paintings call to you across a gallery, regardless of subject. By encouraging a free approach to tonal 'weighting', it challenges our default association of sky with lightness and light-absorbing land with heaviness.

Materials

- 2 × black and 2 × white sheets of paper no smaller than A3.
- 2 × sheets grey paper, mid-way between black and white (Canson mi-teints papers no. 431 Blue-grey and 429 Brown-grey are excellent).
- Digital camera, for taking photos of all your results as you go.

Collage – nearly symmetrical, even-sized.

Collage – asymmetrical, even-sized.

Collage – uneven shapes, white dominant.

Collage – transition between 'figure and ground' dominance of black and white.

Method: black and white

Cut out and tear small and large black and white paper shapes. Torn shapes work better than cut shapes because paper randomly tears in either direction and can preclude shape 'habits'. Place or scatter black shapes on A4 white paper and white on black paper, overlapping if necessary. Looking at the relationship of the shapes to the frame shape, arrange the shapes to achieve different factors:

- Symmetry/asymmetry.
- Evenly sized shapes/uneven.
- Only small shapes/a few large shapes.
- Randomly dropped/carefully arranged to look and feel right for you.
- How did it feel to consciously arrange symmetrically?
- How easy is it to arrange shapes asymmetrically within the frame shape?
- Did you reach a point where the shapes looked as though they could be either white figure(s) sitting on a dark background or black on white? How does this feel? Do white or black shapes look bigger or smaller? Do they stand forward or recede?
- Look at your photo results and put them in order of preference. Do favourites have something in common?

Method: black, medium and white

Using black, medium grey or white as the ground, let this collage exercise spread in any direction that you like. I recommend that you start with a simple brief and then elaborate it. For example:

- Geometric shapes.
- Personally preferred shapes.
- Different height × width frame ratios.
- Differently shaped frames.

Application of this practice

Choose your favourite four collages and paint each one in monochrome. Paint the shapes of the mediums and darks directly in water and DT medium colour. When dry, add the darks using DT again. This practice will really help the next exercise.

Morning Backlight. A near-monochrome painting which relates to the invaluable collage exercise.

EXERCISE – RESTORE AN OLD FRIEND

To see that these exercises really work, find a painting that, although you may like the subject, you believe is at an impasse. You don't know what more it needs – it has never 'felt' right or it is nearly finished but you are feeling timid about making those last bold marks. Stick it on a wall where there is space to stand well back.

Then, as before, shuffle appropriate white, medium and black shapes on different grounds for a short length of time. When you then look back at the 'stuck' painting, you will know instinctively what it needs.

Another practice that I find useful is to photograph the painting and reduce the size. The obvious compositional needs will shout out.

EXERCISE – LIGHT RHYTHMS

Make a toenail or charcoal sketch for a new painting, concentrating on the lights throughout. Then, when you have an accurate rendition of the subject, improve the links between the lights by reshaping, moving or eradicating them, vigorously erasing and reinstating where necessary. Before you start wor-

Charcoal sketch for *Man and Sea*. An attempt to express the contrast between man-made solid structure and the mutable, uncontainable quality of, not just water, but tidal sea. Liberating for such a subject, the groundwork was made in charcoal and final marks in compressed charcoal.

rying about the verisimilitude, remember that landscape is amenable to change, that this is an abstract concept and your sheet of paper, yours to do with as you wish.

Look at the composition, especially the significance of light shapes, their quantity and overall rhythm in the painting to achieve mood. Then paint from this image without being distracted by reality.

Watercolour tip: save more lights rather than fewer. If an area is still white you retain the choice to paint it but paper once painted never retrieves its sparkle and clarity.

People often give up on a painting too soon but it is not over till the last dark marks sing. This leads us to the next exercise.

EXERCISE – AN INKLING OF THE DARKS

Black is modest and arrogant at the same time. Black is lazy and easy – but mysterious. But above all black says this: 'I don't bother you – don't bother me.'
Yohji Yamamoto – fashion designer

Man and Sea. Having established the light rhythms in the sketch, I was able to plunge straight into the marks. I used a diagonal mark of gold oil pastel to flicker and emphasize the unpredictability and menace of the sea, to which end I used sandpaper to re-find some whites. Finally, the left side was lightly glazed to reduce its relative brightness. I was being heckled during this demonstration and released my irritation by 'allowing the sea to knock the flagpost down' but later returned its 'ghost'.

WE ARE NATURE

I had a painting friend who once said, 'You know, nature is seldom right.' At that time, just starting to paint the world, faithful to every leaf, I found his remark heretical and questioned his 'absolutist' conviction. Is there a right or wrong other than subjective opinion? I am now more aware that I am just another element of nature, like a tree adjusting to its environment, and reaching out to listen to him has had its influence upon my inner opinion and style.

What can you learn?

By painting the dark shapes first with waterproof ink, this exercise helps to equally focus on the very important, often visually crucial, dark pattern.

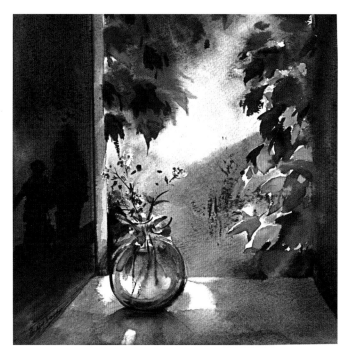

Forget-me-not – Brand Talon. This painting relies upon a small passage of light.

Materials

- Permanent/waterproof black ink
- Painting materials

Method

Find a subject and make a pencil line drawing as a broad guide. Then plan your painting on sketch paper by making several alternative patterns of only the black shapes in ink to establish a good rhythm of darks.

One way is to work only from the original subject or photo every time, rebalancing with each sketch, but for a greater sense of freedom, work only from the last trial sketch and let go, cast off from the original subject. There are pros and cons to this idea. While it can throw up habitual rhythms, it can also develop an awareness of your own instinctive style and move it on. I think both are true of the examples illustrated.

Finally, choose one image and working onto your statement of darks, confidently paint in layers, with diluted ink or transparent colour towards the lighter tones.

If you have not done this before you may feel reticent and the longer you have been watercolour painting the more this may affect you. After a few though, an awareness of 'darks pattern' develops and less attention is given to their significance as object-related and more to their important role in the composition. I usually make the first image to study the existing pattern of blacks in relation to each other so that I have a base from which to explore. This feeling of discovery is exciting and always builds my confidence.

What can this method achieve?

This exercise helps to balance up a watercolourist's technical obsession with the lightest shapes, giving way to a more realistic view of the tonal world we live in. On a scale between black and white most natural land-based objects, including people, are more than 50% light-absorbent. Have a look and do not be frightened to paint richly and darkly. Importantly, do not give up on a light painting; the best is often yet to come.

Merston – original photo. I chose this subject for its full range of tones, curves and straights, manmade and organic aspects interwoven by shadow and reflection – the real and illusory.

Merston – ink sketch, clockwise from top: I made several sketches sometimes including middle tone. At first, I reduced the man-made wall in relation to the natural stream area. Then, painting without the photo, I veered the other way, remembering that the light on the wall had been my main subject of interest. Looking again at the original photo, even as I took it, I felt the subject was too busy and the shapes too equally proportioned. This exercise revealed this, and some personal habits to me. Because the image was about summer light, the wall and the stream, I lowered the viewpoint to give them more importance, cropping information at the top to expand the foreground, finally choosing one to colour.

Merston Stream. Here, the stream 'stars' alone, featuring both verticals 'above' and wandering curves below. Interweaving reflection and reality within a minimal structure gave me much to consider technically. Everything was underpainted WW and DW with a scratched border acting as a ha-ha at the wall, where planes change.

CONCLUSION

It is not only the facts of the subject, shape, local colour and tone that can inspire. It is often the unique light on the facts and the painter's subjective mood in the moment. An apparently un-noteworthy tree passed every day can suddenly star in an exquisite and breathtaking event because the angle of the sun, the weather and the artist's awareness momentarily fuse. Suddenly, this is not just 'any old tree'. It has a lifetime, constraints, needs and urges like a human but within another form and timescale. How can you resist painting this moment – which belongs not just to 'any old person' but to you alone?

In the beginning was the light – refrain

We are an animal group that has managed to avoid extinction; whose antecedents have survived the tribal threats and weather extremes of millennia because of their skills, strengths and ability to co-operate. Over this long period of time, we have by adaptation developed a highly refined attunement to visual information and through the arrangement of tone and colour can, for example, distinguish fresh, ripe and mouldy food, identify a friend from a distance or an animal in the undergrowth.

Yet all this is only possible by courtesy of light. Its general qual-

ity and quantity can tell us where we are climatically, what time of day it is and what an object may feel like, texturally. Light also allows us to perceive and respond to colour. A red sweater on a dark night has no visible colour and with no light to reflect that coloured part of the spectrum to our eye, a lemon is not yellow.

Yet at dawn or twilight with a little light, even a 'black' object begins to display its planes and texture; the amount of reflected light may be minimal and the colour balance subtle but our eager animal eye and brain are always wanting to make sense of it and know what it is.

In brighter light the full gamut of information is available to us with many different elements absorbing and bouncing back different parts of the spectrum of colours. We can inspect our world, which, though visually 'noisier', is less potentially threatening now with 'some light thrown on the subject'.

Our survival inheritance to work out, 'What is it? What's happening?' is so strong that it can really challenge the daring of a painter who aspires to move from representation to a looser, less defined style. Equally, an abstract painting can intrigue, disturb and (especially if the painting is expensive) even anger a viewer's brain just by tickling the reflex response: 'What is it meant to be?'

Also, this animal imperative drives both the fast, efficient eye (information) and brain (translation) mechanism to work togeth-

er as one. Because light (stimulating rods) and colour (stimulating cones) are perceived simultaneously, they are often confused. Tone and colour, though interlinked, are not the same and the distinction between them makes them worthy of individual study.

If light and darkness with high to low contrast can induce

human sensations – from alert discernment to fear, comfort or sleepiness – then colour, from bright, clear, saturated primaries to neutral tertiaries, has an additional power to affect our mood. Identifying how colour 'touches' you and the expression of that entirely personal feeling will be explored in the next chapter.

Five-minute life study. Gentle tonal contrast highlights the colour change from external blue white light to interior orange light. Three blue-grey WD marks were painted: the figure and the background, right and left. Key registration marks were scratched in. Fast drying conditions allowed me to add the interior pale orange light to the right side. To intensify both tone and warmth of the torso, this simmering complementary was overlapped with SOS while the upward facing arm, breast and thigh colours were kept discreet.

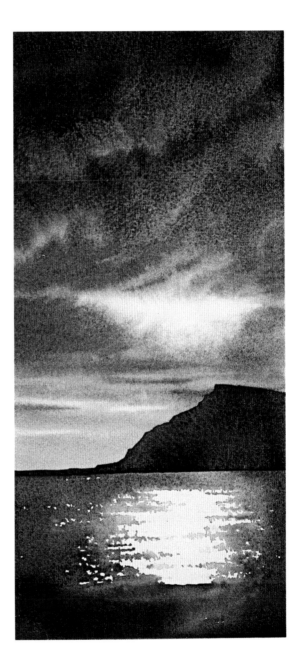

Icelandic Headland – Twilight. Accentuating the feel of condensing, heavy, low, moist air, swathes of different greys were mixed with flocculating Ultramarine. Made in the studio, this very wet painting allowed drying time between its three stages: WW, DW sky; FB sea and foreground. When the sea sparkle was satiny, I dripped yellow next to the reserved white edge to add a glowing transition of colour to the tonal contrast; Last the headland was painted WD and DT.

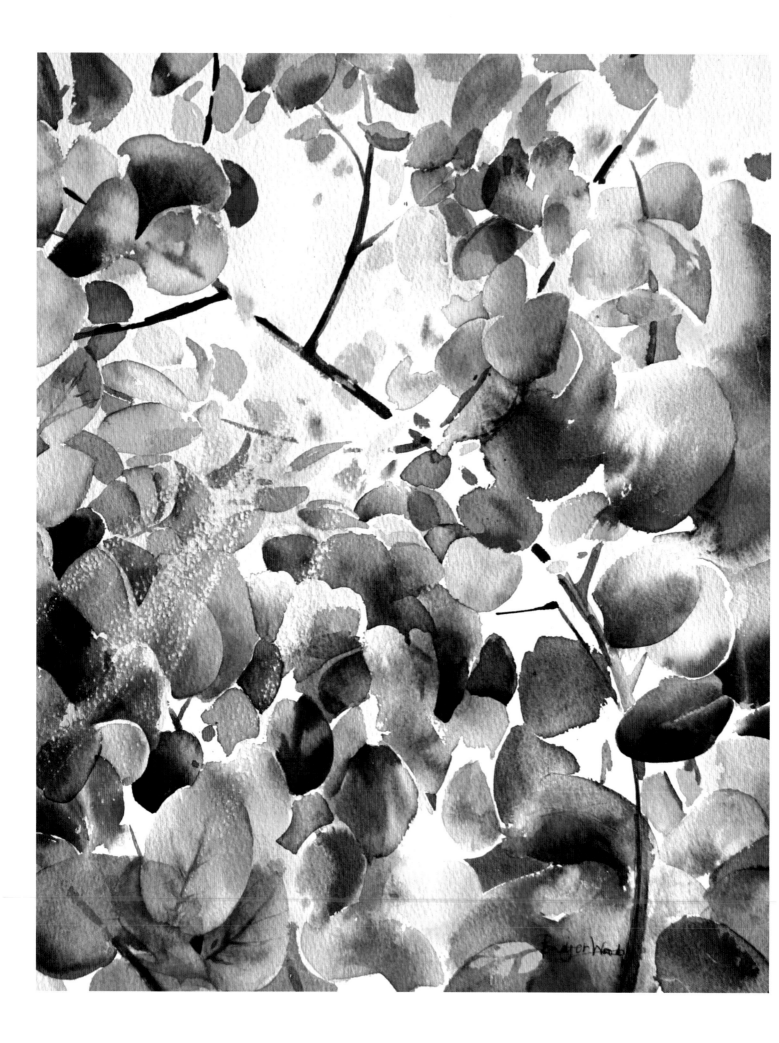

COLOUR

Reflecting the mood of both subject and artist

Imagine night and blackness. Without light we cannot perceive colour in the external world. As light increases we are able to make out the forms of objects with our peripheral vision of tone. Then a little more light allows central vision to gradually distinguish the colours of the objects. It is light that brings colour to our eyes.

EXPERIENCING COLOUR

In Western culture, just as the words 'light' and 'dark' have a primeval association with good and bad, the words 'bright' and 'dull' can have, when affixed, connotations with weather, cleverness, liveliness or happiness.

'Colourless' is often linked with sadness, physical bloodlessness or low light conditions which are mysterious, even fearful. Yet, if we feel secure, low light levels which are sombre can quieten the eye-brain mechanism towards sleep and peace.

'Colourful' can imply more noise, something joyous, and a 'sunny' disposition is associated with optimism. The more light there is, the brighter and more numerous the colours we can distinguish. The more tone and colour information by which we can identify others and be recognized, the more energized and confident we feel, unless we want to hide.

All of the Big Five – colour, tone, texture, shape and scale – inform and affect our daily survival needs, entertainment and pleasure. The last four may be to some extent quantified and measured in numbers and their common effects upon us described and shared in words.

Colour however, is the aspect of vision that most powerfully links with specific human experiences of mood and emotion, rendering them indefinable, except by visual means. Of all these elements, colour has the most idiosyncratic impact upon an individual and cannot therefore be objectively described in creative work as 'right' or 'wrong'. Only the exact hue of a colour can tweak a nerve for the artist – and the number of colours and combinations discernible by homo sapiens is near-infinite.

Though colour associations may be broadly discussed and amplitude and wavelength measured, the often-subliminal experience, response to, and preference for colour and its balance are unique to each person.

How and why do we see so many different colours?

We owe our perception of colour to the ability of the human eye to respond to the behaviour of the coloured rays of the spectrum of white light and the brain to identify them. Here are a variety of reasons why colours appear different.

LOCAL PIGMENT
Objects have degrees of local (innate) pigment, which absorb and reflect different selections of coloured rays to human eyes.

LEFT: *Eucalyptus* (detail). Expressing the joys of wet watercolour and every colour under the sun.

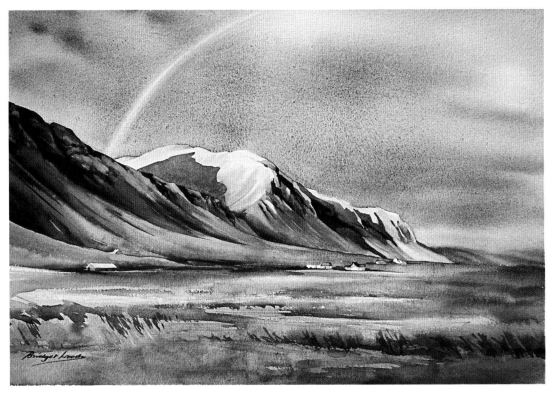

Mount Esja – Evening Light After Rain. Here, several factors are affecting received colour: local colours of rock, scattering of light by air moisture, the low angle of the sun emitting a yellow light that is not so prevalent in the shadowed areas.

FILTERING

White light itself may be partially interrupted by a filter, which, like theatre lights, absorbs, and lets a part of the colour spectrum pass through, bathing us and our surroundings in colour. Look through coloured glass or plastic at different coloured objects to observe how the filter blocks some colours.

DISPERSION AND SCATTERING

Interference by particles in the air affects the colour of white light photons reaching the eye.

ANGLE

Our position on earth in relation to the sun changes the balance of the coloured rays of the spectrum that we see. Though most noticeable at sunset and sunrise, the colour of light is gradually changing between dawn and dusk as the world revolves.

COLOUR BLINDNESS

Many people are to varying degrees less able to distinguish between certain colours, most commonly red and green.

CONE CONDITION

Colour-stimulated cones in the retina of the human eye can vary from moment to moment, as we shall see.

BRAIN VISION

For survival purposes, we have evolved a phenomenal ability to identify, name and memorize local colour in changing lighting conditions. The snag when painting, however, is that this skill often gives the brain a desire to override the colour message sent by the eye. An obvious example is the perceived blue-grey of white daisies in shadow which the brain reads as 'white'.

When all these feisty 'players' combine to define colour, this can cause a mental scramble, even 'onstage fight' when painting a subject like bluebells at sunset so that these influences, and others, take the perception of Colour, like Beauty, away from absolutist pronouncements (such as, 'That is blue') towards a more flexible concept.

In reality, the experience of colour is a personal event involving object, light, eye and brain.

Ready and primed to respond to 'untagged' colour

The variety of colour in life is a visual treat and, unlike the dark to light range of tone, offers infinite choices and combinations. Exploring this diversity in transparent watercolour is smooth and fast because (compared to the longer blending methods of opaque media) lightening, darkening and mixing is simply a matter of adding water or paint, in the palette or on the paper. This potential gives more confidence and time to revel in the luscious delights and subtleties of personal 'premier coup' colour expression while still leaving options open for further over-glazing later, to neutralize or enrich.

Our response to colour, and the other visual elements, is likely to be affected by associations we make within a specific climate, history and education and we often name pigments accordingly, using words like 'Brick', 'Kingfisher' and 'Rose', which may have a different, or even no significance in another culture.

For this reason, although I may become poetic about colours in the context of a specific painting during and after its creation, I am keen not to limit my own, or anyone's choice by defining colours with my own preconceptions in advance of idea and action. Remaining factual when describing colour allows me to respond to its full potential, unfettered by the external influence of positive or pejorative tags. An unbiased approach also helps to identify, mix and enjoy colour with an open 'heart' and mind.

I find that 'hot' (for red) and 'cold' (for blue) are sloppy associations and are not helpful adjectives to use when, for example, I want to visualize the vivid range of blues that remind me of clear sea and sky on a hot day, searing white sun or frost, the orange and 'boiling' hot reds of leaves and the yellow of low sun that heralds cool autumn or the cold shiver of night at the end of the day. I also question the necessity and usage of this practice.

The actual visible colour temperature of heat (measured in Kelvin) is after all, white blue at its hottest, then orange, yellow and finally red. Within the range of human survival, a fire may glow red, giving off a relative warmth but instinctively we know that there is greater heat of a different colour: white, the colour of sun, which also represents snow and ice.

As co-operative pack animals we may not wish to contradict certain traditions. Some 'rules' are founded upon unquestioning habit, passing fashion, sacred 'secrets of priesthood', which may be based on empty myth or ancient truth. You are free, as an artist, to question them all and do not need an intermediary to paint. The best outcome will be that you express yourself.

The inherited colour associations that human animals do have in common are driven by personal and genetic survival and are mostly connected to food, foliage, farming and repro-

CAN A COLOUR BE WRONG?

Endeavour to remain open to colour association and avoid painting habits and formulae. Like plants, there is no such thing as an ugly or wrong colour, only a colour in the wrong place. A weed is a plant; it is only the descriptive name that links it to the idea of 'unwanted'.

One day I was admiring swathes of yellow flowers tumbling through an overhead trellis in Madeira and the owner said 'Oh, this Thunbergia is awful. It gets everywhere.' Not, alas, in my garden. Yet how I do value the daisy.

duction. After these our common colour language begins to diverge as it is affected by other influential factors including gender, habit, culture and fashion, which can vary widely. So do not allow either verisimilitude or 'this season's colours' to trim your access to myriad colours in order to honestly put your own personal response to your world on your sheet of paper.

Test your openness to colour. Is there is a colour that you think you do not like? Describe it in purely untagged colour terms (e.g. yellow/green brown). Paint a broad strip of it and then, alongside and glazed over, many other colours to see whether, influenced by association or unreasoned dogma, your enjoyment of colour has been stifled and to what degree context can affect feeling.

The importance of colour contrast and similarity

Technically, the most important aspect of colour for an artist to identify, practise and then intuitively use (like textural brushstrokes) is the physiological effect that different colours have upon the eye and brain. Beyond that, I believe in freedom of choice for everyone.

Compositionally, our attention is caught, attracted more by primary and secondary colours and by the edges of contrasting, complementary colours which, like an alert, flag up 'change'. Conversely, our eyes more easily wander around a colour 'passage' where similar colours are painted adjacent to each other.

The area quantity of colour in a painting is crucial. A small flash of a primary or secondary colour in a large expanse of either its opposite, or neutral, colours will have greater pull than a larger mark or two analogous, or neighbouring, colours.

Keen Painter at Selhurst Park. This painting features many edges of contrasting colour, ranging from sizzling to simmering with few colour passages where the eye can wander from one colour to its neighbour. The aim of the contrasts is to draw the eye round into a circular offset vortex containing two tiny colours, which although they are analogous (orange and pink) have no link with their immediate surroundings. The smallest orange shape is intended to make a visual link with the foreground falling leaves, above and below to give the painting figure a sense of space, connection and protection. The simple tonal story offsets the busier colour.

Because our histories are different, so is our taste for colour combinations, which can even differ with our mood and physical condition. To express a sensation of happiness we may, dependent on conditions, choose either primary and secondary highly saturated colours or more neutral browns, greens and blues that, though sombre, are restful to the eye.

COMPLEMENTARY DAZZLE – THE STIMULATED EYE

To unravel the complexities of colour response, we can begin by simplifying the whole system to its root components – the primary and secondary colours. Then, by also discovering the

Star dazzle: a star shape of bright pigment colours. They are similar to the colours of the rainbow but instead of appearing in a row, they are arranged in a circular format.

subtle powers of tertiary colours, we will find the path to our own preferred choices and personal expression.

To begin with we will look at the effect of opposite, or complementary colours.

EXERCISE – STAR DAZZLE

Materials

- White sheet of sketch paper
- Fine pencil

Preparation

Draw a small line triangle in the centre of the white paper and keep the pencil in hand ready to write. Without moving your eyes, gaze at the centre of the coloured star (above) for a whole minute. Then look at the line triangle and, without moving your eyes, write in the colours that you 'see' around it. If the colours that you see begin to fade, have a 'top-up' by repeating the

process. (Tinted spectacles have an effect on the results.) Do not move during this experiment.

What colours did you see in the after-image? Were they lighter or darker than the paper?

The cones on the retina at the back of the eye that are stimulated by a specific colour gradually tire. When the gaze is transferred to a white surface, instead of seeing a reflection of all white light (a combination of the spectrum of coloured light), those specific cones are too tired to respond immediately. Yet, the other cones in the same area of the retina which have not been stimulated are 'ready for work', to respond and send their message to the brain. For example, if a retinal area of orange-sensitive cones has been stimulated, it will temporarily 'see' or read blue instead. This is a method you can use at any time to help you to identify opposite or complementary colours.

IDENTIFYING COLOUR

The cones (and rods) in the retina are continually reviving to a neutral state to make a balanced visual assessment. So, when trying to identify a colour (or tone) to mix, rather than stare at it, move the eyes around and back to the subject to keep the whole retina refreshed for a neutral response. If you hold a fixed gaze, as demonstrated, little by little the cones for that colour will tire and the colour itself will be 'taken for granted'. But when the eyes then move, its complementary after-image will change other surrounding colours.

This effect is marked if you are painting in an ambient light that is already coloured; for example, when painting a wood from the outside in blue-white light, then inside, where the ambient leafy light is yellow-green. The same neutral grey-brown trunks may appear to be orange-brown (complementary to blue) when painted in daylight and rich purple-red brown (complementary to yellow green) when painted in woodland light.

'White' sheep on a bright green field appear to become pinker and the shadows of snow at sunset change from grey to purple then blue as the ambient light of a lowering sun changes from white to yellow to orange. When teaching, in order to discuss colour decisions, I first take time for my own eyes to adjust to a painter's environment in order to share their ambient light conditions.

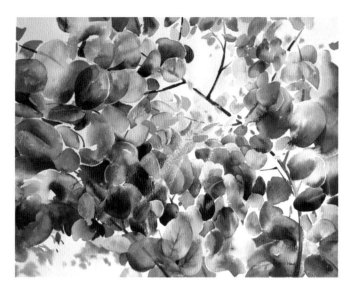

Eucalyptus. This cacophony of bright colours has a complementary pattern that reveals itself. As the cones adjust, colour contrasts increase and a pattern of reds, subsumed within the blues and greens, spirals with diminishing scale into and 'up' towards the sky.

Note: apart from continual cone and rod refreshment, the efficient labelling of the brain's memory plays an important part in our perception. When conducting this experiment for the first time, some people initially experience what they expect to see afterwards. Sometimes that is the same colours or the white that they anticipate.

If the results of this after-image experience surprised you, just think that whatever colour and tone you are looking at now will affect whatever you look at next. Will you paint what you see, a neutral view or what your brain knows or expects?

EXERCISE – DEVELOPING COLOUR INTUITION

This play session is experimental and fun.

What can you learn?

With a little practice, you will automatically know as you are painting, how to swing your colour mixes towards or away from contrasts or passages in order to attract, divert or ease attention

Complementary dazzle: two orange sample shapes with blue complementary added and painted over the top.

within your composition. This skill is one of the cornerstones of painting and worth developing, especially for watercolour, as it is key to transparent glazing decisions. Like any skill, it starts with trial, error, experiment and play.

Method

Make a random brushmark of any colour that exists in the pigment spectrum: primary, secondary or anywhere between them. Look at it for a minute, then at a bright white surface to find its exact opposite (complementary) colour and concentrate on identifying the colour factor. Mix this colour as accurately as possible. Remember that the tone of the after-image will also be inversed (see centre triangle of the 'star dazzle' after-image).

A way of checking whether these two colours are complementary is to mix them together (with clean brushes in another palette) in visually equal quantities. If balanced, they will combine to make a neutral grey-black by absorbing a balanced amount of the light spectrum achieving just the same effect as mixing visually-equal quantities of red, yellow and blue paint primaries. Any variation towards another colour will demonstrate an imbalance in the mixture (for example, towards green shows a preponderance of blue and yellow in the mix; brown shows red and yellow and so on).

Make sure that the first mark is dry, then carefully put that opposite colour, either WD or using DT method, around the first mark and watch the edges dazzle and attract the eye.

Make test shapes to see the effect of darker and lighter tones of both colours. Complementary colours that are similar in tone usually sizzle more. With less tonal information the brain is more intrigued and has to work harder to distinguish edges. Also for this very reason, the eye will be searching for that edge and within minutes the appearance of each colour at these edges becomes more intense because of the mirrored after-images of an unsteady gaze. Test this effect on the eye and brain. This explains why for example, a horizon of blue or blue-green sea often appears to have a rosy or orange colour 'floating' just above it. If the sky is that colour the effect will be intensified as your eye bobs above and below the edge.

EXERCISE – SIZZLING COLOUR

Colour contrasts can be bold and eye-catching for an instant 'hit'. However, tertiary versions of the same colours can be used to simmer alongside each other for a subtler and sometimes longer-lasting effect. The choice is yours.

What will you learn?

- By focusing on only two colours, this exercise allows you to explore fully the range and potential of high and low colour contrast while also exercising your tonal skills as more or less spectral light is absorbed.

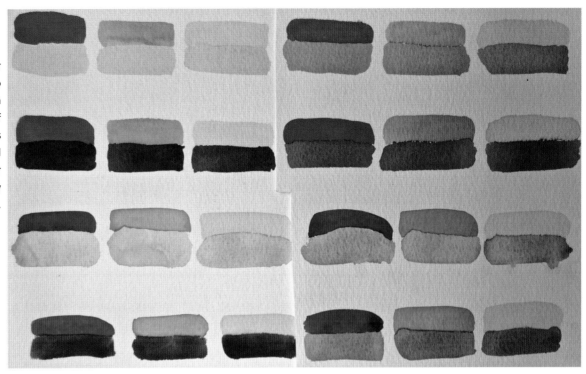

Sizzling colour swatches: two colours may seem limiting but each of these combinations of pure and neutral opposite colour creates a subtly different sizzle.

Method

Make a very strong, highly saturated puddle of two complementary colours (to test them, see above) and keep them as pure separate sources. If dilution is necessary then transfer some of each to other mixing spaces.

Make a sample chart of colour combinations to see how tonal difference affects the impact of colour contrasts.

Then make a painting using only these two prepared colours from high saturation dazzle to grey.

Use any methods: glazed, mixed together or diluted to any degree. Concentrate on the power, quantity and placing of these two colours, either sizzling side by side or gently simmering in quieter colour passages, when mixed towards tertiary neutrals.

EXERCISE – SIMMERING COLOUR

For a more nuanced use of colour attraction use neutral versions of any complementaries adjacent and see them gently simmer. This can be done by finding and mixing complementaries as before and then adding, in other mixing palettes, a little of each colour to the other so that you have colours which range towards each other and finally make subtle greys i.e. less saturated.

Sample page to test blue/orange combination. Testing opposite colours to make grey and preliminary trial sketches.

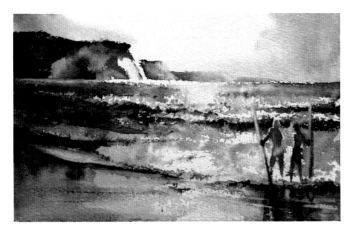

Sizzling colour: *Surfers*. One of a series.

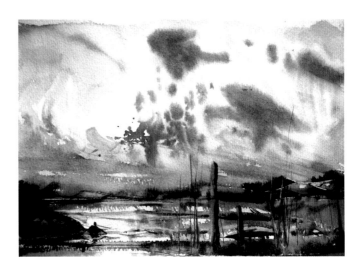

Sizzling colour: *Wharf, Evening Sun*. Using opposite colours.

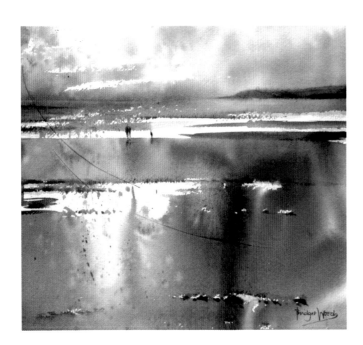

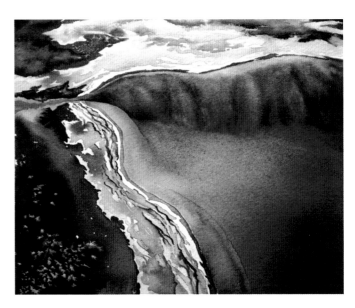

Blazing Sun – West Wittering. Here I used a range of orange-yellows and complementary blue-purples, keeping the colour contrasts near the top and colour passages at the bottom. Only transparent pigments were used for the shining, silky quality of wet sand. To break through the dominance of horizontals, an arc line was scratched in the paint when wet. To mimic the after-image of sunblaze, Quinacridone Gold was spattered on the sky and clean water onto the beach areas when damp.

Geysir Pool – 1. A range of pure blues sits alongside tertiary ochres and chocolate browns for a subject that literally simmers. My choice was driven by colour, texture and two-dimensional considerations: contrasts of sharp silicates and soft water, complementary colour and the sinuous simplicity of shape.

EXERCISE – CHANGING MOOD

Sometimes the colour in a painting does not feel right or express the sensation experienced in the moment. Often this is because a desire (or habitual self-discipline) for visual accuracy has produced a colour combination that is just not appropriate either to your mood or that of the day. Despite looking like the subject, verisimilitude can often overwhelm self-expression.

What can you learn?

- The following method, which advocates working onwards with a painting that you deem to be unsuccessful, can have a profound psychological effect that benefits personal working practice. Yes, the texture of the painting may become muddier as the desired image emerges but I find that this only increases a determination to be both bolder with paint and clearer about the message of my next painting right from the start.
- In the long term, giving yourself permission to strongly overpaint, in both senses, can turn a watercolour 'victim' into a painter. A watercolour is, after all, only paint and paper.

It is possible both to improve paintings and to lose paintings that are close to successful. Either way, it is not possible to do this exercise without learning more about ambient colour, stretching your imagination and courage and practising perfect washes and DT.

Materials

- Paintings that lack the mood or atmosphere that you wanted them to convey
- Camera

Method

Photograph your paintings as a before-and-after record.

Choose colour(s) that you know will transform the image to express the 'right' feeling for you or the mood of the moment – or if in doubt, designate any mood. Mix the colour(s) in quite strong saturation so that some can be easily transferred to another palette and diluted if too strong.

BETTER TOO FAR…

Watercolourists often hold back the pigment in the early stages of a painting for fear of overstating tonal values, knowing that opaque light paint is not an option in transparent watercolour painting and, in doing so, miss two important points specific to this medium:

- Water is flexible and offers easy spreading mobility, dilution and strengthening.

- Watercolour painting is a serial process. Technical skill develops on the back of the last painting, especially the one that you recognize to be 'muddy'. Creativity develops as that skill, which is only a vehicle to expression, becomes automatic.

If you want intuitive handling of watercolour, it is far better to run the risk of ruining a painting and know why, than never to have taken that risk. It is a clear choice.

With a fully loaded brush, glaze over all or part of the painting with mood-changing colour, either by referring to your memory or random choice. Or, to avoid lifting paint, very gently selectively wet the painting with a large soft brush loaded with water and drip the colour onto the surface using DT to achieve the right mood. To a degree, this allows you to introduce other colour and change your mind without the friction of the brush scrubbing up the paint and paper.

Also, if you need to reserve, draw attention to, or accentuate some light/colour areas, then plan in advance, draw round and leave them un-wetted and if they are accidentally lost it is easy to very firmly blot.

Then photograph the results and compare with the original painting.

Tips

Do:
- Be decisive, remembering that any colour may be glazed anywhere.
- Be clear about mood and colour choice (write words if necessary), before you act.
- Take risks, remembering that the painting was not on your 'to exhibit' list and is now a playground.
- Remember that colour dries so much lighter and that this is an experiment.

Do not:

- Be influenced or held back in your colour choice by visual reality, including the colour effects of recession.
- Keep moving or dabbing the colour around because, when wet, the vulnerable paper can be broken and underpainted pigment and sizing disturbed and smeared causing matte 'muddiness'.

What does this achieve?

We are geared to painting a 'decent' image by finding out and painting what we see. This apparently innocent and often, in watercolour, tentative quest can easily block the expression of what we actually feel about what we see or our mood in the moment.

As an exercise, changing mood halts bad psychological habits like giving up too soon or restarting, often only to repeat and reinforce the same mistake. It also encourages a more direct handling and honest message. Even a black painting on a tough paper can be washed, glazed and scratched. I sometimes find that I only begin to engage and learn when I have mentally

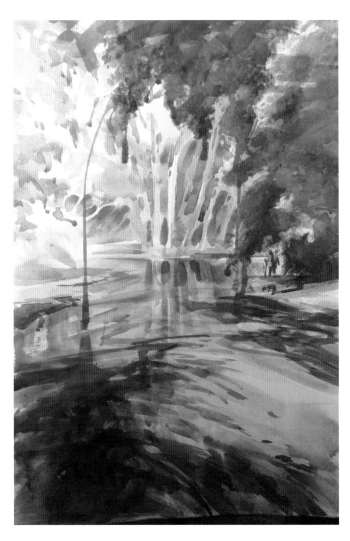

Asnières – first painting. Though made in oppressively hot sun this painting was light, flat and dotty.

Asnières – with red glaze. I washed dark cobalt and green over the trees and added a rich orange to the foreground water. Detailed foreground trees were simplified and the painting gained a much stronger tonal rhythm but still needed even more overhead weight and heat so a glaze of deep red was added.

'ditched' a painting.

Practically, this exercise also drives home an awareness of general tone and colour perception, which can be easily overlooked when slowly building up a painting from one small area to the next. While the iris of the eye is dilating and contracting to let in more or less light in different circumstances to access an average reading this factor can also produce an average painting. For example, land and sky/indoors and outdoors may be, according to a light meter, extremely different in tone but the flexible iris can tempt the brain to erroneously link the relative 'light, medium and dark' assessment of both areas as similar. Colour resolution, as we have seen, also applies to the ambient differences between reflected, electric and day light.

Asnières – underpainting. Twenty years later, I chose to demonstrate the same image from an original reference photo. This underpainting says much about my change of approach. Not prettier but a much deeper, richer, braver interpretation from the outset.

EXERCISE – COLOUR COLLAGE: TEAR THROUGH HABITS

Time: preparation 15 minutes; painting 45 minutes.

Personal choice

This project guarantees a looser, more exciting approach to painting, a development of colour awareness and personal taste, and produces a diary.

Landscape painting usually involves various standard factors, depending on location: sky (light), horizon (tonal edge), land-based objects (generally dark, light-absorbent), water (multi-tonal, reflective). These generally appear to us in predictable colours: blues, greys, greens and browns and in shapes, textures and sizes with which we are familiar.

Making collages tears through habits and can cut through boring ruts. Painting from a collage is flagrantly liberating for a topographical landscape artist because it encourages risk-taking and play. The less you feel inclined to do this exercise, the more it will probably excite and benefit you in the long run.

What can you learn?

- To give yourself permission to play and experiment, whatever your usual working process.
- To identify yourself, what you really like and feel now, without fixing that idea.
- Cutting and tearing when choosing images also cuts through the habits of subject choice and interpretation. As a regular practice it nourishes new ideas to represent the individual artist more authentically. It also feeds the imagination, working well in tandem with the Logbook where new influences can pop out without pressure.

Materials

- Colour supplements, advertising brochures
- Sheet of black card (white on reverse) or white, grey or black paper
- Painting materials
- Hairdryer
- Camera, preferably digital
- Timer

Method

Leaf through magazines and without thinking why, choose, cut/tear out colours and colour combinations, laying them out on a big sheet of cartridge paper or card. Arrange and rearrange the colours, varying the proportions by tearing or overlapping. This is about your colour preferences, an instinctive colour selection in the moment so, not to be distracted by the significance of the content, have your magazines upside down. The arrangement will be abstract so while the shape and colour of letters or collections of words may be interesting, use them only for their visual quality. Turn you and the composition around each other by standing at a table or, to avoid fiddling, work on the floor, pushing shapes around with your toes. Enjoy the visual difference between space and action and see how broad, empty, neutral areas can intensify the detail of gem-like colours, and vice versa.

Assess, arrange, edit. Photograph from time to time, compare, rearrange. After 15 minutes, stop.

Download the photographed images, choose one arrangement (or crop of it) to paint 'from'. Cut your watercolour paper to the size and format that feels right to you in the moment. Put on the timer for 45 minutes.

Start anywhere. Methodology is not the subject of the exercise. This process often starts with a patchwork precise approach to painting because the colours may have fewer components in common. Forget processes that you usually employ which are prevalent in traditional landscape painting, such as underpainting or searching for connecting colours. Either leave a gap between shapes or let adjacent colors run together if they are not dry or firmly blot with a tissue if it really is important that they stay distinctly discrete. Keep an eye on the timer. Feel free to glaze colour over areas when dry. Walk round your painting to view the composition for its balance and quantity of colour from different angles. Allow these different external circumstances to encourage your use of the richest/darkest/lightest of colours.

After 45 minutes, stop.

What can this express?

A truly personal expression of your colour design choice in this moment. Experimenting and giving your feeling for colour free rein, you will develop respect for your imagination and personal taste. Whatever the subject, your paintings will be enhanced by the extension of your colour library. Whether you like to write notes on colour combinations and formulae or not, every time that you make a colour choice, your memory will register and your experience and skill will grow richer and deeper. This is a free fast extension of sketching with the addition of instant colour and is a key to keeping your painting alive with imagination.

As a diary

Colour confidence will take root and flower within you. Old and safe colour formulae will be replaced by an expressive colour instinct. Trees will never be just green again.

Do this on a weekly basis, record and date photos, to see how your colour preferences change. Though abstract, this exercise will liberate you to paint an arrangement of colour that you alone have chosen. Your arrangement need have no basis in figurative imagery but will enhance your representational painting. Every time you make a choice you are gradually letting go of the average opinion, the dictates of fashion and culture and refining your personal colour identity and confidence. For this reason it is useful to use magazine sources from a variety of periods and cultures.

Subject-led

Think of a place that you know (but have never painted) and your feelings about it. Then in collage, choose the balance and type of colours that best express your feelings. Don't worry about the texture or the shapes and their meaning, only the amount and type of colour.

> *Be like water making its way through cracks. Do not be assertive, but adjust to the object, and you shall find a way round or through it. If nothing within you stays rigid, outward things will disclose themselves.*
> Bruce Lee

Mood-led

Pick an abstract mood-word, e.g. fear, honesty, suspicion, joy.

Word or idea-led

With closed eyes, randomly pick three words from the dictionary and play with visual associations and links.

Collage. It was hard to choose one collage and painting from many evolving colour stories.

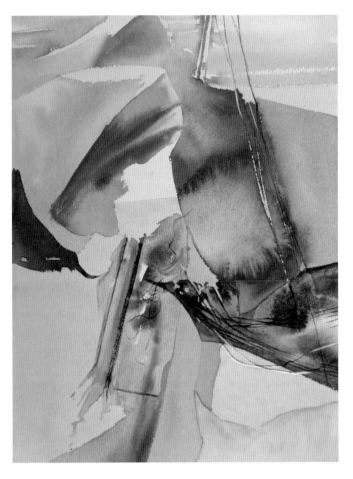

Sea Air. The joy of painting was enhanced by seeking out colour subtleties (sizzling colours) and the surprising technical freedom that is made possible by the limitations of a pre-ordained abstract design; my design to develop or edit, as I have.

Music-led

Choose different pieces of music.

Construct collages that express these subjects for you and then paint them using any technique that feels right for the mood.

Dorset Cliffs (collage). Subject and mood led this image of a favourite place from childhood.

Dorset Cliffs, Soft May Morning. Warmth, softness and space in the morning mist.

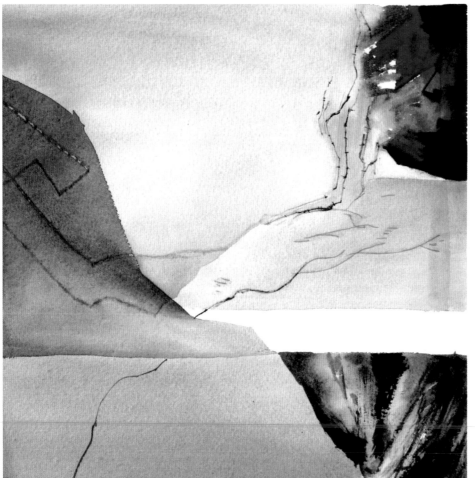

Earth. Inspired by thoughts of earth, sea and sky, this small painting can be read in any direction like a 'rolling' square.

COLOUR SHAKE-UP

EXERCISE – COLOUR SHAKE-UP

While learning to paint any external subject, such as landscape, the aim to accurately explain what is seen is paramount. Voracious 'fact-finding' can drive the process so powerfully that it becomes automatic and gradually an unspoken boundary line is drawn in the sand, brown, blue and green of reality.

By consciously making random colour choices, it is possible to pass these barriers of reality or 'safety-zones' to a world where the whole gamut of colour is available for a more personal interpretation.

What can this achieve?

This practice develops a well-flexed elastic access to any colour, which when added to other elements of choice – subject selection, cropping, mark and focus – brings an enlivening sense of mental freedom and flow of expression.

Materials

- Pantone Formula Guide or other paint guide
- Colour swatches or magazines

Method

Whether working from reality on location or from reference material in your painting space, choose any image. Then, with

Bloxworth Forest: photo reference for *Dorset Blue*.

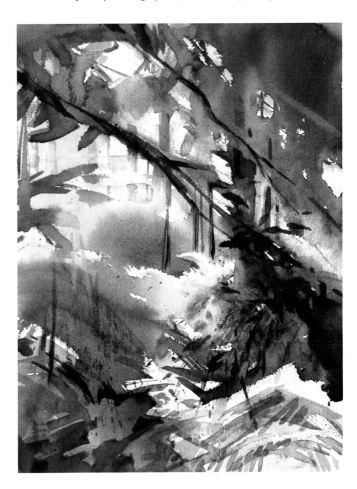

Dorset Blue. Dominant blue, then green and orange were chosen randomly for this painting. The existing underlying shape and structure allowed the colour to take over.

COLOUR POWER

EXERCISE – COLOUR POWER: THE EMOTIONAL IMPORTANCE OF COLOUR

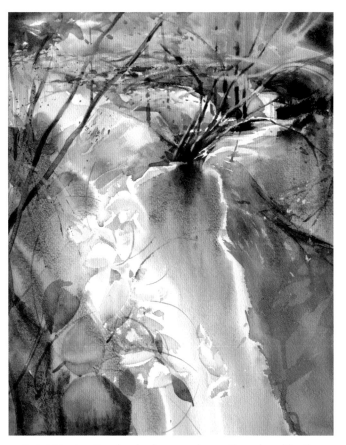

Quiet Stream. Randomly chosen colours, though unlike the reality, were coincidentally landscape in nature.

Colour eye bath

The following exercises push the power of colour in its evocation of mood to the limit. Drenching chosen images in limited colour can be very liberating to any artist who has become stuck in the rut of countryside colours, personal habit or always allowing the detail to tell the story.

What can you learn?

* To become aware of the effects that different colours can have upon an individual at different times.
* To use this observation to express different moods and create a powerfully emotive effect on the viewer's response.

Materials

* A selection of single coloured cards or fabrics ranging from primary through secondary to tertiary colours of any tone.
* Patterned fabrics or wallpapers (Minimum size: approx. 30cm).

Preparation

Surround your eyes with a sheet of coloured un-patterned paper or fabric, resting your gaze for 1–3 minutes and note by writing down, without moving your gaze, the effect that it has on you. Try not to push yourself to respond. This may take some practice and vary at different times, depending on your mood or the time of day. Also note the after-image that you perceive when you stop. Does the reduced tonal variation of flat colour

your eyes closed, randomly pick three colours, from swatches or magazines. The first colour choice will take up the largest area in the painting; the second, a medium area and the third will make a very small appearance. Each colour may be used in any tone. If chosen, text (like this, for example) would be any neutral grey between white and black.

Though the combination may feel uncomfortable, stick to your choice. To avoid being sucked back to original colour assumptions, if working from a photo, use a greyscale version, or place the image sideways or upside down.

have an impact?

Now try the same with card, wallpaper or fabrics that have either large or small uniform patterns, again noting the different effects upon the eye, brain and senses.

Method

Zoom in on one area of any chosen subject so that the scale of shapes is large within the picture frame. This will lose some of the story-telling detail that may override the impact of the colour message. Choose one colour that feels appropriate to your subject and using any technique, paint the image exploring both extreme and subtle tonal variations of that colour.
Note: the consistency of highly saturated colour is more syrupy so, for translucent WD marks, mix plenty to allow it to flow and remember that thicker paint will not spread as far in WW conditions.

Two-colour eye bath: minimal colour/big effect

Using the same methods, paint another subject using only two colours, which may be complementary or analogous (opposite or near to each other on the paint spectrum). Before choosing, spend some time visualizing the mood that you would like to express.

Although any tone of each colour can be used, the colours will be painted separately rather than mixed together.

A starting point can be to use the colours that are opposite to reality, like colour photo film negatives.

CONCLUSION

Advertisers know that colour has an emotional impact on a consumer public. A specific customer type is pinpointed and back-

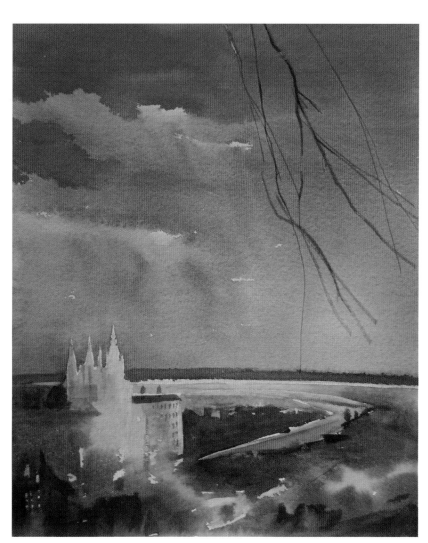

Prague Orange. I chose these two colours to express dignity and warmth.

ground commonality researched. If the marked target is broad even a single colour can be used as a powerful tool of persuasion. We may be partially aware of this but it is interesting to make a conscious comparison of the packaging within ranges of different products.

Uniforms are often uni-colour so that colour choice is crucial in its relevance to the corporate image and message. Compare your feelings about different uniforms within different categories: military (past and present), football, airline, school, business, for example. Age, fashion, gender and nationality are a few factors that will already affect your response.

So, when it comes to selected colours in varying quantities within one painting, the combination itself, regardless of storytelling or representational imagery, has, like a dish, a unique flavour that comprises the sum of the parts. This potency can evoke an emotional sensation, which springs from a series of memories that are triggered by an innate association between the senses. For example, 'When I see these colours, then I (usually) smell this, hear that, taste that and then I feel this.'

For example, a jagged configuration of sunshine yellow and flame red can symbolize a cheap, ready meal of meat and chips to the tribe of one continent, but signify drought or wildfire in another country to a family whose livelihood may depend upon providing the ingredients for that very meal.

These linked sensations can range from a whispered, subtle hint to the overwhelming roar of power and often happen unconsciously. An artist, whether painting a flower or war, is conscious of this and has the choice to express the subject, their response to it or use a communal visual metaphor, like a yellow stripe for a ray of sunlight.

The communication pyramid

Total immersion in colour, either from an emitted light or reflected walls can provoke an almost physical sensation. Though there are global human links with certain colours, like yellow, orange for the warmth of sun and red for the danger, or attraction, of blood or fire, it is not a given fact that each culture will have the same emotional response to all colour combinations.

Shared subject matter, that is, the breadth of 'universal' experience amongst all humans, is as limited as it is profound. Physically, we are all born, then live, subject to the laws of light and gravity, and die. These few facts can invoke myriad images that could be commonly understood around the world, constituting the broad base of a metaphorical 'pyramid'.

But what, how, and whether we want to communicate a story or emotion, can vary between different cultures, gender, age, rank or time in history. This band of common understanding is further narrowed by the long-, mid- and short-term evolution-

ary and geographic circumstances of man's existence on this spinning earth. A birth may be an 'everyday' event, yet individually, we are here by exceptional chance. Weather, climate, meteorites, and adaptability willing, we animals have learnt to use, and fit within, our environment. Between the icy Poles of this magnetized, miraculous blob of mostly molten magma, the extreme human concepts of survival and luxury vary greatly from Equatorial to Temperate living – and so does the relevant imagery.

This band of shared experience is narrowed still further by tribal, political, religious and individual family background. Whether global or unique, the colour message is further refined by personal experience and mood in the moment. Here is an example.

A buyer once told me that she loved the small coloured shape of the distant river in a painting, which reminded her of a particular place, great happiness, company and security. This colour was also my reason for making the painting but her 'river' was, in my reality, a field of young blue-green oats, contrasting with surrounding browns. My mood, by contrast, was of quiet, nostalgic solitude.

Colour and science

So, how much scientific knowledge do you need to use colour successfully? As little or as much as suits your temperament. Although they are involved, there is no point in letting the sciences get in the way of creativity.

Physiology, biology and psychology: the eye and brain

As we have seen, certain colours and combinations can rest or stimulate the retina and brain. This knowledge increases an artist's ability to subtly or dramatically direct the gaze around a painting. However, the brain's processing of the information is personal.

Physics and chemistry: the nature of different pigments

Paints behave in different ways according to the way that they are made and the pigment that is used. Generally, there are three categories: opaque, semi-opaque and staining. Pigment particles may be electro-magnetically pre-disposed, like Ultramarine, to gather (flocculate) or vary in size with larger, heavier particles appearing 'granular' on the paper surface and finer particles staining by instantly clinging to the surface of the

paper like dye. All have their benefits and certain combinations will react when mixed to behave in interesting ways – which, by mingling or repelling, create differing textures.

Until the nineteenth century, the lack of a wide range of colours developed a traditional 'limited palette' which is still used by many landscape artists. It comprises a selection from tertiary earth colours, umbers, siennas, greys, madders with semi-opaque cadmium reds and yellows and secondary red-blues and greens. This combination is less likely to create visual colour shocks and while it is useful for representing the colours of nature in calm, neutral colour passages it often contains some fugitive (fading or discolouring) pigments.

Then, the historical story of the painter was radically affected by the advent of the camera in the nineteenth century, and the chemical development of bright, lightfast colours.

The use of the camera both questioned the societal role of artists and offered the potential to release them from aspects of facsimile copying. Suddenly, anyone could make an exact likeness with a photograph. Now with an ironic twist from digital technology, anyone can make brushstroke paintings without a brush.

New colours worked hand in hand with these notions to expand the methodology of expression. Notably, a cheaper version of the expensive lapis lazuli Ultramarine (Outremer, mean-

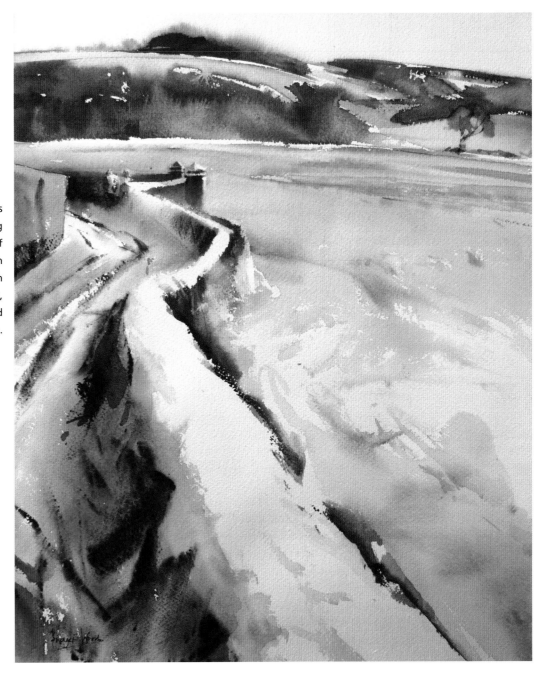

Cornish Winter Walk. This virtually 'two-colour' painting celebrates the rich range of lightfast blues and rich browns possible with affordable Ultramarine, Phthalo and Quinacridone and just a touch of Cobalt Violet.

Organic Fretwork. Playing freely with bright colours has also created exciting neutrals.

ing from 'over the sea') blue was developed in a competitive race between the English and the French. Later, with the development of colour photography and printing, lightfast pigment manufacturing made another leap.

Rediscovered recipes and synthesized colours, which can now be bought and internationally identified, have had a powerful impact on the art world.

Since the cave painters and throughout the ages, available pigment was determined by region and limited to earth, organic, animal and mineral colours, many of them light-fugitive. Today, the products available cover the brilliance of the full range of visible colour, are lightfast and internationally accessible.

So now a completely different 'limited' and cheaper palette of spectrum-like colours offers anybody every option, from mixing neutral browns and blacks to painting the brightest variations of red, yellow, blue, green, purple, orange and pink. When bright pink arrived on the scene it was known, tellingly, as 'shocking' pink and considered to be garish, gaudy, even offensively vulgar to many people. It comes as a surprise to many to discover that it is a primary paint colour. (If you are in doubt or wincing, I urge you to mix a bright pink PV19 with yellow to make a bright red and, separately, with blue for a rich purple. Then mix a bright red, PR188/PR254 with blue to see the resultant greys and decide which 'red' is a basic building block that cannot be mixed.)

Quest(ion) and (re)search is a personal affair

Simply put, the act of painting is making marks for any reason that you choose. For this process to flow, it helps to discover how your eyes respond to similar and different colours and how to make any colour with ease, as covered in Chapter 1. These are skills, based not on complex secondhand recipes but on trusting the value of experience and your own understanding of what are simple, basic facts.

If the reason for painting is to 'hear' and express a personal response then taking this direct approach establishes a practice unimpeded by intermediate 'noise'. Authenticity is at the heart of expressing your individual history, unique memories and associated feelings. You are the only person who holds the key to the significance, influences and preferences of colour in your life and for this there is no formula.

Scientific knowledge is not necessary to paint successfully,

but as a painter and experiential learner already discovering the 'physics' of paint and water, a growing desire to explore may lead you to research historical events and current findings. Nevertheless, while mathematics can project ideas, fact is proved by experiment like yours and, no matter how tempting or forceful a creed to the contrary may seem, not everything is known about light, colour and perception. These are still, like love and the universe, a mystery to be further explored.

As an artist, please, as I try to do, remain open, question everything and remember that, while it may be influenced by philosophy, fashion or physics, choice of colours is not a science but a personal affair to be savoured.

If we knew what it was we were doing, it would not be called research, would it?
Albert Einstein

The next chapter will delve into more visual 'drivers' and bring together the elements of our visible world as they combine to give us our sense of place within it.

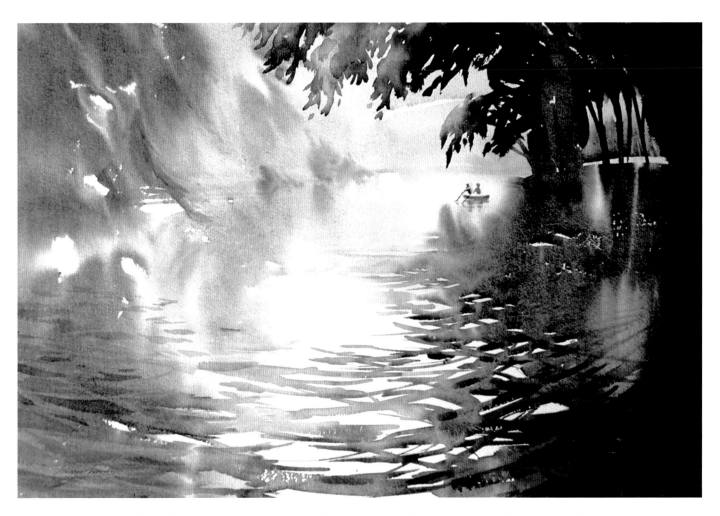

River Dronne – Evening Light. This painting took more nerve than time and is still one of my favourites for its spiralling structure, like hands lightly holding a precious orb. It is for me reminiscent of 'passing clouds' in t'ai chi: a rolling movement of strong and soft, near and far. Process: apart from parts of the horizon, the whole paper was wet for a broad underpainting, WW and DW. Very dark, syrupy colours were mixed while waiting for it to dry. Then, by first painting the shapes from the overhanging trees on the top right to the ripples bottom left in clean water, all the sharp-edged marks from upper right to bottom left were achieved by DT. This one wet mark covers the description of the trees, their trunks and the bank which are positive (dark on light), the ripples which are 'negative' shapes (around the 'positive' lights) which transit to 'positive' darks on a light shining river, then become dark over the medium underpainting. I kept this mark wet by dripping in water until the whole shape was completed. Then I dripped very strong colours into this wet mark, being sure to correspond the colours in the trees to their reflections. All that remained were the single SOS mark, which strengthens the bright green tree sweeping down to the river, and individual WD marks on the water, bottom left – and at the last, the twins in the boat.

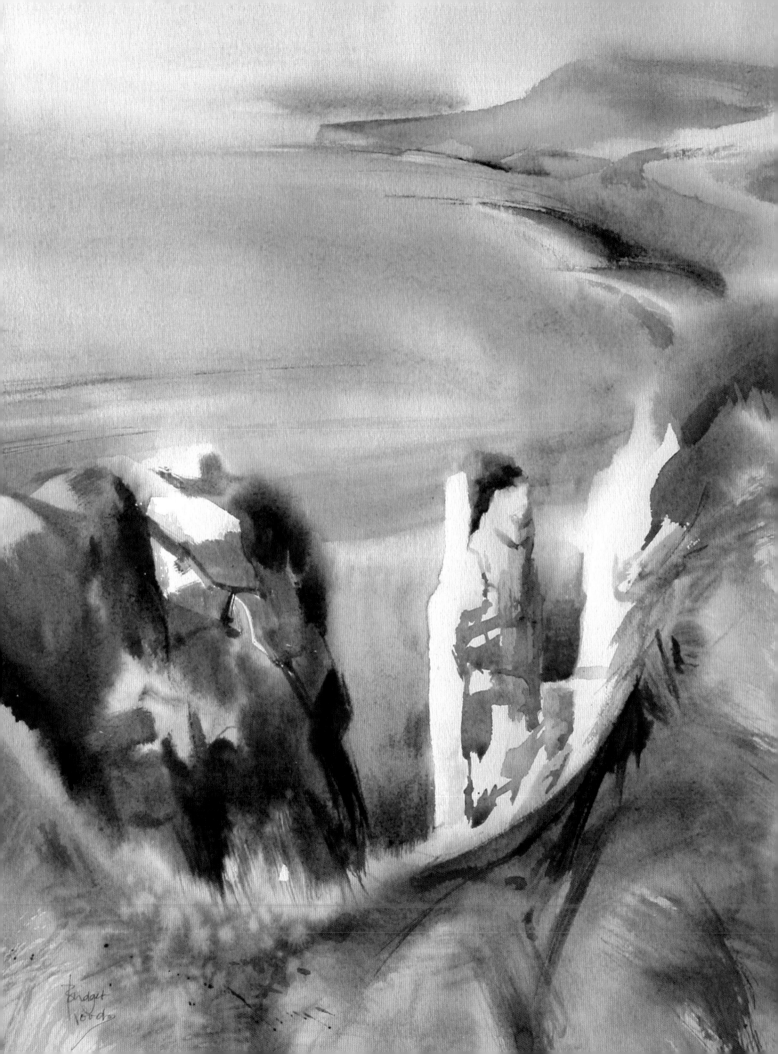

CHAPTER 5

SHAPE, SCALE AND RECESSION

A sense of place

In 1995, the Hubble telescope was pointed for 10 days at a patch of sky which appears blank to the naked eye. It's a tiny piece – much smaller than the area of sky which you'd cover with your little fingernail if you had your arm outstretched. And in that apparently blank area of sky, the Hubble Deep Field Image discerned with amazing clarity more than 10,000 galaxies. Each galaxy is made up, on average, of about 100 billion stars. Every star could like our sun, be orbited by planets. That is the size of the universe that we live in.
Naomi Alderman, *The Guardian*, 1st May 2010.

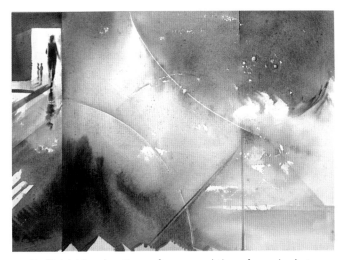

Twilight. Visual notions of space and time, from single to chronological.

Like light and dark, three useful colours and the drying quality of watercolour itself, the principles of shape and scale may seem simple. Yet, as part of the perception of three dimensions, their combinations, like colour, are infinite. Specifically, because they inform us of our unique place in space and time on the world, their effect upon our daily lives is profound.

To use this in any form of painting, from illusory to decorative, the facts, as well as the effects, are worthy of study.

This chapter will look at some significant aspects of this subject, posing questions which will develop in the artist a deeper understanding of the importance of an individual 'world' view.

Edges (where tone and colour are discernibly different) help us to identify the shape and size of other elements in our physical environment and, by scanning and comparing the spaces,

LEFT: *From St Aldhelm's Head.* This breathtaking vantage point looks back along the Dorset coast – approximately 185 million years in geological time from Cretaceous to Jurassic and Permian.

estimate the distance between them and our position in relation to them, near or far. Movement and speed are also assessed by chronological changes of shape and size. The ability to translate them allows us to quickly deduce the potential impact upon our lives of external elements, from insects to windblown trees or rain clouds, triggering sensations of, for example, intimacy, fear, power, freedom or calm.

Broadly, the sequence of see, interpret and respond in our environment is a crucial life skill and usually happens automatically. But for the artist wanting to express a unique viewpoint, a more conscious understanding of the middle process of translation is important. To use an analogy, we may be aware of two slices of bread (see, act) but it is the filling (what? where? when?

147

why? how?) that makes a sandwich special.

This super-sense not only allows an artist to say much about the 'relationship' between the elements within a painting but also adds richness, value and an extra dimension to daily living.

When discussing the composition of well-known paintings, I often hear, 'But surely that arrangement was just coincidental?' The appearance often is, but, as with photography, there are snaps and there are images that tell a story.

> *Some critics will write 'Maya Angelou is a natural writer' – which is right after being a natural heart surgeon.*
> Maya Angelou

PERSONAL WORLD-VIEW

Our sense of place upon the world is most importantly influenced by planetary conditions.

While the earth may be performing on a cosmic stage with a cast of many millions, our best-known supreme power is the one that most affects two of the greatest influences upon human life: light and gravity.

Light (the subject of Chapter 3)

Our sun allows us to see by day and, sometimes, as it is reflected by the moon, by night.

Its energy supports all life on earth and is responsible for weather and climate.

Gravity

As our planet moves around the sun, while we are within Earth's atmosphere, we are bound by gravity to fall towards it. Within this strict confine we learn by dint of muscle power and perseverance to stand up, balance and run and soon become less consciously aware of the key influence that gravity exerts upon life. Yet the importance of human physical response to this constant is so profound that it can fundamentally affect the way an artist both chooses and presents a subject.

Field of vision

We might assume that our visual range when stationary is a circular field of vision but by looking straight ahead, spreading your arms and wiggling your fingers until they 'disappear' at the edges you will be able to construct the shape of it as an ellipse that is wide relative to its height.

It is the land which is usually first scanned for survival information: elements to be either aimed at or avoided, such as people, cars, wild animals, crops, trees, mice, which may provoke response of comfort, danger, threat or protection.

When we are looking 'around' we prioritize the 360-degree range of our own personal perspective of the world's surface, wider than high, known as 'landscape' shape. Shape and scale, as distinguished by their edges, are the two members of the Big Five which point out the way for us to read all the visual factors that describe objects and space. They are influential in the compositional structure and 'message' of a painting.

Directional marks

The subliminal impact of the force of gravity is such that, when people are asked to verbally associate with a single isolated drawn line, drawn at different angles, the response can be lively. Here is a selection of related words:

Vertical: upright, power, straight, alive, pro-active, block, balanced, standing, barrier, post, protagonist
Horizontal: repose, passive, laid down, inert, flat, horizon, dead, sea, comfort, fallen, surface, sleep
Diagonal: active, unbalanced, falling, rising, running, uneasy, energy, movement

Another frequent and rational response is that it is 'only a drawn line, has no associations and means nothing at all'.

Yet, if not singly, when verticals, horizontals and diagonals are combined they relatively define each other and tell a more specific 'story' (when, for example, seven lines suddenly become 'a table, of course.'). (See page 9 of *Life Drawing* by this author, The Crowood Press.)

PERSONAL RESPONSE TO SHAPE

EXERCISE – A PERSONAL RESPONSE TO SHAPE

Edges help us to identify shapes to which we respond. How much can they convey the feelings that accompany that recognition when viewed independently?

Method

Take a look through any magazine or brochure to see (or, more importantly, feel) the difference in your response to vertical, horizontal and diagonal edges. Now try the same experiment comparing round or curving shapes with square shapes and straight edges.

Curving down: stable, rooted, landing, protective, unhappy
Curving up: friendly, playful, unsafe, optimistic
Curving sideways: bulging, sensuous, bending, soft

If factors other than shape, like writing or colour, are influencing your response, question why and try looking at images in a less familiar mode, upside down, in the mirror or in monochrome.

Our surroundings affect us in ways which may be long-term or transitory. For example, a happy childhood growing up in mountainous country could give one person a comfortable default concept of the horizon as not horizontal but broken diagonally by jagged rock faces and pine forests. Raised on flat-land, empty desert or gently rolling hills, this same image may be either anathema for another person or temporarily, very exciting.

Contemplate where you live and where you like to holiday. Here is a sample of spoken reactions to shapes:

Square, cube: man-made, safe, boring
Triangle, pyramid: earth connecting to sky, stable, impractical
Circle, sphere: rolling, edgy, timeless, strong

It is ironic that a sphere or oval can be considered 'edgy' when we all began life inside the secure comfort of one and continue to live upon the surface of another. In other contexts though, this shape can also have an uncomfortable, uncontrollable quality rather like drops of water or mercury, hinting at rolling motion and an unpredictability that will only be 'cornered' by gravity. However, because there are no weak sudden changes on any plane of its edge, this shape can also evoke strength and eternity, and in reminding us of the sun and moon, appear as infinite as these elements which have always been in our consciousness. And yet, despite a theoretical knowledge, until the world was viewed from outer space and until recently in maps, our small-scale 'view' of it was, and still is, remarkably flat. So, compositionally, a circle thrown into a structure of straight edges can create an almost tangible contrast of energies.

Edge, line and shape

Shapes are visible by their edges. An edge is the boundary between one area of tone and/or colour and another, while a line is a narrow shape, like a string and is used for simplifying three-dimensional information into flat symbols, directing attention or making code shapes like numbers and these letters. It can also be multiply hatched, as in a toenail sketch, to express blocks of varying tone.

The border

POSITIVE
The border of a subject is a finite statement and attracts attention that can please, tease, comfort, excite and frighten depending on its placement. In reality, where tone and colour are sim-

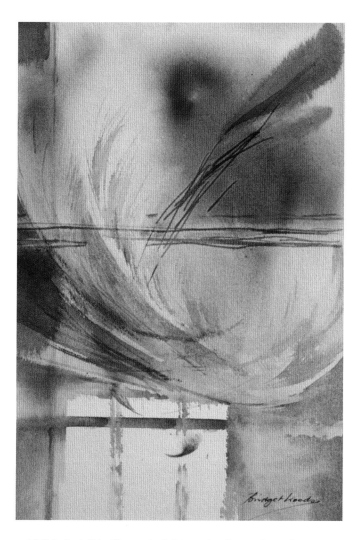

Visible Invisible. Sharp straights and soft, curving edges are used to differentiate between tangible elements and invisible energies.

ilar, a visible edge is often indistinguishable yet the viewer's brain is swift to find a defining clue nearby and fill in the likely information for this 'lost' edge. Tonal or colour interchange, which swap along the same edge, can also interest the brain's perception and keep it guessing.

NEGATIVE

The visual world that teeters between the recognition of object and/or ground shapes is full of potential for both design and meaning. More than independent background, spaces and 'between' describe the relationship, connection and interaction of objects. Not using opaque paint (for light over dark) develops a super-consciousness of the paradox of positive painting for negative description. So, for watercolourists who, by necessity, fast become experts in the recognition of negative shapes, the door to this world is especially open and inviting. In life, many things that are lit from above are defined by their darker surroundings. Have a look round now at the negative/positive percentage.

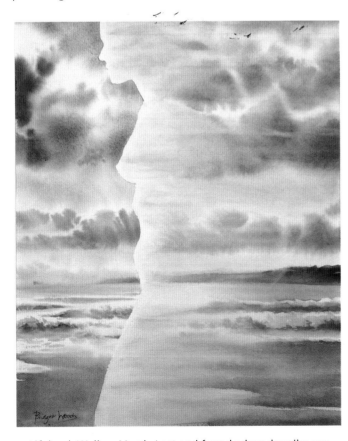

Lifebook Walks – March. Lost and found edges describe our everyday human capability for the simultaneous perception of outer reality and the 'inner screen' of visualization. Here, the paper was wet to the edge of the figure and both sides painted separately. Then when dry, the paper was tilted sideways, re-wet and primary colours dripped on.

LINE – PROTECTION, PRISON, DISTRACTION, WAY OR DIRECTOR?

Lines, often used as an abstract device for defining an edge that is not visible, can have an encompassing feel, which may be a comfort or a cage for the subject or maker. A dark line can draw attention to the edge rather than the substance of an object or drive the gaze around it. Drawing a line can be read as:

Making a maplike boundary
An act of possession
Exclusion
'Fixing' prior to colouring-in
Cutting the picture plane into interlocking pieces for design
Independent of colour and tone
A negation of 3D picture-making
A device for defining otherness or aloofness
A beaten path

Line not only underlines: it is also an accentuator and usually the basis of 2D communication in numbers and letters in many languages.

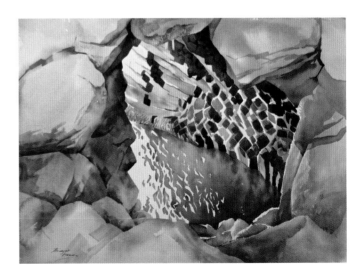

Basalt Inlet – Snæfellsnes, Iceland. This visual paradox looks deep down into the 'recent' past of Iceland's volcanic history. Visual surface water patterns are at once negative and positive, reminiscent of interchanging figure and ground of Gestalt and Escher's Angel and Demons. The spewn rock of blasted magma contrasts in both 'soft', eroded (WW, DW) and mathematical form (WD, chisel brush).

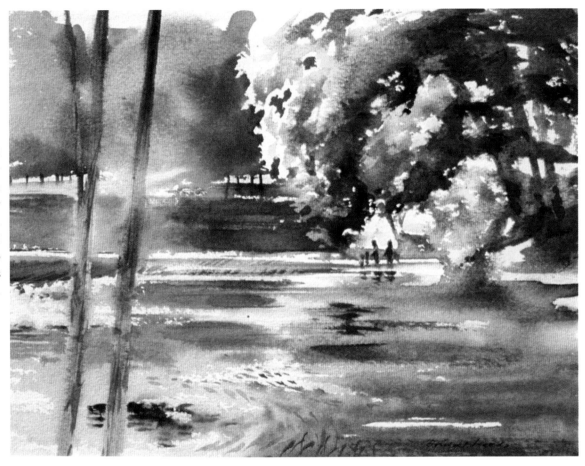

St Leonard des Bois. Intense sunshine and reflective water create an unexpected interplay of dark and light, negative and positive marks to intrigue the viewer's perception.

The picture plane

If you can see it, you can paint it. In reality, the brain can interpret 2D information 'seen' into 3D 'fact'. The representational painter takes a flat painting surface, re-presents the 2D information as seen and trusts that same process of interpretation to convey reality and invoke the illusion of 3D. This 'magic' relies firstly upon the ability of the artist to describe the Big Five information or 'clues' without being seduced into describing the 'answer' and secondly, upon the viewer's brain to reinterpret it as 3D.

For the objective or non-objective abstract painter, the picture surface is also a ground for the imagination of real or unreal imagery or design. This is another 'magic' and relies upon the artist's courage in challenging the everyday survival process of looking and, if the artist wants to communicate, a receptive audience.

The semi-figurative artist, led by the association of ideas and senses, treads a ridgeway between these two types of vision. To use and negotiate the magnetic pull of both photo-real and design formulae calls for honest authenticity and self-belief.

Nude Interlock. The figure is held within a framework of interlocking, sometimes dropped, 'threads'. Line is used here to drive the gaze, commenting upon the physiological gravity of sitter and chair and the notion of neural plasticity, using the visual devices of direction, flow, tension, lost edges and ease.

151

SHAPE – THE DRIVER

Using shapes

While the eye is attracted to striking contrasts of tone, texture and colour, shape is an important tool for moving and stopping attention. Although it is only visible by contrast of tone or colour, it is a powerful director that affects the rhythm of visual movement around a painting, which can be as varied as sitting reading, an ambling walk or fairground ride. Smooth, clear edges allow the eye to travel quickly and easily. A passage of long curves can slow the ride right down while bumpy edges or a corner can hold or shock the gaze.

Are there rules of composition?

For an undertaking as personal as painting, there is one criterion: 'Does this composition serve the overall aim of this painting as intended by the artist?' I have never heard of a compositional 'rule' that I have not also seen successfully broken in the search for this ideal.

Eucalyptus and Cotton (on pre-torn paper). Easy rolling shapes and white space evoke a dream of white cotton, eucalyptus, sun and peace. Thrilling.

Ra! In contrast, this image holds a cacophony of shape and colour within the explosion that is sun, blood and life.

It is the artist's subjective decision, dependent on personal history, which informs the choice of space, activity, rhythm and counterbalance within a frame. These factors in turn give significance to the actual shapes. The effect can be read very differently, positive or negative, dependent on context and relative placement:

Close together: tension, intimacy
Space: freedom, alone, loneliness, breathing
Symmetry: order, balance, boring, comfort
Asymmetry: disorder, dystopia, excitement

On a seemingly paradoxical note – symmetrical images accentuate colour after-images because rather than searching for information, the eye and brain are comfortably invited by the structure to rest and the colour receptors have longer to become more imbalanced before the gaze moves.

Just an edge

The facility of the eye–brain mechanism to interpret 2D to 3D can be used as a subliminal tool of direction or expression. For example, painted representationally, the visible inverted V of a road in perspective can be used as a dynamic arrow, or two-dimensional pointer, from here (wide) to there (narrow) or for its 'safe' pyramidal structure. Meanwhile, the viewer interprets and 'imagines' the two parallel edges of the road, three-dimensionally. Visual 'mind-tennis' can also be reversed if a road, painted as parallel-sided, like an aerial view, is interpreted as an inverted 'v'. This device can be used to imply a 'naive' childlike impression, a track so isolated and remote that must be imagined or viewed from above, a road map symbol or a compositional vertical implying power or sacrificially to accentuate other directional edges.

EXERCISE – GEOMETRIC SIMPLIFICATION: THIRTEEN SHAPES

Any intelligent fool can invent further complications but it takes a genius to attain, or recapture, simplicity.
E.F. Schumacher

The human body has its own geometry. We have straight(ish) bones that are destined to arc from the joints. The general centrification of our features and physical symmetry, horizontal and vertical, is played out on cylindrical forms. The shape that we can fold down to, and the whole range of our reach and touch, is ball-shaped like the world.

In minimal mark-making terms, we have a simple choice between curved or straight. This dilemma is hinged to the nature of the human body, which is in turn bound by an evolved response to the power of gravity and planetary movement.

What is this process good for?

- Exploring the effects of shape upon structure and visual movement and by association, the mood conveyed by a painting.
- Freely arranging and changing shapes creatively to stretch the limits of a finite subject and the artist's imagination towards the underlying power of abstract design.
- Exploring the simple basic structure within the landscape and discovering personal preferences.

What can you learn?

- A braver approach to any subject (no matter how complex), an ability to prioritize and the development of personal style.

Materials

- White, black and mid-tone grey paper
- Large sheet of black card (white on reverse)
- Camera

Method

Cut thirteen shapes: squares, triangles and circles in large, medium and small sizes, and two curved lines etc. from white, black and mid-tone grey paper. Throw them on a sheet of paper and 'live' with this random event for half an hour. Then group, spread, rearrange the shapes to suit you, photographing the results as you go.

For achieving greater simplicity in your painting, reduce the number of shapes that you use.

Then choose an image and paint it using either monochrome or colour but paying great attention to the tonal values.

153

How can this method be used?

An intuitive direct response will be developed if the process begins in a purely abstract way. Later, when the complexity of reality needs to be simplified, this structural vision will feel instinctive.

EXERCISE – MOOD THROUGH SHAPE

Materials

Mood words in an opaque bag for 'blind choice' (for example: safe, risky, dependable, sensuous, structured, aggressive)

Method

Dip in and pick a word. As before, arrange shapes as an abstract image, taking photographs, but this time to suit a mood. Then choose and paint etc.

If you have chosen a negative mood word, you may want to balance it up by consciously choosing a positive word.

EXERCISE – REALITY RESPONSE THROUGH SHAPE

Method

Then choose an image, write a few significant words that sum up your feelings about it. Arrange shapes that express your response to the chosen subject. Cut more shapes if necessary.

In order to keep the message clear and avoid photographically copying, reduce the major component shapes within the picture. Prioritizing will be necessary and it helps to paint from the arrangement without reference to the original image.

Also try using one image that expresses two moods simply through the choice and arrangement of shapes.

If you are working in a group, ask each other to guess the mood of the paintings. Some words are much easier to describe than others.

What is the outcome?

This may yield images that initially look mechanical but the process will develop your confidence and give structural strength to your painting. The marks may be curved or straight, small or large, but when we combine them we express ourselves in one moment in time.

Thirteen Shapes. The number of shapes can vary to suit your intentions.

Greyscale woodland photo. A complex subject was deliberately chosen for this sifting exercise.

'Risky' (arrangement 1). 'Bones' selected for a jumpy combination of white shapes on a black ground suggesting night and the unknown with falling and flying diagonals, curves and random spacing of disparate scale and shape.

'Safe' (arrangement 1). By using black and medium only with reduced contrast, the tonal contrasts are quieter, softer. Verticals and horizontals are encompassing, grouped.

Dorset Wood (safe painting). Light warm colours and symmetry have formed a cocoon.

'Risky' (first stage). Though the colours were chosen, the underpainting subconsciously suggested to me a bright and glowing circus with its potential for surprise.

'Risky' (painting). The dark second layer cuts into the gaiety, harshly isolating and colliding the 'performers'.

SCALE

Scale and distribution of image

Compared to the past, when few people could read and write and a big message could only travel aurally or a tiny painting take a long time to arrive, now a house-size image can be sprayed or printed overnight or a small image instantly seen around the world on large screens.

Scale of painting

A painting no longer needs to mimic a photograph but, given sufficient resolution, can be digitally transmitted at any scale. So, the artist's choice of working size is now open to many possibilities. Though the range of arm/hand movement, brush/paper size and portability have an effect upon a painting's size, with modern technology, the artist can now dictate the scale and distribution of the image to a greater degree than before.

Scale of shapes within image

Our sensory reaction to space and action is strong and when visually translated is a powerful tool of expression in painting. Dominance can be illustrated by changing the relative area of any element within the portable finger frame. Doing this will change your personal statement and, if you choose, your style.

For example, the sky above a flat horizon may be so light and airy that the scale brings a powerful emotional uplift, sense of longed-for freedom – or emptiness. However, low storm clouds, darkening that same sky, may have an oppressive effect on the relatively tiny painter. This sense of vulnerability may be

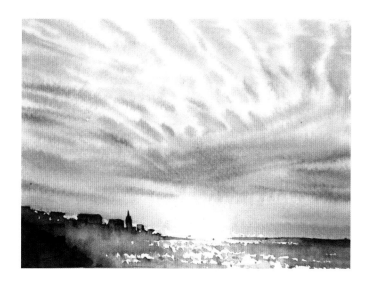

Tiny Sunset. Although this painting is 6 × 4in, it contains a world.

far greater in the country than if those same clouds were overhead in a town park or city street where trees or buildings dominate the field of vision and shelter is close.

EXERCISE – MOOD THROUGH SCALE: OUR IMMEDIATE ENVIRONMENT

What will you learn?

- By exploring extremes of scale, the artist will be better able to adapt their unique viewpoint in relation to a landscape.

Materials

- Cartridge paper: 3 large sheets
- Charcoal (minimum 1cm diameter)
- Plastic eraser
- Camera
- Painting materials

Method

With no outcome design or image in mind, play on a sheet of cartridge with the chunk of charcoal using it both on the tip and side to make marks of varying width. Photograph as you go. Spread the charcoal with your hand and fingers to make large areas. Turn the paper around.

Explore all the extremes of scale, drawing and pushing large or small shapes. Using the eraser and charcoal together, change the significance of large/small areas within any borders that you choose and change in the process.

Thick/thin marks
Even-sized shapes
Empty space (which may be medium or dark) and frenetic action
Figure and ground – try not to make lines and fill in; rather, by considering negative shapes, inhabit a middle or dark tonal region (not assuming that the mark is the shape)

Choose a landscape subject. Make two charcoal drawings (which do not need to be recognizable) to express two totally different ideas about the same view.

A remote distant view of the landscape, which gives it a grand, immense or impersonal feel as though the artist were apart from it. For example, the landscape elements may be compressed to small similar-sized shapes and viewed from above.
To convey the sense that the artist is small and within the landscape giving the painting a feeling of intimacy. For example, widely vary the perspective scale and place the eye-line low within the view.

TIP FOR ON-SITE PAINTERS

To adjust to this way of seeing, carry a set of geometric shapes (adding to and changing them frequently) and a colour magazine with lightweight paper. Quicker than using a pencil, less messy than charcoal, and avoiding laborious line, they can be used to freely doodle ideas, shapes, colours and size variation of action and space. If weather conditions are windy use a small set of shapes in a small notebook and fix them with non-permanent glue.

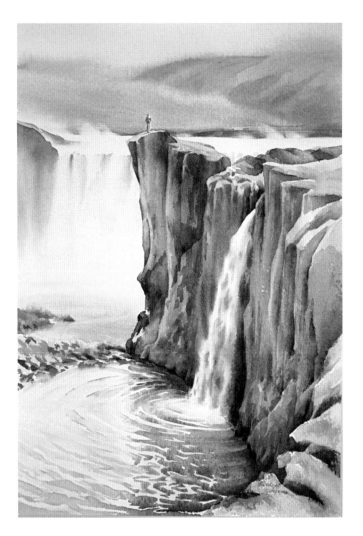

Goðafoss (crop). The human figure now has increased dominance, space and stability having gained attention as the only, small (i.e. precious), sharp mark (defined subject) in an equanimical (square) open world of curving horizontals. How easy is it to forget the original image?

Goðafoss (portrait). My response, showing human scale within a dramatic and precarious landscape.

Goðafoss (landscape). Here, the accentuation of a dominant horizontal changes the sense of stability but adds 'aloneness'.

RECESSION

Awareness of our surroundings, where we are in relation to immediate and distant objects, can give a sense of security or alert us to danger. To find out what is really there and how far away it is the brain takes visual clues from each of the Big Five.

The natural process of translating the perceived to the actual size, colour, etc. of objects, near or far, is efficient. So fast that to use it effectively in painting requires conscious observation of the original facts perceived. This awareness can be used for painting a refined expression of any relationship, whether it be 'person and landscape', 'two trees', 'three lemons' or 'four people'.

Imagine, find a photo of, or (ideally) observe a forest of identical trees that continue indefinitely into the distance, subject to the same lighting and weather, or any view with distance. To express what you see, it helps to identify the difference between near and far, comparing foreground and distant trees in terms of visual signals, the Big Five.

Aerial perspective

Particles of moisture or pollution in the air between viewer and subject will alter a clear view. This interference scatters some of the coloured rays of the spectrum of white light and changes the perception of both the real colour and tone of the object. The greater the distance, the more particles so the greater the change. Variety of particle also has an effect.

Blackthorn Spring. Although local colour and tone have their effect, this view contained most of the elements of aerial perspective.

I find it useful to intercept my brain's immediate resolution of the facts to 'normal' with an unfamiliar viewpoint by occasionally looking at the view upside down to more clearly accept and check the differences I really see.

Generally, the visual contrasts tend to be as follows:

VISUAL ELEMENT	NEAR	FAR
COLOUR	richer, more vibrant, towards yellow, orange, red, more visible contrasts, actual colour	towards purple-blue grey, less visible contrasts, particles scattering orange-red end of spectrum
TONE	generally darker, more visible contrasts	paler, less visible contrasts
SHAPE	more complex, detailed edges	less visible, simplified edges
TEXTURE	sharper, clearer edges, wet on dry, dry on dry	softer, blurrier edges wet in wet dry in wet
SIZE	larger	smaller

EXERCISE – CREATING A THIRD DIMENSION: A JOURNEY INTO SPACE

What can you learn?

- This exercise illustrates how to create the illusion of a third dimension on flat paper. Recognition of the visual relationship and difference between 'here' and 'there' encourages the search for technical ways to describe them which is as close to giving a spatial sense of place as possible.
- Because these paintings may end up quite mauled and muddy, this exercise really drives home the need to be alert, engaged and decisive in the first instance of painting.

Materials

Two paintings that look flat
Camera

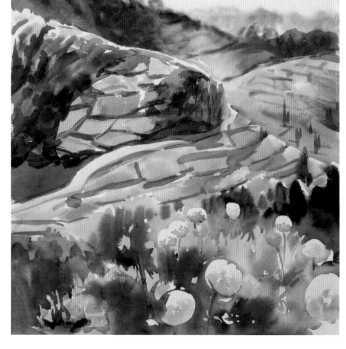

Madeiran Landscape (before additions). To challenge the exercise, this painting already had a degree of soft blue lilac distance and sharp foreground.

Method

Photograph the paintings in their present state. Then, by using all the above observations and methods, give them 3D depth, for example, by glazing opaque blues, adding WW, DW to the background and sharpening, brightening and adding clearer, large detail in WD, DD to the foreground.

Work two paintings simultaneously, adding another wash while waiting for the first painting to dry. Try different methods on each and take risks by freely wetting, dripping, tipping, using fingers and scratching.

What does this convey or express?

A more three-dimensional image in representational terms.

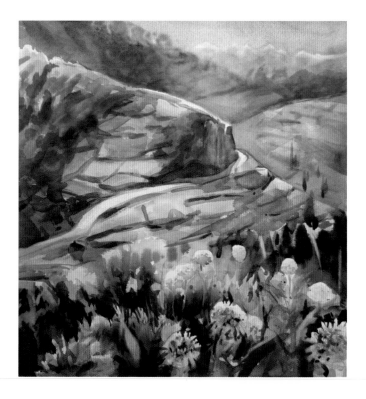

Madeiran Landscape (after additions). What seemed like brave visits to this painting (more than expected) proved in each photograph how ineffectual hours of tinkering can be.

ATMOSPHERE THROUGH RECESSION/ALTERED IMAGES

These same techniques can be used for less prosaic abstract ideas or expressing what it is/could be like to be me here, then, now or in the future. Spaces and the connection between them, describing not just independent facts but their relationship and interaction, are crucial for this.

An artist's view, animal reaction, whether subjective or objective within the environment, can be conveyed, when identified, in different ways by:

- Re-prioritizing the Big Five. For example, use texture, colour and scale to dominate if 'pollution in the landscape' is the message, or colour and group variation (scale) for wild flowers.
- Placing of the horizon, high or low. This can dramatically change the feeling of man's relationship with nature.
- Changing the image format, i.e. the height-to-width ratio of the painting. A long, thin strip in either direction tells a different story and presents different compositional challenges from a square format.

Glass and Ice. Tiny seedheads hold an expectation of life through the nadir of the year.

Glass and Ice (crop). Showing hard, black protection, the shiny whites of these imagined seeds were themselves preserved from invading water during painting by selective FB when initially wetting the paper.

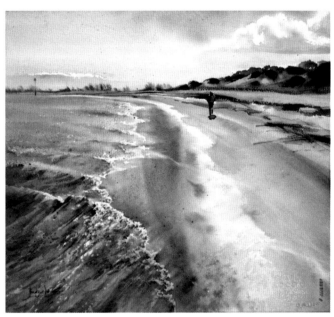

Winter walk. Relative scale, pattern, the horizontal/vertical interface and a desire to express multi-coloured foam without losing movement drove this painting.

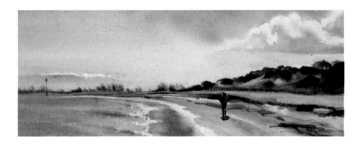

Winter Walk (crop). The mood changes and the figure becomes the unchallenged subject.

- Cropping the subject to make it personal when everything is visually tempting. Try a variety of selected areas.
- Changing viewpoint and eye-line – taking an unusual view, losing the familiar horizon allowing inventive play with the 2D picture plane and negative shapes, including the concept of figure and ground to intrigue the brain to search.

Use these ideas to explore structural and spatial relationships.

In studying and playing with the Big Five, you give your attention to your world and will receive far more in return. At any random moment, whatever you see either before you or on your 'inner screen', take time to reflect upon the painting possibilities that might express it. Play, experiment and research. The 'daily logbook' (ten minutes per splash) will loosen up the flow and those ideas will come tumbling out naturally.

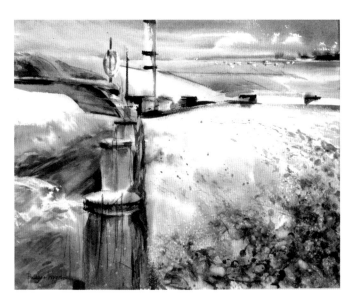

The Hinge. The proximity of water either side of the sandspit of East Head was in danger of cutting it off. Texture, curving rhythms and a low eyeline highlight the effect of the groynes against the sea.

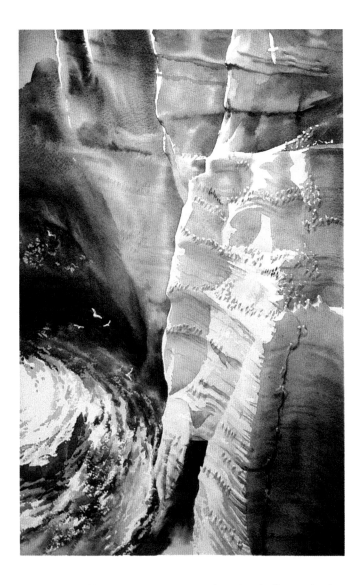

Kittiwake Cliff. A vertiginous view with an ironically comforting pictorial structure. So many birds called for masking fluid for each tiny head on the nearer cliff face, which was painted separately from the rest of the painting. To also underpaint the left-hand piece in one selective wetting, leaving dry shapes for flying birds and sunlight on water, called for nerves of steel and pre-mixed paint before the thrill of DT.

East Head. An aerial abstract of the same subject using shape and mark to express the contrast of timespan and the elements of man, water and sand.

'Little' Dunlin. While swimming one evening, I was aware of the large scale of these dunlin relative to the background figures. Normally small and timid, skittering along the tideline they were unaware of my presence. How soon, I wondered, back in 2004, before this sandspit belongs only to them? Painted from memory and reference material.

CONCLUSION

In concluding this chapter I am aware that bringing together the Big Five, the base elements of tone, colour, texture, shape and scale, for the pure gold of their subtle composite use, signals the start of the journey into the individual inner screen of experience.

Representational painting is comprised of visual 'nuts and bolts' which, given a shared view (or perspective) of the subject can be discussed, measured and described by the words, 'This is/is not like that'.

By contrast, in climbing the 'communication pyramid' to the narrower heights of self-expression, words relate less and less to the intimate language of emotive depiction, thus illustrating, perhaps, the very reason or primal need for choosing to paint.

Expressive painting is concerned with the experience of an event or idea which may be timeless or millisecond-specific; a whole sensation triggering a subtle emotion that transmutes into visual idea.

And, if watercolour is the medium we have chosen to express the layered palimpsests of our feelings and responses, then by comparison, the word is an ineffectual descriptor and, like a drunk at a party, can only haplessly wave around pointing, asking, 'A bit like this?' and mumbling 'I really love this but... I can't say why.'

When exact words begin to falter, makeshifts, analogy and metaphor step in. The following paragraph calls upon gambling (1), clumsy invention (2); and music (3).

The odds (1) that a feeling-image (2), translated into words in the mind and then spoken or written, will re-translate back identically to the mind of the reader are long. So the next chapter, which concerns the message of expressive painting, may be seen quite broadly as an overview of ideas which I hope will, at times, resonate or strike a chord (3) with the reader.

Oriel Wander. After a day's intense teaching I was keen to go for a walk and paint. Too tired, I decided instead to make a free painting. Only afterwards, I saw that I had to offload the passion of students' ideas as each one of them is referenced here (from Salvador Dali's 'Mae West lips sofa' to the 'flight of birds') before I painted the large sweeping arcs of my virtual wander from the bedroom window.

163

THE MESSAGE

Identifying and expressing your response to the subject

Life is a whim of several billion cells to be you for while.
Groucho Marx

IS HUMAN EXPRESSION AN IN-BUILT IMPERATIVE?

The earth and everything upon it behaves according to planetary movement within a cosmos so large that, at the moment, we cannot even imagine or, like the minutiae of our own neural activity, fully understand.

As a group of atoms existing within this gigantic sweep between large and small, the human may be uncomprehending, yet – to a greater or lesser degree – aware that everyday events are also unfathomable phenomena. For the human gaze, despite observable patterns, and cyclical familiarities, our situation is awesome; and we explore, try to rationalize, challenge or accept this situation.

The simple things are also the most extraordinary things, and only the wise can see them.
Paulo Coelho, *The Alchemist*

LEFT: *Fragile*. Looking up in a grand man-made futuristic complex to see tiny figures reflected in a single sheet of shattered glass struck a chord of vulnerability.

We may believe that we can express ourselves when, where and how we choose while, by contrast, a 'simple' flower is obliged to open its face to the sun, show its colours and hope that a passing insect, also driven by instinct to its centre, will pollinate and continue its species. Yet we too, are circumscribed: driven by genetic legacy from the past, animal awareness and habit in the present and by a developed capacity to visualize the future and express ourselves. From the exhalation of our first cry, we soon become so effective at communication that it is easy to forget that to expose our needs and share our findings and feelings is a prerequisite for survival. This may be decided less by choice and more by co-operative tribal programming and/or a primal imperative to relate to greater powers (for example, the sun, the earth or world-maker).

We 'show and share' vocally and physically in ways made unique to each of us by the influence of circumstance and culture – either directly in the live arts, such as speaking, singing, dancing, or, by proxy, through drama, music, writing, painting, sculpture or film, in which a creation is displayed as a representative of its author or performed by another.

Meanwhile, technology continues to develop methods which, by electronically messaging words, images and action has potentially affected live communication, social or artistic, yet which, by reaching a global audience, has led to an increasing awareness and appreciation of international arts. Also, regardless of physiological limitations, these developments provide extended or alternative means of personal expression on any scale.

The word 'message' is used here to describe the expression or communication of a sight, feeling, response or idea, in paint, whether that image is made for one person, many others or only the artist to see. 'Message' can apply to any image, rang-

Happy Flowers – Light Lunch. Sunlight can transform the everyday.

ing from a photographic celebration of reality, a single emotive mark, an ambient texture describing a sound or the visible cosmos, to a non-objective abstract pattern or linear symbols.

Creating a message with watercolour is an activity available to everyone, regardless of age and background. Its portability, brilliant and now-lightfast pigments and non-toxic materials give it the potential to democratize self-expression as a combined mind, body and spirit activity for all, without harming the planet.

No one is too important or unimportant to express, signal or share by making a painting. As a means of personal statement it is not the preserve of the few and even when the artist's original message is not understood or we ascribe our own interpretation, from portrait miniature to graffiti, an artefact can cause lively debate, whether it be Leonardo da Vinci's *Mona Lisa*, Malevich's *White on White*, Damien Hirst's diamond skull, *For the Love of God*, or a painting of flowers by Winifred Nicholson.

> *People are capable, at any time in their lives, of doing what they dream of.*
> Paulo Coelho, *The Alchemist*

Confidence and bravery

If you sometimes find it either difficult to get started with a new painting idea or rejoice in successes, please be assured that you belong to a very large group (of which I am a member) and consider the following.

To create something which has not previously existed is already a daring thing to do, but creating it in a way that is different (not only to the rest of the world but also to 'conventional you') takes courage. It is important to listen to the ideas of your quiet inner voice and whenever they arise immediately write, draw, vocally record or 'sketchpaint' them to hold onto their vision. Doing this reinforces what you may already feel but also acts as a memo and by habit will build and strengthen an inner support team.

When we 'take the risk' to create something new, the effect of change may delight and excite our eyes and senses but unnerve our safety needs (for example, approval or paying the rent). So, in the early stages of development, do not look around for affirmation but be your own guide and counsel. Show your work when you have developed a greater confidence in your message and can step out onto the firm foundations of that honest and genuine statement. Then, you will not be knocked off balance if others, whether family or gallery owner, do not like or

Sketch for *Boudicca*. A brilliant model drawn from ground level inspired freedom of marks.

Boudicca. The charcoal sketch encouraged more daring marks in paint.

approve of your changes, but know that you have a choice to conform or follow your path. Without financial income or patronage, expediency can drive this decision, even (often especially) for professional artists.

There is no shame in conforming when necessary.

Nothing hides behind the patency of authenticity.

Originality is rarely familiar or comfortable at first.

As for approval, looking at a painting is easier than making one.

WHAT DO YOU WANT TO SAY?

There are widely differing reasons for wanting to paint. Some can be straightforward: the conscious, urgent need to communicate a political idea or the exploration of another artist which nestles in derivation or conversely, the unconscious experience of physically making marks, totally regardless of the outcome.

Others are more quicksilver and elusive to define but precious to the artist. Writers and poets may relate the effects of a vision in words but nothing compares to a splodge and spattering of yellows floating across partially wet paper to cheer the body and spirit without alluding to its meaning or calling it *Daffodils*.

Identifying what you want to paint

ASSOCIATION

Have you noticed how a place, even a photo, can evoke a sensation that is quite strong yet intangible? A flavour, a quality that is the result of a uniquely prioritized sum of the Big Five plus other factors like sound, smell, weather, health, company and mood. On another day, the same place, although objectively identical, can feel totally different.

If the experience of a place is new, a describable response may

not be immediate because the senses and memory, alert, taking in, scrambling, rushing to liken and compare the new to the known, are too busy to pass an overall appraisal in the present moment.

Equally, if the place is familiar there may be less conscious sensation but for the opposite reasons. A few reference points, recognition of surroundings are sufficient to allow us to say, 'I have come home, there is no need to be hyper-vigilant, I can relax.' It is no coincidence that horror films often use the background of safety: home, friends, routine, family, holiday, for example, to lull the viewer's senses and increase their sensory shock when the 'threat to survival' suddenly appears. While writing, I shudder even now, recalling the worst screen moments of fear, psychological and physical, that I have experienced.

Equally, the sensory 'view' can suddenly change when a positive surprise like an unexpected letter, smile, sunray, flower or small patch of blue sky after rain transforms the familiar backdrop.

We are continually noting relative differences and 'samenesses', using them for survival, comfort and entertainment. Sense-brain messaging can even reawaken other related sensory signals in both the present and the past. For example, when, in the present, I distinguish the sound of a Morris Minor car from other traffic, I can 'see', then 'smell' and 'touch' the interior of the car that I drove many years ago.

Mother and Baby. A clear 'story'. I was prepared to work fast and small but this baby and mother were so peaceful that apart from a page of paint sketches I also managed to make two half-sheet paintings of this timeless subject, of which this is one.

SIGNIFICANCE

I showed a city-dwelling friend a photo of lava: a curving, scarlet, molten stripe on a dark brown-black hardened ground which, drawing on her visual memory, she guessed to be car lights in a rush hour winter gridlock.

This association is inversed in an anecdote about Marlene Dietrich who was, apocryphally, happy to be stuck in a traffic jam on a rainy night on the Champs-Élysées, because she was 'enjoying the line of rubies going up and sparkling diamonds pouring down' towards her. Coincidentally, it is molten magma that brings 'jewels' nearer to the earth's surface so this visualization links neatly back to the lava stripe of 'car lights'.

Outside Inside – Harbour Dawn. A boat offers both inner and outer existence and change.

Gloaming and Glimmering. Though the title suggests light conditions this painting attempts to leave space for individual interpretation. That 'water' is commonly perceived illustrates how eager the brain is to make sense of little information.

These relative qualities, stored familiarities, links and responses are often the inspirational factors that drive a person to want to paint. Observing, identifying and recording them is a kind of loving through paying attention with a curiosity to know more. It is either accompanied by an urge to share or just to put 'out there' for yourself as audience, to make your mark, repeat, remind or learn from.

Links between the senses are powerful tools of expression available to artists. A link, when expressed in a painting, may be so general that it is classic – for example, a painted Madonna and child in its representation of archetypal mother and baby, may be understood and felt by everyone – or so personal that no other culture, gender, age group, family or (to use my previous example, non-Morris Minor driving) person will know the same feeling.

Past, present and future

So, these visual associations vary depending on the individual history we have laid down. Each human brain will automatically search stored memory for links with its unique past in order to decipher the present for the sake of survival in the future.

At the end of a day's teaching, whether portraits or life drawing or landscape, a mottled floor or surface can appear either as faces, bodies, skies and trees because my brain is currently searching for that information. Leonardo da Vinci consciously used this method to envisage a painting and simplify its composition:

Outside Inside – Summer Cool. One of a series exploring association and assumption, the outside here suggests the control of formal topiary while nature roams inside.

Look at certain walls dirtied with various stains or with a mixture of different kinds of stones. If you have to invent some scene you will be able to see in them a resemblance to various landscapes adorned with mountains, rivers, rocks, trees, plains, wide valleys and hills. You will also be able to see various battles and figures in quick movements, and strange expressions on faces, and costumes, and an infinite number of things which you can then reduce into separate, well-conceived form. With such walls and mixtures of different stones the same thing happens as it does with the sound of bells, in whose pealing you may discover every name and word that you can imagine.
Leonardo da Vinci
(from *Leonardo's Rules of Painting – An Unconventional Approach to Modern Art* by James Beck)

CAN WORDS HELP?

Stating and naming

Can words help to describe what the artist aims to express in their painting, both generally and specifically?

I believe they can be helpful either for the artist, or the viewer, or both, or neither, depending on the individual and the circumstances. Familiar examples are 'the artist's statement', the 'title of the exhibition' or artefact. Arguably, if painting is the chosen means of expression, all could be considered superfluous. Added words can detract from, interfere with or overwhelm an experience originally deemed by the artist best explained in visual terms.

Equally, for the artist, words can serve as a working tool, a useful focus or structure for visualizing their practice, which may incidentally draw the viewer towards their aspiration and 'set the stage' for a positive response. So the code of written letters can offer an intentional addendum to enrich, offer clues, or drive the interpretation of the viewer.

Words can also partner an image to create a combined sensory experience.

Do words help or hinder the transmission of an idea?

When I am painting, key words spring out unbidden from the image to describe it, so when they are in my mind they are reinforcing the intention of whole picture. For me, letters and numbers, both spoken and written, have links with sound, pitch, colour, tone and texture. Colours of letters or numbers make word and number pictures. In combination, as phrases, sentences, or telephone numbers they can describe a whole image. So I mentally use them to identify artwork and, more practically, to preserve both the original feeling of a piece in the making and the location of the physical painting itself. Each image has its own unforgettable history.

Critics, art historians, television and democratization

Websites, publicity and reviews often offer a description of an artist's aims as a condensed verbal aid where one single image may be unrepresentative of their whole output. Sometimes, though, by the time an artist's underlying reasons for painting have been converted into words or the results described by a professional reviewer, the distillation can be unintelligible to

Regeneration. For me, the letters of the word itself have made this painting. If they were rearranged to have no meaning the colours would remain the same but the shapes would be different.

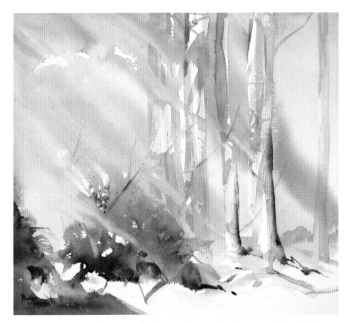

Winter Wind. The visual description of ephemeral, invisible energy and time link me to watercolour.

susceptibility to believe the 'written word' and my scepticism of it are just a few other important factors.

Experimenting and trialling can identify whether, and how, words can help you in the making or showing of your work. Nevertheless, they are subsidiary considerations, which like satellites only orbit the magnetic heart of the painting process, namely, its intention – even when that intention is open-ended exploration.

EXERCISE – LOGOVISION: WRITE/SPEAK YOUR STATEMENT

What can you learn?

- With the caveat that painting is neither writing nor speaking, view this process as a personal experiment to see whether words can assist any or all of the following: you, your painting, your audience.
- To discover and develop word and image connection skills which may raise and transform subconscious ideas into conscious images.

Materials

- Large sheet of plain cartridge paper
- Pencil, charcoal and eraser
- Painting materials

Method

Scribble down in pencil anywhere on the paper any ideas in words that conjure up subjects, images or methods that you would like to explore with your painting. Phrases or single words are equally good because they can be rearranged, prioritized and put together into a sentence. Erase, repeat or re-place words freely. Use charcoal, narrow or broad, to accentuate key words or smudge it, allowing this friendly medium to move between words and image, if it feels natural.

If writing feels difficult at first, talking may be easier. Use a voice recorder or carefully choose a friend or mentor who supports your creative self with whom you can share your painting aspirations. It is helpful to record this conversation for playback. Note which words and ideas are repeated and feel genuine.

some of us, leading the reader to feel either included in a comfortable club or excluded by a sense of elitism. I advise moderating both sensations remembering that words are only a code used by a person who, just like you, has a subjective view.

> *...all this talk of art is dangerous, it brings the ears so forward that they act as blinkers to the eyes.*
> Edwin Lutyens

However, in the actual process of painting, hold onto and cherish any hooks that link you to your message or remind you of the reasons why you paint and have chosen watercolour. If that feeling or associated image can be identified and brought readily to mind with words, use them as a trigger to revive confidence or to stay focused while developing your skills. Words, used as an internal dialogue, can keep an artist going on the journey.

Do words detract or add to the image for the viewer?

I am not a fast reader, often struggling with long explanation panels in galleries where a visual experience can be marred by colour, tone, font choices, clarity, lighting and noise. I want to be simultaneously reading and looking. My reading ability, my

These processes can raise hidden desires from the unconscious and formalize them in a way which many artists find invaluable. Once identified, the idea has given feelings and 'inner screen' a form which, as an intention, is only a short step away from realization.

With no expectation, freely experiment with small painted sketches that begin to consolidate your visions.

How can this help the painting process?

This experiment can steer a haphazard approach, often distracted by habit, peer group pressure or sales success towards identifying and confidently expressing you, the individual, as you develop. It can also establish a neural link between the visual, aural and written idea.

Using pencil and charcoal can give volume to thought. Note your ability to stay with words, the desire to expand with images, and whether that was through line or form.

Do not fix your aspirations: this word-vision can apply to a lifetime goal, one specific painting or today's general approach, which may already have changed by this evening. If this process works for you, then use it regularly to gradually form the underlying message that constitutes your evolving statement for yourself or the world.

Also try painting from a poem or piece of prose, or write your own to illustrate.

HOW TO EXPRESS AN IDEA/FEELING – TOOLS NOT RULES

Each element of perception touched upon in previous chapters has its own direct descriptive significance. For example, rough or smooth (texture), light and dark tone (day or night), bright, dull green, red, grey (ripe or mouldy) curved or straight (organic or man-made), large or small (relative to human size). By their juxtaposition and editing, a specific or subtle response to the subject can be described as a three-dimensional world represented on a two-dimensional surface.

However, the power of association and suggestion is so strong that simply by the composition of these visual clues for the seeking brain, the painter can let go the ties of verisimilitude and paint an idea or, especially with the transparency and speed of watercolour, the notions of a fourth dimension of time,

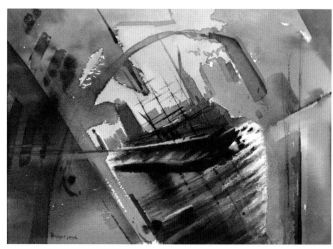

Thoughts on a Warrior. Part of the history of a busy harbour, *HMS Warrior* is passed daily by craft of all sizes speeds and intent.

chronology or levels of consciousness.

Sources of material

There is no substitute for painting in situ for a complete sensory experience but the driving response to any subject is an internal one. This may mature over years of attention, suddenly be triggered by a peripheral glimpse or hauntingly revived by a photo, garment or smell. Distance of time (which can add clarity or safety), gathered skills, and changing experience are a few of the factors which make creative expression, rather than fixed reportage, a multi-dimensional and unrepeatable event.

Using the Big Five to make your statement

When painting in the studio, where physical conditions are consistent, I sometimes start by making a full drawing either in charcoal or pastel to get to know the subject. This allows initial response to develop and, like a bubbling cooking pot, helps to rebalance the Big Five, erasing and fine-tuning until the sum total accentuates what I most want to express. Painting is then a natural progression.

Currently, optics tell us that the eye receives only tone and colour information (stimulation) and the brain usually makes sense of it, using its individual memory bank for comparisons. For example, 'If the tone and/or colour begin and end here, then the object must be that shape, texture and size; I know what that is, I've seen one before.'

If a painting gives us all that information and, especially if the subject is a familiar one, then the brain has very little work to do

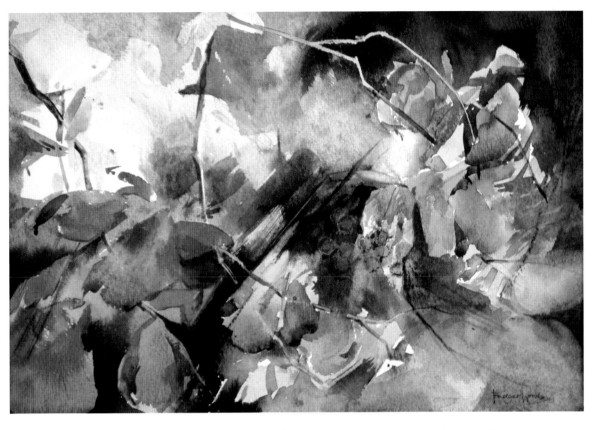

Eucalyptus – Summer Breeze. Ever-present, the subject of my logbook offers daily surprises evoking spontaneous response and finger painting, as here.

and the resulting message will be literally mundane – 'of this world', anyone's world. By personalizing the viewpoint or by accentuating, eliminating or selecting aspects of our subject (however mundane) we automatically intrigue the viewer's brain and say something specific and different about it. Through individual prioritization, expression of your world-view is entirely yours.

The tools of navigation

Navigating around the image with colour, tone, texture, shape and scale passages (similarity) and contrasts, the artist can direct the eye around an image using directional edges at varying paces, sliding, pointing, ordering and jumping, either quietly or with command. Collectively, these methods can constitute different interpretations of the same subject to create an individual message or mood.

Do not be restricted by convention but consider the following contrasting ideas:

- Visual unity/variety
- Photoreal/abstract
- Ambient flat pattern that conveys mood/story-telling with obvious focal points
- Fact/fantasy

- Past memory/present reality/future visualization.

Confidently accept that the more specific your own message, the more refined your audience may be. By contrast, in a visually noisy world, commercial images may employ ever-louder, larger elements to attract the consumer in the race for sales. The focus here, however, is upon personal expression and communication.

EXERCISE – SAYING ENOUGH: LOST AND FOUND EDGES

Materials

- Chosen subject (photo or reality)
- A2 drawing paper
- Pencil/charcoal (i.e. monochrome erasable media)
- Camera

Write down the title of your piece. This could be a place name or words that relate to your feelings about the subject, using any associations. Make an accurate toenail sketch on a large sheet of paper. Photograph.

Then freely add more marks that express 'non-visibles', like

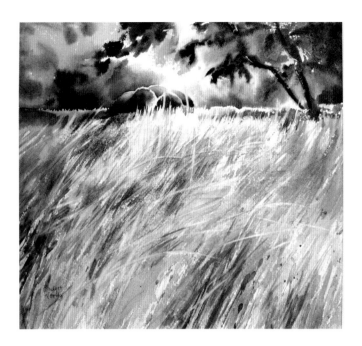

Sunlight – Long Grass. Timelessness conveyed by the soft, ambient surroundings of midsummer.

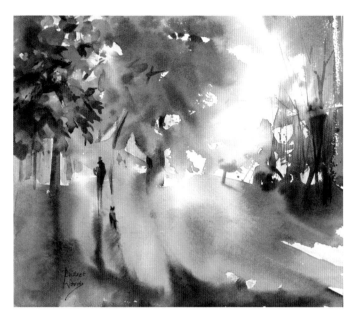

Low Autumn Sun. Dazzled by golden early light, the lack of information is the story in this painting.

sound or mood, for example, and photograph it again.

Finally, selectively erase tonal contrasts to leave just enough edge clarity to define your priorities.

The drawing begins clear-edged, becomes more noisy and only finally becomes quieter, diminishing to leave a few astringent, chosen moments of clarity. The safe, typical watercolour build-up from soft to sharp to detail is actively reversed here with different media. With practice the watercolourist gains more faith in the indeterminate edges of WW and DW not only to 'say enough' but by contrast, to accentuate the important. It also encourages a freer, looser approach.

> *Life is really simple but we insist on making it*
> *complicated.*
> Confucius

EXERCISE – BIG WET IN WET

This galvanizing process is brilliant for loosening-up and losing fear of white paper, or 'white fright'. Start by soaking paper, then enjoy the paint and allow the suggestive quality of soft marks to speak.

Choose a subject and paint the whole subject WW and DW in one go. If necessary, prepare colours in advance to give full attention to the wetting process. With experience you can mix colours while simultaneously wetting the paper. Allow yourself

only 5% sharp-edged marks, no more. If darker than the under-painting, these can be painted when it is dry. If they are lighter or brighter then the paper should be left dry at those edges when preparing the paper. No drawing is allowed except for the 'light/bright' edges so that you know where to leave dry and not to wet. In this case draw clearly and a little larger than the shape to avoid graphite dulling the mark. (It is always easier to creep with water/paint, to reduce a reserved space than make it bigger.) To stop the paper cockling towards these dry shapes, wet the paper on the back to compensate for the uneven expansion.

How can this help the painting process?

When painting on site (to hold onto a concept, the weather, or the model's short pose), working, without sketching, straight into a wet surface displays the supreme advantage of watercolour both for speed and the expression of direct response. It also tests and enlivens the artist's acuity of observation, which can easily become 'flabby' if lengthy initial drawing has become a habit. This process can either lay down an underlying mood to permeate or plan the whole painting, acting as a contrast/complement to a little subsequent surface work, or constitute the final image if immediately developed with DW and other soft-edged marks.

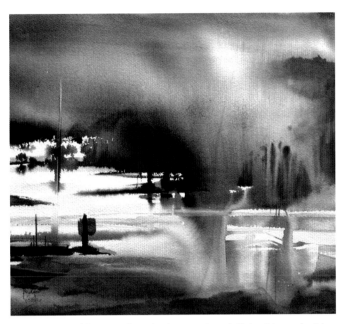

Winter. I could remember the ice, post and distant trees but in the absence of information on the right, I used colour and texture to convey the coldness and softness of snow.

Visualize – from a clear space

This doesn't preclude painting dramatically, even angrily, it is simply a way to relax my body and to empty and focus my inner screen. Although I still sometimes sketch, making several exploratory pencil or charcoal drawings or freely onto the watercolour paper, I usually explore directly with a clean, wet brush on dry paper. This soaking time gives me an initial connection with the paper and time to visualize and prepare my paint. I often start by focusing on the subject, 'feeling' my way round with the brush, inside and outside the positive or negative shapes that are important (often, if the subject is from memory, with my eyes closed). Even though I may eventually wet the whole sheet, my eyes, brain and muscle memory have explored and responded to the subject.

While it is important to have and hold an idea for a painting in mind, I try not to let the idea of the success of the end product overwhelm the execution of painting and to be in the moment that I am painting. Sometimes I wet the paper instinctively and pour on paint. Doing is the way to skill and direct watercolour expression and is only a struggle when harnessed too tightly to the idea of future result.

The difference between a formulaic process and expressive watercolour is that one guarantees competency, repeatability, safe 'gratification' and similarity whereas the second is a riskier personal event which speaks directly to its maker and reveals the mood and the moment, warts and all.

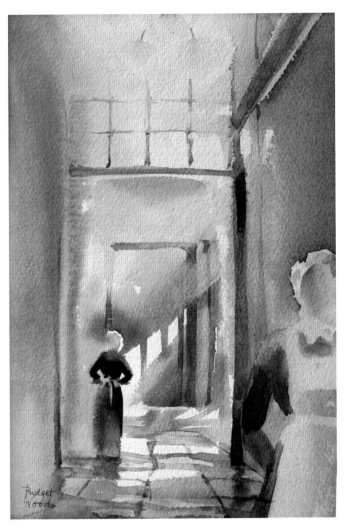

Petworth Passage. To imply ghostly figures and movement I kept the distinct edges few, keeping only the sunlight sharp and strong as the persisting element in a world of comings and goings.

Whichever, it is in this act of letting go, submitting to a trust in the relationship with water, that the artist experiences the adrenaline rush of watercolour.

EXERCISE – FINDING A PERSONAL WORKING PROCESS

I find this practice prepares me for painting, regardless of the time available. Keywords are:

Still – physically quiet
Calm – mentally quiet

175

I want you to be everything that's you, deep at the centre of your being. They must often change, who would be constant in happiness or wisdom.
Confucius

Not in the bin – time to begin

However, the experience of painting may be fun but when the result is not as planned, then learning begins. Take time to physically stand back, move around and consider the next course of action. If the result-harness was too tight the ego will be sore so be kind to it and enjoy a stretch.

If results (future) dominate the mind because experiences (past) have hurt, it is impossible to be paying attention, loving, now (present). Balancing skill, awareness and risk is crucial for progress. It is as easy to be brought up short by skipping observation as it is to lose the message to the detail.

DEVELOPMENT OF IDEAS AND PERSONAL STYLE, AND GETTING UNBLOCKED

Here are some techniques that I use for relaxing or unblocking.

Switch off to regroup – stop to start

For those moments when a strong urge to paint cannot be fulfilled for various reasons of which these are a few:

Too many ideas
Not enough time to focus
Do not clearly know what to 'say'
Cannot get outside to paint landscape
Fear of failure
Self-admonishment: 'I am lazy. Surely painting is "merely" a
 question of putting the right colour, tone, texture,
 shape and scale in the right place?'

The accelerator of self-imposed demand is full on and so are the brakes of tension. Panic mounts and feels painful. These conditions will not allow the free flow of creativity. Each artist tends to prioritize visual elements with, for example, a typical preference for tone and texture but an overwhelming colour response to certain subjects. Some artists aim to refine their own prefer-

ences towards an idiosyncratic style, while for others the goal is the ability to respond freshly to any situation.

So, switch off for a while, visit your own gallery and take stock. Make a display or photographic contact sheet of your recent paintings and, listening only to the inner voice, 'window-shop' what you would wish for, for example, richer, more varied, subtler colour or more or less dynamism in shape or texture. Referring back to the appropriate chapters in this book, write yourself an exercise that would develop a change of balance.

Take a wander into abstraction

Ostensibly, the idea of leaving behind the constraints of realism and message for pure abstraction suggests a sense of release to freedom. However, expressing nothing but oneself is an exposure that takes as much courage as it promises liberation. Seeing and identifying an inner vision is challenging in a world of so much visual and aural 'noise'. Although external influences do affect our behaviour, to try to be inauthentically different defeats the purpose of self-expression when the excitement lies in finding ourselves.

A way of relaxing into and developing personal language is to freely make marks with different tools, including hands and fingers, applying different angles, pressure and speed. Led by 'what if?' and 'why not?' follow a wandering line of enquiry, thought-scribbling between paint, music and dictionary. Covering paper with marks, doodles and experiments raises an instinctive physical response which can lead to unfamiliar territory. It is important not to make immediate value judgments but accept that a directly made mark was relevant to its moment and move on.

I then live with these statements on the studio wall – both to assimilate them and avoid falling prey to one of the 'No-Win Twins' of my perception: one 'good-looking' who supports the safe, known, comfortable and skilful (which can often seem boring) and the other, a 'rough diamond' working towards the strange, unsettling, new and exciting (which can initially seem ugly, inept or childish).

The No-Win Twins are the siblings of the 'baby that got thrown out with the bath-water' and how often, in the heat of the moment, have I blotted an appropriate mark just for its lack of surprise or scrubbed at and tempered a raw, descriptive mark because it shook my vanity?

I try neither to ignore or become subjugated to them but recognize their role and, to maintain balance, often counter each voice (out loud if necessary) or fix their taunting, but useful, dialogue in writing.

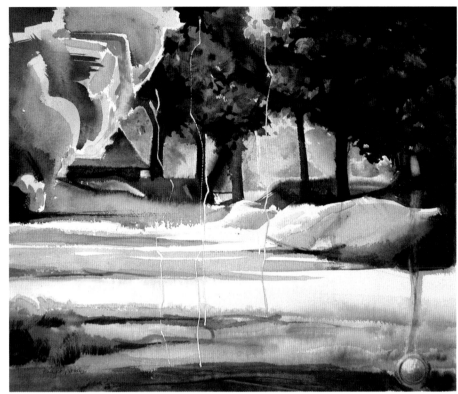

Retreat. A place of gentle kindness expressed in a structure of cool, calm protection with falling sighs.

By three methods we may learn wisdom: First, by reflection, which is noblest; Second, by imitation, which is easiest; and third by experience, which is the bitterest.
Confucius

EXERCISES – WITH HOMAGE TO…

Copying is giving attention, love.

With homage to reality

Do not be ashamed if your reason for painting or drawing is to accurately copy something representationally or photographically. By giving out your attention to any external subject and taking its visible nature into your awareness, you are connecting with and memorizing that external something, which will enlarge, enhance and enrich your life. Non-judgmental attention is a form of love. Whether the subject is from reality or a photo your product will bear your mark.

Remember, this is your life and your sheet of paper to do with as you wish.

With homage to another artist

The feeling of one artist's work speaks to another. While trying to express our own sensation, we suddenly see a painting which either points in a similar direction or simply amazes us technically. I believe that this is neither sudden nor a coincidence: rather that by searching, we put ourselves in the way of clues.

'I know how that feels. How did they do that?' Do not hold back but find out. After all, copying is only an arrangement of the Big Five, in the right order.

For me, this experience has always offered treasures. To be able to:

- Step into the shoes of a painting hero;
- Understand and learn new, technical, often 'risky' procedures;
- Use unfamiliar combinations of colour;
- Often feel that my version is 'better' – not through arrogance, but an appreciation of living paint versus print and respect for my own quirks;
- Have a sense of arrival somewhere new but, as though refreshed by a 'drink break' on a hot walk, feel a strengthened urge to get back to my path and move on;
- Remind myself that although 'taking refreshment' or

copying is relatively easy, someone else developed and made the original and acknowledge that fact to spread public awareness of the artist (especially those who are living).

With homage to yourself

Close in on one of your own favourite paintings and see if you can identify why you like it. Then copy it, allowing the previous exercise to influence its development.

Love is the greatest refreshment in life.
Pablo Picasso

EXERCISE – TAKE THREE WORDS

Randomly open a dictionary or encyclopaedia at three places to pick three words. Ruminate around their juxtaposition and what might describe them visually, however surreal the image. Freely 'wander' onto and around the paper with a brush.

How will this help my painting?

Having a subject chosen by you but by chance can break habits of subject choice, open the mind, inform and develop the imagination.

EXERCISE – TRUST YOUR MESSENGER

As science seeks to understand the outer and inner spaces of existence and the behaviour of man, veracity is continually challenged. But each person is a solitary witness with a unique and biased reality.

For an artist to make a 'photo real' painting, the complexity of 3D facts must be present but the experience of a situation lasts in the memory, kept alive and morphing as it is recalled and compared to subsequent experience. Which of these is closer to the truth? Is truth single, finite, measurable, definable or flexible? This exercise explores a description of the truth via the 'facts of feeling' through drawing and painting.

Choose a photographic image of your own to draw. Make a tonal charcoal drawing of your subject as accurately as possible. While drawing, muse on the feelings that you have for your sub-ject, and why you chose it. Select and write down several words to sum up your response to the subject.

Put the original photo away where you can no longer see it and mentally let go of it so that now you will trust the drawing as a 'messenger'. Then, with eyes closed, focus only on your words and go through the Big Five checklist visualizing: What colours? How many? Primary, secondary, tertiary? What percentage of each? Would great contrast or subtle range best describe them?

What overall rhythm does the image have – staccato or lyrical, symmetric or asymmetric?

Then take a new sheet of paper and referring to the image in your mind, freely redraw your existing image in coloured pastel, perhaps changing the format and allowing the image to wander into complete abstraction.

Then put the tonal drawing away and, trusting the new 'relay messenger', refer only to your pastel, making an image in watercolour which continues to distil the feeling from the facts.

How will this help my painting?

By slowly and methodically following this process a few times with a variety of subjects, this develops the confidence to express an honest response to any subject, whenever, anywhere you choose, without getting bogged down in the 'facts'.

In no case do you get one answer which is universally accepted because it is true: in each case you get a number of totally incompatible answers, one of which is finally adopted as the result of a physical struggle. History is written by the winners. In the last analysis our only claim to victory is that if we win the war we shall tell fewer lies about it than our adversaries... But I still don't envy the future historian's job. Is it not a strange commentary on our time that even the casualties in the present war cannot be estimated within several millions?
George Orwell, *Tribune* 4 February 1944
(© estate of Eric Blair)

EXERCISE – THROW OF THE DICE

Painting is largely about choice. There are times when I can no longer 'see' my painting (in particular or general), decision-making faculties are exhausted and a type of myopia takes over (as it can with millimetric changes to a portrait). It becomes difficult to see the woods for the trees and every painting begins to

Rain Window – Arvo Pärt. Painted indoors on a rainy day to Tabula Rasa, music by Arvo Pärt. Associated words were: tender, thin, anxious, wire, profound, glassy, stretched, glazed, sadness.

feel 'samey'.

At times like this I relax and allow my creative energy to breathe by letting chance take the strain.

I have a normal dice and have converted a second that has each of its six faces labelled with, for example, a colour, tone, etc.:

6 colours: rose, yellow, blue, scarlet, green, purple
6 tones: white, light, medium light, medium dark, dark and black
6 brushmarks: WW, DW, WD, DD, SOS, FB
6 shapes: curve, vertical, diagonal, round, square, triangle
6 styles: organic, geometric, ambient, minimal, busy, serene
6 moods: happy, sad, quiet, noisy, tight, loose

These are only examples, which can be used in any way to apply to any source material. First write a list of your selected categories and for each of them, throw the normal dice to find a number for, say, how many colours are to be used. Then throw the marked dice that number of times to determine them.

Continue with the other categories, e.g. four colours, two tones, one mood etc. Then interpret or design your painting without deviating.

How can this help my painting?

In the short term, it rests the brain and stops fiddling with minutiae. In the medium term, by prioritizing visual facts in fresh ways, it eases up and stretches the mind, revealing new pathways, processes that can question habits. In the long term, this 'game' can direct a sea change for individual expression. Though the aspect of chance may be random, a subconscious, nagging desire for redirection can slip through with the process because in fact, the artist designs the overall game plan and controls the number and type of potentially infinite variables.

Fixed categories and random chance offer the artist a paradox: permission to paint anything within strict rules.

Just playing with water and dripping in colour can de-stress and untangle blocked creativity. The time and the paper are never wasted. It is not possible to put brush to paper without learning something because your brain and muscle memory store the experience for next time.

PARADOXES OF WATERCOLOUR AND PAINTING

As an experienced, but still learning, watercolour artist, I envy absolute beginners the first time that they stroke dripping brushloads of colour across wet paper, watching colours run and mix when tipped. The moves may be repeated but that first personal discovery never will be.

Because beginners are often more concerned with control and outcome they sometimes miss the thrill of the event and apologise for the glorious marks that they perceive to be a

messy accident.

As an onlooker it can be at once exciting and heartbreaking to see creative play subjected to judgmental duality and favouring the negative. Watercolour continually encourages the artist to let go and exchange the desire for conscious control for an awareness in the very moment. Engagement with, and observation of the material now, brings the skill that allows the artist to be aware in the act of painting in the future. This cycle is another aspect of the serial nature of watercolour. Development often appears in the next painting.

As an artist, this principle still drives me forward, to imagine and stretch out towards more moments of discovery guided by the question, 'I wonder if...?'

> *It took me four years to paint like Raphael, but a*
> *lifetime to paint like a child.*
> Pablo Picasso

What are the ideal character traits in a person for painting watercolour?

Aspirational – to set your own (not others') goals and
 standards
Methodical – to make and follow a plan
Optimism – to believe in progress
Courage – knowing that the marks will always show
Sensitivity – to be aware of sensory links, response
Visceral – raw, animal response
Daring, foolhardy – to risk an idea with no planned
 outcome
Reserve – to gently breathe in inspiration, contemplate
Spontaneity – to respond to the behaviour of weather,
 water, mood
Patience – to wait for paint to dry
Eagerness – a positive desire to paint
Anger – can often flag up real desires
Serendipity – to enjoy and use the unexpected
Perseverance – to make another painting
Curiosity – to explore different conditions, ideas
Kindness – develops even-handed appraisal
Factual – accurate, objective
Imaginative – dream, 'inner screen'

The list could go on until there is a realization that few people have all those characteristics and that all traits are useful. The dominance within us of certain qualities over others determines our uniqueness and personal style.

Breaking habits

As little as one conscious attempt at a different method taking just 20 minutes can break the enslavement of a lifetime habit. It is simple to create a project which can break a habit and develop different behaviour. For example:

- Do you really want to paint faster? Set a timer to make several paintings in an hour to find ways of speeding up painting.
- Too impetuous? In advance, think through and write down a numbered list of every stage of your proposed painting. Then methodically follow your instructions to balance your approach.
- Too many small marks? Enlarge one small area of your subject, use a large brush and set the timer.

Your character will still shine through in the decisions that you make. The most important factor is to develop your style, gained through play, which is experimentation driven by curiosity and choice.

EXERCISE – Painting in and out of character

Method

Write a list of key words that you believe describe your personality down the left-hand margin of a sheet of paper. Ten will be ample. Then write down the opposite words on the right-hand side of the paper. Now cover the first list. Then, like an actor, imagine the image that this other character would make. What subject would this person choose? Now systematically go through the Big Five and imagine the colours and their contrasts (or lack of them), tone and contrast, etc. that would express this personality.

Paint the painting that you have visualized in your head.

This process is not designed to encourage inauthentic painting but to flex up the rigid habits that we get into and allow decisions to be made by choice, not habit. I have successfully used this method to, for example, calm or energize myself.

Painting – a subjective or objective experience?

A watercolour painting is a one-off performance.

At a film or play, you can relax, sit back and allow yourself to be drawn into and lost in the world created. Now, though, as creator, you are simultaneously behind the scenes and also imagining how this will look from the comfy seat. You are not only making the characters, words and costumes but are also producing, performing and directing. You are the maker and the audience. The moments of being an objective audience are precious shortly before you begin to review your creation like the worst critic, then to defend it, like the fiercest, most protective parent. These roles are not easily interchangeable because it is impossible physically and mentally to 'be' in both places simultaneously.

Therefore as a maker, it is a skill to study effective methods of expression objectively. Study paintings that you like, to see if you can consciously identify their appeal as well as just letting them weave their magic upon you. Identify any common links; then review your own paintings with this awareness.

Two sides of a coin

The patience and practice necessary for acquiring watercolour skills can impede instinctive expression. Skills are the very route to instinctive expression. The journey to these skills is well worth the initial engagement because the medium actually shows the artist the way. Watercolour is both close in substance to the physical and the imagined reality of the human world. The desire to express a particular subject incites the aspect of watercolour that is next to be added to your experience. For example, as water and pigment mix, the appearance of a cloud, rain or the notional idea of time can be expressed in watercolour as easily as the solid form of trees and rock. So the skill is learnt as you go along. Once yours, like driving, ease of handling becomes instinctive, which encourages the confidence to say anything, at any speed.

This is not to say that all skills have to be intuitive before being used 'on the road'. Though accompanied by an instructor, most driver learning begins on a public road. No, truly letting go and surrendering to expression happens when the artist feels that they have sufficient skills, whether it be visualization, drawing or handling of the medium, to do so. This a personal decision which usually happens naturally.

It takes courage to paint onto white paper knowing that when it's dry there's no going back. It takes practice and mental agility to instantly work out the subtractive colour when glazing layers and, because light-over-dark is not an option, more mental gymnastics while your brain is admiring the light, positive image, to convince your hand to paint a dark, negative shape over or around it. It takes tolerance to accept that you can't bully or poke watercolour into submission without it telling on you (through mud-stained tears), and humility to accept that it loses something of its intrinsic glory when it is forced or pushed into place, and then perseverance to start again. Nevertheless, it is crucial to decide whether the medium or the message is driving your painting.

Spring Light After Rain. Like the title, this painting and I fell in together, heralding a return to confidence.

THE MEDIUM OR THE MESSAGE

Watercolourists use the medium in a different way. For some, it is a convenient and portable tool for recording information or sketched ideas. For others watercolour is used in conveying factual accuracy, for example, in botanical or miniature portrait painting.

Lovers of texture, light and colour relish the fact that, being of the same substances and properties of earth, water, air and fire, watercolour can directly express weather and landscape in all its differing lights. In its behaviour, the drying speed, layering and transparency of watercolour also has an affinity with the nature of physical human life, movement, thought and time. In these respects, the medium is the message.

The practice of watercolour painting itself can teach the artist to be:

Thoughtful – plan or explore, there will be a visible chronicle for reflection

Skilful – visible layers offer an immediate understanding of colour and tone

Incisive – making this mark, whether tentative or bold, is a visible act in time

Experimental – watercolour skills, like life, are a serial affair and, with only paint and paper at stake, will improve with reflection

Watercolour, the artist and time

Watercolour is the natural all-round medium for honestly expressing the experiences of the human mind, body and spirit. Its very process combines the elements, you and time. This applies to the direct topographical sketch in the moment, the suggestion of an idea or an extensive many-layered, longer piece of work.

Watercolour is throwing off the traditional perception that it is only used for the small study e.g. botanical, or five-minute holiday description of 'things', or washy hint of colour, safely locked in by a stabilizing ink line.

Using watercolour as a logbook, a mirror, a map to plan a journey

Watercolour is for me a metaphor for life, which acts as a reflector when I want to find out 'where I am' in relation to my environment, feelings or progress through life. Whether figuratively or not, self-consciously or not, I just paint. When I study my painting, the transparent honesty of watercolour acts as a mirror, telling me where I am and where I have been, and then as a tool, pointing me in the right direction.

Equally, by painting where I want to go, I find that visualization and expression of that idea, however broad, firms up the plan and puts me on the road to action.

Watercolour represents more to me than a recorder of visual fact. As my approach to life subtly varies and evolves, the mutable nature of water not only responds sensitively to these changes but also keeps me on my toes by inspiring new processes; continually inviting, provoking and satisfying my curiosity. The actual painting process anchors me by bringing together past experience and the visualization of a future idea through action in the present. This provides a continual life-lesson in balance and counter-balance which, when my relationship with watercolour is alert and flowing, brings past, present and future into single focus. These are the magic moments that keep me bonded to watercolour.

MY EXPERIENCE OF THE PAINTING JOURNEY

• Starting at the bottom of the mountain visualizing, looking up, 'I wish I could be there'.

• Take risk, leave familiar, climbing unfamiliar to begin with, then getting into comfortable stride.

• Pain sets in, muscles ache, I want to stop, ready to give in (always a sign of being near the top).

• One last haul.

• Arrival, euphoria, celebration (the pain has stopped).

• Relaxation, boredom, familiarity, irritation sets in.

• It is not possible to be simultaneously at the base to see the progression – only ever 'here'.

• Look up – another mountain – not visible from the base.

• Prepare to take another risk, and so the cycle continues.

What I have learnt is that every time my painting feels most difficult, that this sensation denotes the last haul to a new place, a significant step forward. I no longer fear it but rather, have faith in it.

Realized achievement has, in time, given way to a subjective enjoyment. Savouring this journey, which continues (despite hold-ups), in turn encourages an honest and unique visual statement.

Towards Space. My life was too full so I made this painting to consciously take me to a simpler, more spacious place. However, it surprised me in two ways. I chose gold fingermarks to represent the 'best' in me climbing to a higher space. The final effect was of a dull distressed gold of faintest gleam and well described my own opinion of my underachieving self. Secondly, although my life actually became busier, my mind's eye had seen the space and making time to paint the painting reminded me to focus and enjoy each activity in the present. I suddenly relaxed into an airy spaciousness where disentangling 'now' from past and future became a possibility.

Any coward can fight a battle when he's sure of winning but give me the man who has the pluck to fight when he's sure of losing. That's my way, sir and there are many victories worse than a defeat.
George Eliot

Slough of Despond

The exercises outlined below are for low painting moments of frustration, anger or deflation. These happen less for me now, not because I think that I am a 'better' painter but because I can now feel one coming and understand what they represent. They often happen when there is a disconnection with the medium and/or subject. The symptom is feeling 'disappointed with results'. Trying too hard for an engagement with the future blocks an alert awareness of action in the present.

EXERCISE – PAINTING THROUGH A TANTRUM

When angry or disappointed with results, these processes have brought me back from the brink of giving up painting several times. They stem from the genuine feeling that there is nothing

to lose and only require the perseverance to let go and give just one 'last' moment of attention and engagement.

Method

When frustrated, put the offending painting away for now and grab another sheet of paper. Haul out the full mark-making kit, those unused 'disliked' pigments, nearly-finished, dried paint tubes lying around and, cutting them open down the side, make wings to scratch and dig out dried, neat paint.

Depending on the energy level of the mood:

- Paint the first thing that you see, saying, 'It doesn't matter what it looks like because this will be my last painting!'
- Make instinctive, random marks with water (or completely wet the paper) with any utensil, including fingers, nails, knuckles and thumbs. Then drip and drop paint into the wet surface, using neat or dried paint. Have fun and forget what it looks like to anyone else.
- To gain distance and a greater sense of physical freedom, put the paper on the floor and using big brushes fixed to sticks, walk round the painting, listen to rhythmic music, dance, get the oxygen going, swing

your arms and let go the energy of frustration and use its dynamism to create.

Not only will you feel better after this practice, the painting will usually tell you where you are. I usually find that I have fallen in love with watercolour all over again and discovered new colour combinations.

EXERCISE – WHEN DEFLATED, INSPIRE YOURSELF

Exhausted by the decision-making involved in painting, getting fiddly and dabby or visually overloaded, have a break and put the painting away. On new paper, relax and doodle with a loaded brush of paint or water, dripping, changing colour and brush size whenever you feel like it. With no outcome in mind let your hand wander where it wants to with the paint and water.

If you really relax, I guarantee you will make marks to inspire.

Amongst my friends from the Slough of Despond are the accompanying paintings. Each one saved me from giving up.

However uncomfortable it feels, I now recognize the 'Slough' as the signal that I am either more concerned about technique and control than my subject and, bored with cruising known territory, am dragging my heels, closed to both surprises or real engagement in the present or simply fearful of future change. I am ready to move on and the joint sensation of increasing acceleration and braking begins to grate on my nerves.

Nevertheless, though the Slough of Despond makes an increasingly loud noise, it is a triumphal, if discordant, fanfare for exciting development, a new beginning. If you ever feel it, please read what it is trying to tell you.

Probably the most telling anecdote that I can give to express my gratitude to the significance of watercolour painting in my life is centred around *A Sense of Place*.

I was painting in a life workshop (incidentally awaiting a brain operation, already cancelled three times). The pose was relaxed and lying down. For the first time I could ever remember, I found myself painting a black background all around the figure. I could add no more so started another. This time the colours were bright and positive and I put in a random set of background shapes and colours. Then I realized that I had unconsciously painted a place, iconic for me, in Dorset where I grew up. I knew that in that session I had painted my way through my darkest fears and into a place of utter peace, happily at rest.

Anemones. 'Bring it on' (anger) – a tiny posy painted large. One day, in frustration, I was about to give up painting altogether. This little bunch of flowers 'called' me to just let go and have fun with deep, rich, yet subtly different rainbow colours. During this vigorous process, I experienced, not control of, but partnership with the medium and decided to continue painting.

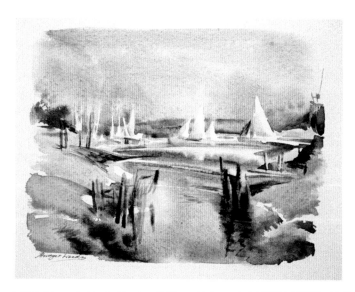

Itchenor. A fond farewell, this tiny little painting turned what was planned to be a sad swansong to utter joy.

Garlic. With gritted teeth I started to paint the 'first thing before my eyes' to prove that it was time to give up painting. Intended to be one last dance this little painting lifted me up with heavenly colour and pushed me forwards on my journey with watercolour. I wish I had a better photograph.

DEMOCRATIZING PAINTING – THE RIGHT OF EVERY PERSON

Painting expresses a response to life, when words, photographs, sound or movement are inadequate, or to re-interpret facts. Paint can make visible a subconscious feeling or idea in order to release or understand it better, and I believe that as everyone has the right to speak, sing and whistle, they also have the right to paint if they choose to. All that is needed is the right tool for the job in hand and the skill to use it. Skill is born of practice; practice is born of the will to do.

Expression through painting, even if seen only by the artist, is literally putting a personal response 'out there'. Much music finds its expression through the combination of lyricist, composer, instrument, musician(s), voice(s) and conductor. In painting, however, the artist is the writer, composer, conductor and the voice of expression. Furthermore, with watercolour, white paper and a few colours you have not just one instrument but a whole orchestra of 'sound' in your pocket. You can create unlimited imagery ranging from sensitive to crude, subtle to sensational and roam beyond the realistic to an imaginary world of fantasy and dreams.

There are composers, musicians, singers, orchestras and conductors. Once in a while, but only rarely, their necessary skills all conjoin in one person. As expressive painters in watercolour, we are choosing to create this 'one-night only performance'. Single-handed.

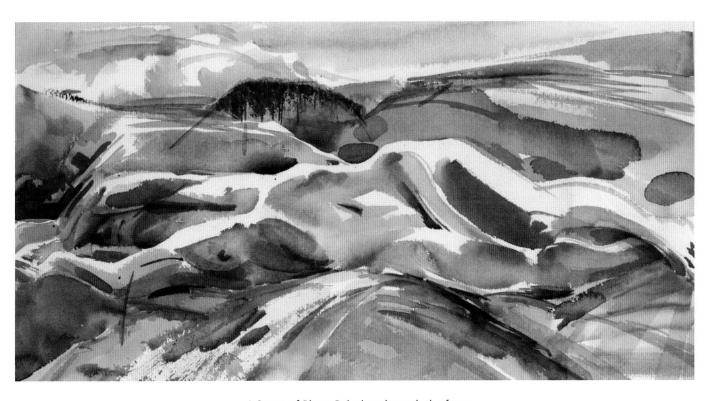

A Sense of Place. Painting through the fear.

Jago 1. For a commission, several versions were made. These are examples.

Jago 2. Originally intended as the underpainting; I decided to add no more.

I can understand the brilliant technician of observation who chooses to copy, the composer whose voice wants to get a message down on paper and the conductor who influences the balance of sound as part of the team of people who give expression to that piece. It is no mean feat to take on any of these roles. But to take them all on – brave? Definitely.

> *After exploring many instruments, I have found that it's all too easy to get carried away with their known sound and the themes that suit them. Although each has a beloved image, the Harp has so many tones and so many images are invoked, all with that wonderful trait of sounding as if the piece were naturally written for it. A work transcribed for harp brings a new vision, an enigmatic quality and a 'look' which is always paramount.*
> Jonathon Venez, harpist and composer

Painting is for me the unfolding of a sequence:

Inspiration – breathing in of the subject
Connection – mingling with its nature
Aspiration – visualizing
Attention – focusing
Expiration – letting go the marks
Expression – showing
Exhalation – letting go the painting, the final out-breath

If it feels good

Which aspects of painting give you the most pleasure: visualizing, planning, making, showing, selling, giving? Like juggled balls these change their priority. The greatest reward for me now comes from the act of making, rather than outside approval. Selling adds another dimension which usually feels like a meeting of minds, a link of recognition with the buyer – an empathy which is never forgotten by this artist.

As your painting improves, so your critical faculties will improve and refine. For this reason, painting will always be a challenge. There is no beginning, middle and end. No one single answer.

Also, watercolour is so sensitive to personal mood and weather atmospherics that the paint-drying and timing coordinates are rarely the same, which means that the excitement of discovery with watercolour painting never ceases.

> *Life loves to be taken by the lapel and told: 'I'm with you kid. Let's go.'*
> Maya Angelou

Absolute basic understanding and respect for water and an open mind are the cornerstones of the good watercolourist. This does not change: only the experience, its duration and individuality of application.

Painting – noun and verb

A painting is a noun and may be a destination that beckons us to walk with our gaze fixed ahead. Painting is a verb, not the destination. With eyes fixed only on the goal, the dissatisfaction of non-arrival can easily dis-'engage' the artist along the way, inducing impatience and outweighing the pleasure of the painting process.

While it is important to have a goal (long, medium or short-

term) and a strategy, it is useful to maintain a happy balance between the two. This sounds easy but while watercolour offers so much, it can be a capricious vehicle of expression. In my opinion, it is not a medium to be mastered at the cost of sapping its life force. It is incumbent upon the artist to be prepared and then run with it. These moments of balance are precious; neither noun nor verb, they are also outside of time.

You will become as small as your controlling desire; as great as your dominant aspiration.
James Allen

To infinity and beyond

With watercolour it is possible to find a comfortable process which works sufficiently well to describe a viewpoint, give painting pleasure and even result in sales. Indeed, it was the 'infinity' of a flat sky wash seen in a gallery that made me gasp and influenced my decision to choose this medium. It was only later that I discovered that this wash formed part of that artist's routine method for painting potboilers.

Or, this same humble medium, inanimate until you and water are added, has the ability to take the landscape artist on a personal and intimate journey. Maintaining a lithe capability and open-minded awareness to this potential enables an acuity of vision, descriptive prowess and refinement of style. Like the thrill of life drawing or the jigsaw riddle of a portrait, the external components and your mood in this moment will never be repeated. This vigilant approach is anything but routine. A wider audience may diminish as your message becomes more specific but those who do hear you are listening with an open mind and your painting experience will far transcend pleasure.

This book hopes to offer not the quick fix that judges right and wrong and hooks you into another artist's style, but rather some routes for identifying, creating and enjoying your painting aspiration with less trial and error; most importantly in the time, never wasted, that it takes.

By grace of the natural affinity with life-giving water, the thrilling sensation of discovering myself and confidently expressing my world has been unlike any other.

This book is only my story with watercolour so far.

Walk With Me. Still one of my personal favourites this painting beckons to walk in and through to the light on a continuing journey.

Aqua, Terra, Ignis, Ardor - water, earth, fire and passion. The underlying force of volcanic power surging through ice.
I believe that artist, medium and message can combine as one to express 'duende'.

DEDICATION AND THANKS

No man is an island,
Entire of itself,
Every man is a piece of the continent...
(John Donne)

I would like to dedicate this book to my brother Roger, who taught me so much and sadly died in February 2012.

A book, like a painting, can represent one person's response to their world, known or imagined. I feel fortunate to have been born within the freedoms of this time in history and location on earth and given such a rich and fertile seedbed of family and friends to nourish my curiosity, humour, integrity and passion for life, ideas and expression.

The whole makes me who I am.

THANKS

Greatly missed and an important part of my creative development for over twenty years: Trevor Rush (d. 2012), bespoke framer, for always finding time to turn my tentative 'scraps' into paintings while 'anaesthetising' my exhibition nerves with dry objectivity and jokes; Denis Hughes (d. 2008) for his honesty, faith in my potential, unconditional friendship and giggles to tears.

To Ali and Sue who gave me temporary sanctuary and a little table in front of a window 'in case you feel like painting....'. To all learners who come with me to explore the potential of water-colour and inspire me with their observations and questions, which, as experienced watercolour painters know, are *never* too simple. In particular, one small group of which I gradually became a part; flexibly numbering between five and ten, we became 'Five Brushes', encouraging and challenging each other with taxing watercolour projects all year round. To John and Sakura who 'reminded' me to write this book and got the flywheel started. To Derek and Alda who kept it going and all my chums in Iceland - what a joy to teach! To Graham, Blu, Jexica and many others for their warm moral support. To Rob who generously scooped me up from a 'stall dive' with his vision and confidence-building skills and to Caroline and Freda for, as ever, sound advice.

Though the process results in a double exposure as artist and author, making a book of words and pictures is a solitary business. I am grateful to the Penny Black Choir for both providing a constant warp thread to the everyday weft of creative and technological ups and downs, and for the chance to develop a different form of expression within the positive energy of a group.

My special thanks go to Sue Colyer, without whom this book may not have made the publisher's desk. Offering first to read, she then kept me on course through the last stages with compassionate tenacity and encouragement saying that she would stick with me to the end. Though also having her own life and painting to consider, she has done just that.

Finally, to all the family, friends, ideas and paintings waiting to be enjoyed 'when the book is finished', I can only say that I am excited about the future and thank you for waiting.

Bridget Woods, 2014

FURTHER INFORMATION

When buying materials, a local art shop can offer personal advice, allowing the artist to see, try and have instant access to products. There are also many online companies that sporadically have special offers on different materials and also provide a good delivery service.

Ken Bromley (www.artsupplies.co.uk) is the online company that I mostly use. It is a friendly family-run company, which will, by phone, offer guidance and advice and give delivery that is fast and reliable.

Other recommended equipment and suppliers include:
Khadi paper, including cards and Zig Zags (www.khadi.co.uk)
I also buy sable riggers from Handover (www.handover.co.uk)
Ivory short flat and squirrel brushes from Rosemary and Co (www.rosemaryandco.com)

Bridget Woods currently teaches regularly at:
Tidy St Studio (www.tidyst.com)
West Dean College (www.westdean.org.uk)
For details of the author's other courses in the UK and painting holidays abroad, please refer to her website:
www.bridgetwoods.co.uk

INDEX